Carpet Diem

ALSO BY GEORGE BRADLEY

Poems
Terms to Be Met
Of the Knowledge of Good and Evil
The Fire Fetched Down
A Few of Her Secrets
Some Assembly Required
A Stroll in the Rain:
New and Selected Poems

Translations
Late Montale

As Editor
The Yale Younger Poets Anthology

Carpet Diem

Tales from the World of Oriental Rugs

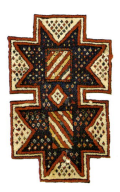

George Bradley

HARPER

An Imprint of HarperCollins*Publishers*

Note: This is a work of nonfiction, and to the best of my ability the events and experiences herein are presented as I remember them. Many names, as well as some places and circumstances, have been changed in order to protect the integrity and/or anonymity of the various individuals involved. Although the scenes and dialogue are based on my recollection, they are not intended as word-for-word documentation; rather, I have written this account with the aim of conveying the essence of what was said and the gist of what happened.

CARPET DIEM. Copyright © 2025 by George Bradley. All rights reserved. Printed in Canada. No part of this book may be used or reproduced in any manner whatsoever without written permission except in the case of brief quotations embodied in critical articles and reviews. For information, address HarperCollins Publishers, 195 Broadway, New York, NY 10007.

HarperCollins books may be purchased for educational, business, or sales promotional use. For information, please email the Special Markets Department at SPsales@harpercollins.com.

FIRST EDITION

Designed by Leah Carlson-Stanisic

Photographs by Chris LeQuire

Library of Congress Cataloging-in-Publication Data has been applied for.

ISBN 978-0-06-339493-3

25 26 27 28 29 TC 10 9 8 7 6 5 4 3 2 1

It is naught, it is naught, sayeth the buyer; but when he is gone his way, then he boasteth.

—PROVERBS 20:14 (KJV)

Acknowledgments

Every carpet collector dreams of benefiting from the talents of a fine photographer, and so my thanks first of all to Chris LeQuire for the splendid images of the carpets illustrated in the pages here. Those pages would not have found a press or reached a public without the efforts of my agent, Glen Hartley, who has had inexplicable confidence in my abilities for many years. Thank you, Glen. My thanks also for the faith, hope, and fortitude (in this case, publishing virtues) demonstrated by the management, marketing, and production staff at HarperCollins. In particular, Leah Carlson-Stanisic and Milan Bozic proved sensitive and accommodating designers of the book's interior and cover; Rachel Elinsky and Samantha Lubash were an energetic and resourceful publicity team; while Miranda Ottewell was an expert and meticulous copy editor who saved me from many infelicities and outright errors. I have been lucky enough to work previously with a number of able editors and editorial assistants, but none has been more so than Sean Desmond and his indefatigable assistant, Jackie Quaranto. They were endlessly encouraging, patient, and flexible during the unexpected personal setbacks I encountered while publication was in process, and the fact that the book's appearance was not overly delayed and that it turned out so well is due largely to them. I also wish to thank my many friends in the carpet world for their generous sharing of information. I received more assistance than can be acknowledged here, but I do want to mention that of Elisabeth Parker and Sheila Fruman. Finally, several people—Jeff Berry, Spencer Boyd, Jay Clayton, Tom Farnham, Paul Kane, and Mary Jo Otsea—read some or all of this memoir in manuscript, and I am most grateful for their suggestions and enthusiasm. They helped enormously.

Contents

ONE **I Fall in Love**
The Jerusalem Consul's Ferahan-Sarouk 1

TWO **The Deep End of the Pool**
The Gold-Field Kurdish Carpet 15

THREE **Because You'll Never See Another**
The One-Off Northwest Persian 35

FOUR **A Handshake Business**
The Old Derbent Kelleh, Part I 51

FIVE **The Rug or the Money**
The Old Derbent Kelleh, Part II 71

SIX **Kayseri *Pazarlik***
The Anatolian Prayer Kilim 93

SEVEN **The God That Was Stolen from Me**
The Flawed Khamseh 113

 A Dealer Story
 The Tibetan Temple Thangka 137

EIGHT **The Goldilocks Option**
The Rebuilt Shirvan 155

NINE **The Hajji Babas**
The Fragile Tabriz 185

TEN Wrong about Everything
The Reduced Kazak 209

ELEVEN But If They Could
The Sufi Kirman 237

Appendix: Palette 251
Glossary 253
Bibliography 271

Carpet Diem

ONE

I Fall in Love

The Jerusalem Consul's Ferahan-Sarouk

My great-grandfather was a public man and is the reason I collect carpets. A soldier, a minister, and a diplomat, he was US consul in Jerusalem during World War I. After his posting to Palestine, he moved on to France and ended his diplomatic career in Nice, where in his old age he acquired a lady friend by the indubitably French name of Josephine. In 1931, feeling his eighty-five years, the consul decided to return home, and along with the lady he sailed for America. He didn't quite make it. Instead he died at sea, and Josephine appears to have panicked. Not reading English and not knowing what compromising information her lover might have left in writing, she burned his papers. All of the public man that came off the SS *Belgenland* when it docked at Pier 59 in the Hudson River was his body and such items as he had loved too much to leave behind: Josephine, a few pieces of furniture, and dozens of oriental rugs.

Josephine soon went back to Nice (where my great-grandfather's heart is now buried beside her), but the rugs remained, at least for a while. In the 1930s decorating with oriental carpets was still the fashion, and family photos of the period show the large rooms of the family home in Dongan Hills fairly laminated with them. Tastes changed, though, after World War II, and by the 1950s no one wanted the old-fashioned look. Wall-to-wall "floor treatments" came in, and the handwoven orientals disappeared. Some of the consul's carpets were sold, some were thrown out, some were left to molder in attics and basements. There were so many of them, though, that every branch of the succeeding generations inherited a few, and so it was that one eventually came to me.

I was eighteen and heading off to college when I found an old throw rug heaped in the corner of our cellar and took it away to the cramped

room of my freshman dorm. To my incurious eye, it looked simply black and tan with a design of snarled branches, and I didn't think much about it during the undergraduate years I spent abusing it with spilled beer and corn chips and occasionally worse. But the little rug proved resilient, and as I moved on through life it moved with me, first to Virginia and later to New York City and eventually to small-town Connecticut. I kept it under the chair at my desk, where it warmed my toes as I worked at becoming a writer. Time passed. I married, my parents died, the World Trade Center was destroyed, the US invaded Iraq, and I had published four books and fathered a child by the time I glanced down one day to notice that my great-grandfather's souvenir was showing its age. There were cracks along its edges and a crease at one end. I pulled it out into the light to have a better look.

The Jerusalem consul's rug was about four feet wide by seven feet long. The beige arabesques that filled its field turned out to be interspersed with leaves and blossoms in many hues, and there was a vine scrolling around its rust-red border that was studded with clusters of grapes. Six small medallions filled the areas left empty by the arabesques, and yet the very center of the rug showed nothing but a pitch-dark blank. It was as if a profusion of vegetation overlaid an aperture into deep space.

Handling the rug, I found it was a pleasure to touch, as rewarding to the fingers as a silk gown or downy skin, and the colors I examined were fascinating. What I had mistaken for black was actually a midnight blue, a deeply saturated dye that gleamed when it caught the light and resembled the ocean in the early dawn or the sky at dusk. I saw that the russet of the border was in fact almost a shade of brown, like the pelt of a fulvous animal. There were several varieties of green, including a pistachio flecked here and there with yellow, and where there was yellow unalloyed, it was the sandy gold of desert places. All of the colors ran a gamut of gradations, changing subtly in tone and intensity wherever one looked, so that the gaze was continually lured onward.

The colors were extraordinary. It was color that first got my attention in carpets, and it is color that continues to attract me to them today. A good rug arrests the eye. I have marveled while drifting over

Caribbean reefs at the scaly brilliance of tropical fish; I have gazed for hours in museum galleries at the luminous panels of Renaissance painters; I have stared out my window in autumn at New England's spectacular foliage; but I have never seen colors elsewhere, in nature or in art, that can match the subtle palette of a fine oriental carpet. Color is to an antique rug what bouquet is to a vintage wine, at least 50 percent of the point.

The more I inspected the keepsake my ancestor had brought out of the Orient, the more I appreciated why he had held on to it. The rug was beautiful. It had sentimental value, too. I decided to have it repaired.

In New England, old objects are a stock-in-trade, and finding someone to sew up my rug did not prove difficult. As it happened, my next-door neighbor at the time was a dealer in antique furniture, and I stopped by one afternoon to see if he knew of anyone who dealt in carpets.

* * *

I discover Gary Clifton improving a secretary desk, rubbing cigarette ash into the lacquer stain with which he is disguising the new beading he's added to the original apron. (The ash dulls the sheen of a freshly applied coat and helps simulate an antique patina.) He is a wiry man with a quick mind, a sharp eye, and a cynical sense of humor. Like many balding men, he often wears a hat, and he wears what hair remains a little long. With his hat on, he looks like an aging folk singer. With it off, he looks like Shakespeare.

"You have any pantyhose on you?" he asks when he sees me.

"Pantyhose? Not at the moment. Why?"

"I think it would look better if I strained the shellac first."

'What are you doing here?"

"Creating a masterpiece."

"You think it will fool anybody?"

"Who's anybody? Me, no. The average guy, you bet."

Gary improves his antiques, but he isn't cheating anyone. He has no retail customers and makes no claims for the furniture he buys

and sells. Instead, he travels around Connecticut and its neighboring states to acquire old pieces at auction if the price is right, and then he works meticulously to make them more attractive. He disguises faults, repairs damage, adds ornamentation, brightens or distresses the finish as seems best, and when he's done, he offers the result at auction again, as is. Watching Gary at work is educational, and not just with regard to furniture. Old carpets, too, are very often "improved." Repiled, reselvedged, redyed. Like beauty, authenticity is in the eye of the beholder. *Caveat emptor.*

"Oriental rugs, huh?" he responds when I make my inquiry. "What do you think of that one? Two fifty at an estate sale last week."

On the floor of his shop is a full-size carpet that shows a grid of square compartments filled with a variety of floral motifs: blossoms, shrubs, pendulous trees. (I'll learn it's a garden-design Bakhtiari, a type made in western Iran.) The colors are bright and attractive—though I'll eventually be able to see that many of them are synthetic and hence off-putting to collectors—and the price of $250 comes as a surprise. Antique oriental carpets at the top end of the market have skyrocketed in price in recent years—the record is now over $33 million—but newly made rugs of merely good quality can sell for very little.

Gary hears me out about my ancestor's rug, and when I finish he gives me two names: Ron Somerset and Jim Barnard. Ron doesn't answer his phone when I try him that evening. Jim does, and I make my appointment.

Jim Barnard lives outside of Hartford on a road that skirts the floodplain of the Connecticut River, and on the day I first go to meet him, spring has finally arrived in the river valley. The reedy marshes and stands of scrub growth are flooded with the snowmelt descending out of Vermont and Massachusetts, and the shimmering sunlight reflected off the countless ponds and streams is gathering strength as the morning approaches midday. Driving past the region's fieldstone walls and clapboard houses and tall-windowed churches, I think how New England is as antique as America gets. Of course, that's a relative thing. The past doesn't have much to work with in this country, where a home is old at thirty years and a town is old at

three hundred. Perhaps for that reason, Americans love flea markets and antique fairs. They spend so much of their time wrapped in the brand-new and the mass-produced that any object made by hand a century ago—a hat box, a wooden doll, a wrought-iron hinge—seems a worthy focus of nostalgia, whether anyone actually remembers using it or not. And because the twentieth century was a disaster for craftsmanship of almost every sort, old objects that testify to painstaking manual skill seem particularly venerable. There's nothing that requires more craftsmanship than weaving a fine oriental carpet, and no antiques fair is complete without them. As decorative items, they go in and out of fashion, but collectors have never abandoned them.

I pass a statue of Colonel John Mason, the ruthless Indian killer standing with sword in hand to glare at our marginally more tolerant age, and come to a gingerbread Victorian close beside the road. The number on the mailbox says it's Jim's. I notice a couple of signs posted warning of security systems and unfriendly dogs, but I hear no barking when I pull into the drive. Instead, it is Jim who hears my arrival, and as I step out of my car, he steps out his kitchen door to greet me.

Jim Barnard has iron-gray hair, a square face, and a straightforward approach to life. His manner is pleasant but no-nonsense, and among the imaginative, not to say inventive, not to say duplicitous people I will meet in the rug business, Jim is among the most honest and down-to-earth. As we shake hands, he looks over both me and the rug I have brought him in rapid appraisal.

"It's Persian," he tells me as I unroll it, "a Ferahan-Sarouk.* Leave it on the porch and come on inside and we'll talk."

"You want me to leave it right here?"

"I don't ever bring a rug in the house until I've checked it for wildlife. If I see anything, I wash it. Even if I don't, I vacuum both sides to be sure. That way no eggs hatch inside and moths don't get into the rest of my carpets. Leave it there."

* For help with place-names and carpet terminology, see the glossary on page 253.

The home's interior is something out of a fever dream. It looks like an Orientalist painting by Gérôme or Delacroix. There are rugs on the floors, rugs on the chairs, rugs hanging on walls, stacked on a desk, draped over a banister, standing rolled up in a corner. And there's a strong smell in the air, too, the distinctive odor of wool that is as pleasing to the nostrils of a carpet lover as the smell of oil paint is to a gallery hound. I take off my coat and take a seat. Jim sits down heavily and gestures to the large carpet lying under the dining room table where we've settled.

"I just got that. It's a pretty good Heriz. I had a better one, I mean it was really good, but I sold it. My wife Cathy was mad when I did."

"Then why'd you sell it?"

"A friend of mine came in and started just throwing down money. At some point, you have to say yes. You can't stay in business if you don't. I've got some things I've kept because nobody's willing to pay enough, but any rug I own is for sale at a price. All right, so tell me about yours. Where'd you get it?"

If you bring a good rug to a dealer, that's often the first question asked. What's your source? How come you found this rug, and I didn't? Why didn't someone call me to tell me about it? A regional operator like Jim makes his money by locating carpets, and as the resident expert he is expected by others in the business to "comb his backyard." That is, when an interesting carpet turns up in his area, say at an estate sale or in a small antiques store, he's supposed to hear about it from the auctioneer or the store owner. If the rug's good enough, Jim will buy it on the spot and take it in turn to the high-end dealers in Boston or New York. Jim's competition in this activity are the so-called pickers, individuals with a little knowledge and some ready cash who go around to small venues looking for items to resell. The city dealers will sometimes train a promising picker with the right instincts and a good eye to recognize valuable rugs, and many people (particularly people who do not come from a long line of Iranian or Armenian or Turkish merchants) first get into the carpet trade that way.

What Jim has that the pickers don't is a greater fund of experience, but he also has his established reputation and recognized role.

If a rug gets to the auction block, it's anyone's to purchase, but the local auctioneers and estate liquidators know Jim and trust him, and they appreciate his repeat business. He often gets a phone call ahead of time.

"Where'd you find it?"

"In my parents' basement. I inherited it."

"I see. Well, what it needs is reselvedging. That means rebinding the sides. I charge ten dollars a foot to overcast the ends, but doing the sides is a lot more work. And a rug like this is woven so densely that it's not easy to sew up. Sometimes you have to hammer the needle through. Anyway, the new selvedges will cost you three hundred and fifty dollars. It'll take me a while."

"Wow. That's a lot of money."

I actually don't know if it's a reasonable price. It's my first time paying for anything having to do with carpets, and I have no idea what things cost.

"Not really. But if money's a problem, I could buy it. Would you like to sell it?"

"Sell it? No, I don't think so. It's got sentimental value, it belonged to my ancestor."

"Nice ancestor. That's a pretty good carpet."

"Why, what's it worth?"

Which is typically one of the first questions an amateur asks. There's no good answer to the inquiry, for a couple of reasons. One is that the cost of an oriental carpet is a unique event. The same rug can bring wildly different prices depending on the circumstances of the sale, so that a bag face that brings two hundred dollars in a small auction in upstate New York might be offered by a dealer in Switzerland for the equivalent of several thousand. At a yard sale, at an antiques fair, in an obscure auction, from a dealer who needs to pay bills, from a dealer who is still attached to a piece recently acquired, at a major auction house with an international clientele, from a kid-glove dealer to the carriage trade . . . where a carpet is bought and who's doing the buying will make all the difference.

The other reason that the question of value rarely receives a satisfying answer is that dealers don't like to be pinned down. They want

to be able to adjust their prices as necessity dictates or opportunity offers.

I once knew a man from a family of Atlanta lawyers who claimed his relatives "billed on the flinch method." When it came time for payment, they would look somber and say: "Now normally in a case like this we'd charge fifteen thousand dollars . . ." And if the client flinched, they'd continue: "But in this case, we were able to save you some money, and we'll only need to charge twelve." If the client didn't flinch, however, the price would jump: "But I'm afraid there were complications on this occasion, and the hours added up, so we can't avoid charging more."

The flinch method is used in some form in many businesses, and it is almost the rule in the carpet trade. There's no blue book value or catalog cost for rugs, and the authors who claim to include price guides in their books are retailing a laughable fiction. Dealers will charge what the market will bear, but nothing is worth anything in this world except what someone is willing to pay. If you are going to buy and sell carpets, you had better learn how to bargain. As an American accustomed to paying the price-as-marked in shopping malls and supermarkets, bargaining was not in my background. An innocent was venturing into the souk.

"What's it worth?" I repeat.

"Well, that depends," says Jim. "In good condition, for a customer buying it at ABC Carpets in New York, five or six thousand dollars. For someone trying to sell it to me in this condition, a lot less. Maybe fifteen hundred."

"I don't want to sell it."

"I know. That's why I told you. Why don't you come see what I've got for sale out in the shed right now? It will give you an idea of what things look like and what they cost. There's quite a range."

The building we walk out to is a windowless addition built on to the home's garage, and I notice more signs warning of a security system posted on the heavily padlocked door. When Jim lets us in, though, no sirens go off and no electronic surveillance system springs into action. The signs are all for show.

"Where's the security?" I ask. "And what about the dogs?"

"Our dog died a couple of years ago, and we haven't had the heart to get another one. I did have a security system once, but I got rid of it. Every time a mouse moved, the thing went off and the police would come to the house. They got tired of that, and we did, too."

"You decided it wasn't necessary?"

"Actually, it might still be a good idea. When I first started in the business, I didn't want anybody to know where I lived. They all know by now. There's probably two hundred thousand dollars' worth of carpets in here, and I'm gone sometimes, to shows and stuff. Well, I've got insurance."

The inside of the shed has shelving on all sides that consists of sturdy platforms stacked above one another like bunk beds, and on the shelves are folded carpets of many kinds. The first few Jim pulls down to show me are Caucasian scatter rugs, many of which have large geometric diamonds and stars and octagons drawn in bright blue and red. In his matter-of-fact way, he sells me on them for a while, pointing out details in carpets he calls Shirvans and Kubas and Gendjes and Kazaks. I'm not ready to spend the $2,000 or $3,000 it would take to buy one, though, and indeed I'm not sure I want to buy anything. After all, I came here to repair what I already own, not to acquire objects I know nothing about. Still, I can't deny that the carpets attract me. The touch, the smell, the fantastic colors . . . I feel an instinctive response, the undercurrent of a growing infatuation, a tingle like I used to feel after the third gin and tonic in a singles bar. And in fact acquiring a collector's mania is a bit like falling for someone. It can hit you out of nowhere, and who knows why it happens? Maybe it's the right moment in your life, and you're ready for a new experience. Maybe you suddenly realize that a hunger of which you had been only dimly aware can now be satisfied. Maybe it's just kismet.

Jim looks over at me now and again, judging my readiness to spend, and eventually we move down to lower price points. I see a small mat with an allover pine-cone pattern and very dense knotting.

"That's a Senneh," says Jim. "If it didn't have that pink synthetic, it would bring a couple of thousand dollars. But it docs have it. I could let it go for, oh, maybe twelve hundred."

I still don't bite, and we descend another level. He shows me a seemingly dark-brown bag face, about two feet square, that has a white star in its center surrounded by a pattern of large concentric diamonds edged with interlocking shapes that look like rows of fishhooks.

"Mushwami Baluch. Baluch rugs are cheap, even though they shouldn't be. That one's only three hundred, and the wool and the dyes in it are really good. Here, come on out in the sunlight, and you'll see it better."

He's right, the bag face comes alive in the sun. What seemed drab in the shed is in fact a textile with many colors. There's a forest green in it and two different blues, and there's a fiery red that glows. The wool is soft and thick, and the condition is very good. What's not to like? And so a little Baluch becomes the first rug I ever buy.

The Baluch are an ethnic group now living in Iran's arid Sistan region and in neighboring Pakistan, but the name is used also in the carpet world for the many small rugs and bag faces produced farther north, on either side of the Iran/Afghanistan border. It's a category that was for many years deprecated by most (though not all) sophisticated collectors, and while Baluch pieces have begun to be more appreciated recently, unexceptional examples still sell for a modest cost, and there is a thriving business in them at the low end of the market. An exquisite textile will be expensive regardless of its type, but a merely good Baluch is so cheap anybody can have one. That a weaving of this sort becomes my first purchase was almost predictable.

I pull out my wallet and use the hood of my car as the surface on which to write Jim a check.

"You wouldn't have cash, would you?"

I don't, and wind up paying an extra $36 to satisfy the state of Connecticut, but most of my future transactions involving rugs will be in greenbacks. Even established dealers will usually give you money off if your purchase is off the books, and the ambiguous characters at the fringes of the trade don't want anything else.

I toss my purchase into my car, and Jim and I shake hands.

"I'll get to your ancestor's rug pretty soon. A couple of weeks. I'll phone you when it's ready."

"OK. What's it called again?"

"A Ferahan-Sarouk."

"How can you tell?"

"By the weave."

"How can you tell from that?"

"I just can."

And that's all the answer I get. What Jim knows about rugs and others don't is what allows him to make a profit, and I will discover that he is never forthcoming on the subject. Even if he wanted to, though, he couldn't help me much. It's too complicated. An experienced dealer can usually identify a rug at a glance, and if not will need no more than a brief examination of its back in order to do so, but the subtleties of weave are difficult to describe and take a long time to learn. There's a saying in the business: "It's not hard to learn about carpets; you only have to touch a hundred thousand of them." An enormous amount of information must be absorbed before one is anything but a beginner, and the education process is so demanding that even experts make mistakes. Beginners make many mistakes.

Jim and I are leaning against my car and beginning to learn about one another. What do you do? (I say I used to work in advertising.) Where did you grow up? (Long Island.) When did you move to this area? (About fifteen years ago, when my daughter was born.) While we're talking, a woman comes out of the house carrying a small suitcase, and Jim introduces her to me as his wife Cathleen. His wife has pale skin, blue eyes, and the kind of curly black hair you might call an Irish Afro. She is polite but unsmiling, and her face looks drawn.

"How long do you think you'll be gone?" asks Jim.

"At least one night. Maybe two. It's whether he wants me to stay and how I feel about it."

"You need any money?"

"No, I'm all right. He'll ask the same thing."

"OK. Call me if you want."

"OK."

Cathleen drives off, and I wait to be told, hoping I haven't stepped into domestic difficulties. I have, but not the ones I imagined.

"It's her father, he's dying. She's been spending some nights at the hospital."

"I'm sorry," I offer, not knowing what else to say.

"Cathleen and he never got along, but she's pretty broken up now. Anyway, I'll call you when your rug's ready. A couple of weeks, more or less, depending when the funeral is."

Et in Arcadia ego. Like any other hobby, collecting carpets is in some sense a refuge, an absorbing distraction from life's adamantine realities. It's the kind of enthusiasm people often turn to in middle age, when they have some disposable income and have begun to feel the undercurrent of time passing by. But life goes on, as the cliché insists, and even as your eye is seduced by a beautiful object that some overworked woman created in some impoverished place, your dog might die or your father wind up in the hospital. Over the years I have come to own over a hundred old carpets (a number utterly unimpressive among rug collectors), and I always enjoy giving them my attention, but I know my diversion for what it is and that its escapism provides no real escape. In my own case, the realities calling for distraction are nothing extraordinary, really. The usual anxieties about aging and the abridgment of ambition. That my knees no longer permit me to fence, the sport I loved and practiced with intense enjoyment for thirty years. That my efforts to maintain fitness in other ways, by running and lifting weights, show a slow decline as well. That the ambition I conceived in adolescence of creating a body of poems to rival that of Shelley or Stevens has not been fulfilled to the degree I once confidently expected. That the writing of verse, which was for millennia understood to be a major intellectual undertaking, is no longer regarded as a serious pursuit, and that poetry is far less appreciated in America today than it was only a couple of generations ago, back when I started out.

Driving home from Jim Barnard's, however, I don't think about such things. With my Baluch bag face on the seat beside me and the prospect of a new fascination beckoning, I am almost giddy with delight. An unknown world—the carpet world—lies all before me, waiting to be explored, and my singles-bar tingle has become a flush of excitement. That life goes on is of no concern to me, not at the moment. At the moment, I'm too busy falling in love.

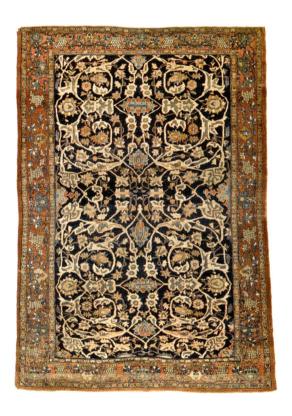

The Jerusalem Consul's Ferahan-Sarouk, 4 ft. 5 in. x 6 ft. 7 in.

TWO

The Deep End of the Pool

The Gold-Field Kurdish Carpet

Beginners make many mistakes, and I will be making them all. To start doing so, I'll need that dangerous thing, a little learning, and, being a writer, my first instinct is to acquire it by reading up on the subject. One of the first mistakes I make is not realizing how widely the literature regarding carpets varies in quality. Sitting after dinner a few days following my meeting with Jim Barnard, my Baluch bag face on the arm of my chair, I examine the dusty old tomes I have just purchased from a secondhand bookstore, volumes written by John Mumford, Walter Hawley, Arthur Dilley, Charles Jacobsen, and others: collectors and dealers from the first part of the twentieth century whose terminology has long gone out of fashion and whose level of scholarship now seems rudimentary. (Even among books published recently, accuracy of information is by no means guaranteed. The best scholars now take a much more disciplined approach to the field than was once the case, but the archival and anthropological evidence they have to work with is often quite thin, and the temptation to speculate enormous.) Turning the thick leaves of the rag paper that was common a century ago, I do my best to memorize the outmoded definitions and categories I don't yet know will be useless to me—Princess Bokhara, Kabistan, Mecca Shiraz—and I give my wife, Spencer, the news.

"I'm going to learn about this," I say innocently.

"What this is that?" she asks, looking up from her own book.

"I'm going to learn all about carpets."

Something no one has ever done.

"Really? Well, let me know when you have," she says, returning her hazel eyes and quiet concentration to the private world of her own explorations, a pursuit that takes place almost exclusively in the

realm of the printed page. She doesn't have the "collector's gene" that I do, and she rarely buys anything for herself, but having lived with me for several decades, she's grown used to my forays into new areas of connoisseurship and my periodic manias for fresh accumulation. She knows it comes with the territory. When I was a teenager, I owned hundreds of rock-and-roll records. When I worked as a sommelier, my cellar contained hundreds of different wines. These days, our little house is stacked to its low ceilings with uncounted thousands of books, a clutter that grows worse almost by the hour. Some people have the instinct to gather and some don't, and the self-denying asperity of the minimalist's lifestyle is not for me. If the impulse to collect has a tendency to run riot and one winds up living amid messy confusion, well, so be it. You can't take it with you, but in the meantime, give me more.

I look through the carpet books for a few days, and then I set forth to put my new expertise to use. I grab all the old rugs I can find. That is, I go around to the area's many small antiques shops and used furniture stores and pay the asking price or close to it for any carpet that resembles something mentioned by the authors I've been reading. There's a lot out there waiting for an indiscriminate buyer, at least at first. It's 2003, and the world economy is running hot. The stock market is soaring, interest rates are at an all-time low, and in response to the easy money in circulation, marginal businesses like junk shops have sprung up all over. Anytime I go looking—anytime I "list to hunt"—I come across another spot within driving distance in which to exercise my prowess.

In a dark corner at the back of a shop selling broken chairs and lamps that don't work, I find what survives of a Perpedil Kuba, a worn remnant punctured by several holes and missing large sections of its border. It lies under a scattering of broken glass, and the owner smells strongly of hashish. Forty dollars, cash.

In a store that sells used garden furniture and the sort of upscale knickknacks interior decorators use as "accent pieces," I find a moth-eaten Shirvan prayer rug that is patched and has a twelve-inch split down its middle. The woman sitting behind the desk doesn't know if her husband will give me 5 percent off because of the dam-

aged condition, but when she phones him with my offer I can hear his eager assent leap out of the receiver. Four hundred and fifty dollars, cash.

In an antiques mall where various dealers rent space I find a little rug that has almost entirely faded to gray. The tag says it's a Kabistan, and because Kabistan is one of the names I've read about, I'm so excited I don't even bother to ask if I can pay less. (A slight discount is standard in such malls, and contacting the dealer in question will often result in a further reduction, but I don't know that.) Five hundred dollars in a check plus the requisite sales tax.

All of these distressed carpets, and several others I snap up as well, come from the Caucasus. A mountainous isthmus squeezed between the Black Sea and the Caspian, the Caucasus is one of those crossroads where peoples collide and history happens. It's where Europe meets Asia, where Christianity meets Islam, and its constricted geography is home to hundreds of languages and, by present count, six different countries. The site of many battles and of much bloodshed to this day, the Caucasus has seen incessant conflict, but the meeting of cultures on its contested ground has been fertile soil for carpets. Enormous numbers of them have been woven there, including my Kubas and Shirvans. Kubas are densely woven and usually small rugs made in the villages north of Baku. Shirvans are less tightly woven rugs made west and south of Baku, and are now often referred to simply as southeast Caucasian. Kabistans are what Kubas and Shirvans used to be called collectively a long time ago.

South of the Caucasus Mountains, you're in Asia, and broadly speaking the weaving of piled carpets is an Asian or Asian-influenced art. There are flatweaves just about everywhere, but no piled carpets to speak of in Australia, the Americas, or sub-Saharan Africa. The world of piled carpets as scholars define them now may be divided by geography and style into seven major categories: Chinese (inclusive of the Tarim Basin and Tibet), Central Asian (all the "stans" of today), Indian (inclusive of Kashmir and Pakistan), Iranian (called Persian in many books), Anatolian (plus Istanbul, across the Bosporus), the Islamic Mediterranean (Syria, Egypt, and North Africa), and Caucasian. Piled carpets have been made in Europe, too, perhaps

as far back as classical times, but European production has been relatively small by comparison with that of Asia.

As with my first purchase of a Baluch, the fact that the carpet collection I initially assemble consists of Caucasian pieces was foreseeable. Like many kinds of aesthetic appreciation, an interest in oriental rugs tends to follow a predictable course, a winding path toward complex response. That's something I should have known already, because I'd been on such journeys before.

I was traveling by train in Italy once as a young man, hurrying around the country to see as much art as I could before my meager resources obliged me to return home, when I fell into conversation with the elegant and elderly passenger who shared my compartment. What was I doing traveling all by myself? Learning about Italian painting? Ah, that explained it. If a person is really taken with it, seeking out such art can consume all of one's attention, and one can be as devoted to the search as a monk is to his prayers. He remembered. So where was I going next?

"Assisi. The art I like . . ."

"You don't have to tell me," said the old man, smiling. "I know what you like. Trecento, Quattrocento. Am I right?"

He was indeed. The art that had spoken to me first, that had reached out of its pinnacled frames and leapt from its frescoed walls to fascinate me and that would eventually lead me to study it in graduate school, was the fourteenth- and fifteenth-century work of the early Italian masters. I was drawn by their directness and intensity, by the purity of their commitment to their craft, the sincerity of their belief in the subjects they depicted.

"You like Quattrocento," said the old man, "and I like Baroque. You can't even imagine how someone could like Baroque, can you?"

I couldn't, not then; yet, having progressed from my interest in early Italian art to that of the High Renaissance and thence to Mannerism and beyond, I begin to understand it now. One arrives in the course of one's life—as European culture did itself—at a taste for irony and self-aware performance, for display as its own end. I haven't quite made it all the way to Guido Reni (though give me time), but these days I can enjoy Salvator Rosa or Artemisia Gentileschi. Just as

one's appreciation of literature shifts and broadens and is possibly refined given a lifetime of reading, so with the appreciation of the visual arts. One sees with different eyes.

There is a road to be followed in connoisseurship, and for carpet lovers, too, what one is drawn to will depend on where one is on the route. Some collectors will develop a deep interest in the subtle variations of the rigidly symmetrical and superficially quite similar "gül" motifs of Central Asia's Turkmen carpets. Some will come to value the graceful formality and precise planning of the finely knotted floral carpets produced by Iran's urban workshops. But what new enthusiasts typically gravitate toward are Caucasians. Their big geometric medallions and profusion of filler motifs (stars, small blossoms, stylized birds and animals) make an immediate impression, and their high-impact designs are easy to identify. It's fair to say that Caucasian rugs are simple, or seem so. They are classified using the names of many small towns in what are now Armenia and Azerbaijan, but the names are applied largely on the basis of a rug's pattern rather than according to its structure. This categorization according to appearance makes it possible for a relative beginner who has memorized the names of the most common Caucasian designs to feel like an expert.

Another reason beginners favor Caucasian rugs is that they see them a lot. Starting in the late 1800s and lasting into the Soviet era, cottage industry in the Caucasus produced an enormous quantity of carpets for export, a boom stimulated by Russian government support, and the result is that Caucasian rugs appear regularly in auctions, and dealers usually have them in stock. The relative availability means relative affordability, and that, too, attracts beginners.

Beginners tend to start with Caucasians, but more seasoned collectors often get tired of them. Their abundance in itself disqualifies them in the hunt for the rare and unusual, and beyond that, they are too unsurprising. Perhaps because they were churned out in such numbers, one almost never comes across a Caucasian carpet of a type and design one has not encountered many times before. Almost. Almost. Unique examples do exist, though they are few and far between, and carpets made before the late nineteenth-century

outpouring do turn up. When that happens, the contempt bred by familiarity is replaced by excitement, and the rug in question brings a high price. So it is that Caucasian rugs appeal to the least sophisticated and most sophisticated sensibilities. Beginners love them, and some of the most serious scholars in the carpet world have specialized in them. Between those extremes, everyone else grows bored.

A beginner is what I am, however, and beginning collectors can't help being what they are any more than can kindergartners or first-time parents. I start off happy with the Caucasians I have gathered, and looking at them makes me smile. Laying them down on the living room floor and turning up the sound on the stereo, I dance around with a glass of wine in my hand and a song in my heart. I'm happy with the rugs I've collected, and yet when I show them to my neighbor Gary a few weeks later, he is unimpressed. Carrying my newly acquired trophies the short way downhill to his house (one learns early that anything involving carpets involves a lot of lifting), I look through his screen door to see him sitting with a basket in his lap, a bottle of fruit juice beside him, and a Q-tip in his hand.

"Can I come in?"

"Sure," he says, holding up the basket. "What do you think?"

"What is it?"

"A genuine antique Indian artifact. Probably Algonquin, but I'm no expert."

"It doesn't seem like your kind of thing."

"It's not, but it was like money lying on the ground. I got it post-auction for next to nothing. The color was faded because it's old, so it looked dull and nobody wanted it. It'll sell now, though."

"Ocean Spray Cran-Grape," I say, reading the label.

"The Indians used cranberry juice as a dye, but I'm getting better results with some grape juice mixed in. I'll paint it up till the colors are bright, and somebody will spring for it. Of course it will be more faded on the inside than on the outside, which doesn't make any sense. But most people won't think to check."

"How much do you think it will bring?"

"Who knows, amateurs at auction are hard to predict. I'd be happy

with a couple of hundred dollars. Cover the phone bill this month. What have you got there?"

I unroll my little rugs, fanning them out around his chair and reciting the names I have learned to call them . . . this one's a Kuba, that one's a Kabistan . . . but Gary doesn't have much of a reaction.

"Well," he says at last, "I guess they didn't cost much, did they?"

"No, I got them for good prices," I answer right away.

I don't know, in fact, whether I paid a lot or a little relative to their value, but I'm uneasy. Gary clearly doesn't like them, and now the rugs don't look quite so good to me as they did just a few minutes earlier.

"They're collector pieces," I add, feeling a bit defensive.

"Uh-huh. They could use some Ocean Spray, they're pretty faded. I should send you to see Robyn."

"Who?"

"Robyn Del Vecchio, she's another person around here who sells rugs. I used to play tennis with her husband until my knee went out. Roger, that's her second husband. Her first was Ron Somerset."

Which was one of the names Gary had given me initially. Rug dealing is a specialty business and a small world.

"You didn't tell me about her before."

"You didn't need every name. Anyway, I thought you wanted a repair, I didn't know you wanted to buy."

"There's a difference?"

"You bet. Dealers, appraisers, auctioneers, with some there's never any problem, others you learn to be careful. Ron knows his stuff, but if I was buying, I'd go to Robyn."

Which is what I do.

I go to see her in part because Gary has left me dissatisfied with what I own already and in part because I am driven by my initiate's fever. Thoroughly bitten by the carpet bug, these days I think about carpets, I read about carpets, I talk about them and probably dream about them, too. I feel an almost physical urge to see and touch more of them every day, and my opportunities for doing so have dried up. Making my rounds of secondhand shops and antiques malls the first

time through, I found many old rugs for sale, but when I go back to the same emporiums a month or two later, I think they've done a very poor job replacing their stock. There are no new arrivals for me to waste my money on. What has happened, as I eventually realize, is that the ones I purchased had been a long while accumulating, and now that they have made their way to me, it will be a long while again before that many others come out of the area's attics. The stores I have been in so far acquire their rugs by accident, when Granddaddy dies or Grandma moves to Florida, and what I want now is a store that has assembled its stock by design and maintains a sizable inventory. I want to see more rugs, I want to see better rugs, and so I go to see Robyn.

As it happens, Robyn's shop is not far from my home, and to this day I'm not sure why Gary initially sent me elsewhere when he could have just sent me to her. Maybe he sided with her first husband Ron after the divorce. Maybe he was repaying Jim Barnard for a referral. Whatever the reason, a mere ten-minute drive brings me to a small barn in an upscale neighborhood of an upscale town, where the sign on the door reads ANTIQUE CARPETS, LLC. Not MAGICAL CARPETS or ALADDIN'S LAIR or THREADS OF THE ORIENT or any of the other silly names that rug dealers so often choose in an effort to create an atmosphere of allure. Just as wine merchants are given to selling their wares by means of a deliberately intimidating mystique, many people in the carpet trade try to attract customers using an artificial exoticism. Robyn's sign is a statement. No horsefeathers here.

She's sitting at her desk when I knock on the door, squinting at a computer screen and holding a phone to her ear. When she sees me, she waves me in with her free hand, but it's a few minutes before she hangs up. I use the time taking a look around. There are several stacks of rugs several feet high, sorted according to size, and there are twenty or thirty full-size carpets, rolled and bound and standing on end along one side of the room. There is a heap of bag faces in one corner, a few folded carpets piled in another, and several pictorial rugs tacked to the wall. And there's that scent, the delicious aroma of high-lanolin wool I smelled in Jim Barnard's home.

I sit down on the bench next to Robyn's desk and wait for her to finish her conversation—something about a motorized wheelchair

for a child—and when she's done, I start right in. After all, I know rugs and know what I'm looking for.

"You have any blue-field Caucasians with interlocked diamond medallions?"

This is a bit like asking in a hardware store if there are any nails for sale, but Robyn treats me gently. She pauses a moment to rearrange her bobbed gray hair, brushing it back off her forehead, and rubs her ice-blue eyes with both hands.

"We have lots of carpets here. Do you need a particular size?"

"I need the right rug. I'll know it when I see it. I'm a collector."

If she's tempted to laugh, she disguises it.

"Well, I close at four, but there's still a little time. Let's go through the piles, and maybe you'll find something you like."

She stands up, and I see that she is a woman of medium height who is dressed in a cardigan sweater and slacks. She reminds me of women I used to see at the salle when I was a member of the New York Fencers Club: being thick through the thighs and backside helps with the squatting and lunging that fencing demands, and no doubt it helps with wrangling a roomful of carpets. Anytime Robyn and her husband take a selection of rugs to an antiques show—and participating in such shows is essential for dealers located outside of major population centers—thousands of pounds of deadweight need to be packed and loaded and dragged and stacked. Merchants in Istanbul or Beirut can afford to employ muscular young men to do the grunt work, and one hears from immigrant store owners that "rug-shop assistant" is a respectable career in the Middle East, but such help costs a lot in this country, and small-time dealers in Connecticut have to lift and tote for themselves.

Just going through the piles takes work. I help Robyn as she peels back one rug after another. Each one has a tag wired to its corner with its name and size and cost. The prices are in the thousands of dollars, and the names (Malayer, Talish, Demerçi, Ersari, Ningxia, and many others) are not the ones I have been reading about. I've no idea what I want, no idea what my "area of special interest" might be, no real idea even what I wish to spend. All I know is that these rugs are far better than the ones I have acquired so far, and that I'm

ready to move up a level in my collecting. It's time to dive into the deep end of the pool.

As the rugs flash by one after another, Robyn can sense which of them appeal. There is a basic distinction in carpet production between "city" rugs and "tribal" rugs, those made in workshops or permanent homes and those made by nomadic or formerly nomadic ethnic groups. City rugs are often floral in design and curvilinear in their drawing, whereas tribal rugs are usually geometric in design and angular in their drawing. Some collectors like to believe that tribal rugs are more genuine and less commercial than those woven in a city, though this is a dubious claim. Nomadic people did of course make items for their own use—animal trappings and transport bags, tent decorations and clothing—but they also wove items for trade, which is to say for export. Transhumance—the seasonal shifting of flocks from place to place in order to find fresh pasturage—is a truly ancient way of life. Sheep and goats were first domesticated some ten thousand years ago, and nomads have been migrating with them ever since. (There are a great many varieties of sheep and goat—merino sheep, fat-tailed sheep, Angora goats, and cashmere goats are among the best known, but there are lots more—and textiles differ in texture and appearance according to the type of wool or hair used to make them.) The yield of the semiannual shearing of their flocks is most of what nomadic tribesmen have to barter with, and what they bring to the bazaar will be the wool itself or objects woven from that wool. Since tribal textiles might be intended to be sold, just like the ones made in urban settings, tribal weavers were not immune to market pressures. They were surely tempted to make more of whatever sold best, and attributing a noncommercial purity of design to their weavings is fanciful. Whatever their degree of innate legitimacy, though, carpets with tribal motifs are attractive to many customers, and as with Caucasian rugs, they tend to make an immediate impression.

Robyn probably knows already that a "tribal" rug of some sort is where my novice instincts will guide me, but she can see I'm not yet willing to pay for the Kazaks and Qashga'is she has available, carpets that are among the most expensive of this type. I linger over many

I'd like to own—there's one I love that has pink medallions on a gold ground—and yet I remain hesitant.

"I've got it," she says at last. "What you should buy is an Afshar. Come look over here."

The rug she takes me to is squarish, about five feet by six, and has a soft white field with large rose blossoms arranged like the five-spots seen on dice. Strangely, the roses are colored green and brown, but they are otherwise realistically drawn, and Robyn tells me they are *gul farang*. That's a Persian term (derived from the Farsi word for "foreigner" and in turn possibly from "Frankish") meaning "European flower," and it is the name used throughout the Middle East for blossoms drawn in the Western manner. The borders of the rug have lots of copper red and denim blue in them, and in between the large roses, the field is filled with dozens of little triangles that appear to have clawed feet. Stylized birds, says Robyn. She says that's the tribal element and is what makes the rug so interesting.

The price tag reads $1,800, but Robyn is quick to tell me I don't need to pay that much.

"We're running a discount right now where everything is ten percent off, and we've had this rug for a while. We could give it to you for even less, just fifteen hundred. Buy it and take it home and live with it for a while. If you decide you don't like it, you can always bring it back and exchange it. You can trade it in anytime for just what you paid. You can't lose."

I dive in.

After we shake hands on the deal, I sit down by her desk to write the check ("You wouldn't happen to have cash?"), and as I do, we talk. Robyn is a good conversationalist when she wants to be, and just now she is making herself agreeable. A successful dealer works at establishing friendships, real or pretended, with as many customers as possible.

"Gary Clifton sent me to you," I tell her when she asks. "He's my next-door neighbor."

"That must be interesting. Gary's a character."

"I'd say he's a bit of a curmudgeon. I don't know if that's fair."

She laughs.

"That's absolutely fair. He and Roger used to play tennis together, and we saw a lot of him. Tell him I said hello. Tell him I said thanks."

"Will do."

"You know, you should buy a pad to lay under your rug, especially if you're going to put it in a high-traffic area. Afshars are made with soft wool, and yours is too nice not to take care of."

"How much would a pad be?"

"Let's see, five by six . . . call it fifty dollars."

I get the pad as well.

"It's the right thing to do," says Robyn. "You'll want to protect your investment."

Laying a pad under an antique oriental rug is definitely the right thing to do: carpets are perishable items, and they're easy to ruin. But thinking of them in terms of investment is foolish. Carpets don't earn interest or pay dividends, and they are luxuries, not necessities. Even by the standards of discretionary purchase, their market is volatile and highly unpredictable, because tastes change. It's possible for the fashions of an entire generation to turn against them, and in fact there are many types of oriental carpet that are worth considerably less today than they were a decade or two ago. Furthermore, while rugs don't pay interest, they do incur costs, needing to be stored and insured and conserved. Referring to their carpets as investments is something many dealers do, since part of salesmanship is to create an aura of value, but experienced collectors know it's a specious idea, and before long Robyn will stop talking in those terms to me. Oriental rugs don't often make good hedge funds. What they can be are wonderful objects of art.

When I get back home with my purchase, I spread it out by the dining room table. When Spencer and I sit down to dinner (breakfast and lunch we eat on our own, but we make a point of sharing the evening meal), I tell her I've taken the plunge.

"How much did it cost?" she asks, looking it over by candlelight as she cuts her food into small bites. As with our different approach to acquiring things, so with the way we eat. She nibbles. I wolf.

"It wasn't really expensive, considering what it is. It took somebody months to make it, and it's a hundred years old."

True enough, but expensive is an elastic concept and a matter of opinion.

"You know I've got Scottish blood, George. How much was it?"

"Hon, I just turned fifty, and I haven't bought a red sports car or an old wooden boat."

"Yes, but how much?"

"Fifteen hundred."

"Oh dear," is all she says.

What I feel as elation, she perhaps feels as vertigo. Another abyss of compulsive gathering yawns.

The next day I walk down to knock on Gary's door again and show him what I have done. The proud moment doesn't last long.

"I don't like it."

"What do you mean, you don't like it?"

"It's a dog, I don't like it."

"What's wrong with it?"

"The drawing's a mess. It's a hodgepodge."

"It's a collector's piece."

I've said that to him before, but this time he doesn't even pretend to be polite.

"It's a dog."

And now I don't know what to do. Gary doesn't specialize in carpets, but he's been attending auctions for thirty years, and he's seen a lot of them sold. As a dealer in antique furniture, he's survived in a difficult business because his aesthetic instincts were good to begin with and because his eye for quality has become highly trained. If he doesn't like my rug, I suspect that by and by I won't like it, either.

A carpet is like a painting in that if you give it continued attention, it will get better or worse over time. Keep looking at a good one, and you will see things you didn't see at first. A fine carpet reveals its secrets slowly. One that is not so good will tell you soon enough that it has nothing left to say. The more time I spend with the Afshar I've bought, the more I think Gary is right. The weaver wasn't knowledgeable enough to render the *gul farang* convincingly—the green and brown roses have come to strike me as grotesque—and the triangular tribal motifs seem perfunctory and overly uniform.

The result is not so much interesting as it is simply an oddity. What I had taken for a creative tension between elegance and rusticity now just seems confusion. The rug's a hodgepodge. It's a dog.

Fortunately, I can trade it in.

Or at least that's what I've been told.

I roll up the Afshar and put it in the back seat of my station wagon and drive the short distance to Antique Carpets, LLC. I haven't called ahead to make an appointment, not wanting to reveal my intentions, but fortunately I find Robyn's door open and no other customers in the shop. Leaving the rug I've brought with me in the car, I say a cheery hello and tell her I'm interested in buying another.

She beams. Little more than a month has passed since my first plunge into the pool, and here I am already back for more. Do I have a particular rug in mind? I do. The gold-field carpet with the pink medallions that I saw as we went through her stock earlier appealed to me, and I'd like to have another look at it. Saying this is very poor negotiating on my part—a good bargainer never admits ahead of time that he is already disposed in favor of an item—but when we pull the rug out of its pile and place it where the sunlight pours through the shop window, the wool sparkles and the colors gleam and I can't help showing my admiration. I clearly love the rug, and yet Robyn is quite agreeable as we settle on a price. Looking back, I think she must have needed money badly that day. As I will eventually discover, she has a child with a serious disability and has heavy expenses in consequence, and here I am with dollars in hand. Her smile is radiant, and her cheeks have the warm glow of a skin-care model.

As we negotiate, we talk about the carpet's features. The wool is heavy and luxurious, and the condition is everywhere excellent. The colors are many and so saturated, they are what auction catalogs call "jewel-like." There is a tribal element to the rug, but it's subtle, two little red birds all but hidden among the rug's polychrome flowers. Robyn enthuses about the central medallions, which are not quite the same tone of pink and yet somehow don't clash. She suggests they are likely the result of two wool lots dipped successively in the same dye bath. Because of the gold ground, she believes the rug is a

Bakhtiari, even though it is not constructed as are most carpets that go by that name, and she thinks that rather than coming from a town or workshop, it was made in an encampment high in Iran's Zagros Mountains.

I'm not so entirely green as I was, and I do better in bargaining than the 15 percent off I got the last time around. We settle on two-thirds of the asking price, which is still more than twice what the Afshar had cost.

"And just like before," I ask, "I can bring this back to trade in anytime I want?"

"Absolutely. Anytime at all."

"Good. I've got the other one out in the car. I'll go get it."

It's as if I slapped her across the face. The warm glow in her eyes is replaced by bitter disappointment, and she turns away sharply.

"Well, market conditions can change . . ."

But she gives up. It's only been a few weeks since our first transaction, so "market conditions" can't have changed much, and she has just confirmed that I can exchange whatever I buy whenever I will. She's cornered, like a new car salesman who didn't ask about a trade-in beforehand. She sits down slumped at her desk and stares off into space, and I go retrieve the Afshar.

I put my trade-in back where it came from and roll up my new purchase to take with me while Robyn fills out the paperwork on the returned rug in silence. When she's finished, she sits up straight and takes a deep breath.

"Well," she says, still without looking at me, "that's over with. That's done."

At the time, I assume she means that an unpleasant episode has been completed, that a painful part of her day is now past, but as the years go by and we keep doing business together, I will come to realize she means more. What she is saying is that, since I seem truly fascinated by carpets, this day was sure to happen. Sooner or later I was bound to become a more canny collector, and hence our dealings were inevitably going to arrive at a point where I could no longer be sold to as to an average homeowner. I won't remain an innocent customer, but that doesn't mean I can't be a good one. And she's right.

In the course of two decades, I will go on to buy over twenty pieces from Robyn, and I will pay her on many occasions for washing and appraisals and repairs. If the individual sales won't enjoy the same profit margin they might with someone else, still there will be lots of them, and they'll add up. In time, she and I will become genuine friends and will help one another when we can. I'll learn a lot about rugs from Robyn, and eventually I'll know enough to be able now and then to add to her fund of knowledge, too. The relationship we build will be mutually rewarding. The trade-in of a mediocre carpet for a good one was a growing pain, a necessary step in that process.

The gold-field carpet Robyn tagged as a mountain Bakhtiari I have since come to believe was made by a Kurd in some village northwest of Iran's Hamadan plain. (The Kurds and Bakhtiari are two of the major ethnic groups found in Iran, though Kurds are also found in Syria, Turkey, and the Caucasus. The two groups, along with the Luri, have been in close proximity for hundreds if not thousands of years, and their rugs and bags are not always easy to distinguish.) The sheer weight of the wool in this rug says Kurd, as do the crablike harshang motifs that are a prominent feature of its design. And while members of the Bakhtiari tribe are fond of the color yellow, all of the rugs I have seen that are undoubtedly theirs (most "Bakhtiaris" are that in name only, being actually woven by other ethnicities in towns once under Bakhtiari control) have a different palette overall. These dyes look like those found in Bijar, a city also in northwest Iran, and while this rug is loosely woven, whereas Bijars have a heavy handle and are among the most densely packed rugs in existence, still Bijars are made by Kurds. Furthermore, the reciprocal medachyl pattern that forms this carpet's minor borders is often seen in Kurdish weaving, and the fact that the outer of these employs a purplish brown is almost dispositive. (If you hear someone mention "a lovely shade of brown," you can be pretty sure a Kurdish piece is being discussed.) So in my book the rug isn't Bakhtiari at all, but whatever it is, it's a gem.

The oldest piled rug in existence is often said to be the Pazyryk carpet, carbon dated to about the fifth century BC and now housed in the Hermitage Museum. (In fact, there are knotted pile carpets found in Central Asia and western China that appear to be even older, but

the popular imagination only has room for one.) The Pazyryk was dug out of a burial mound in Siberia, where it had been frozen in ice for millennia and was thus impervious to insects and rodents. It is about six feet square with a central field resembling a tiled courtyard and borders that show files of men on horseback along with impressively antlered elk. Its rich dyes were hidden from the sun and are still vibrant today, and the overall effect is so sumptuous, it puts the modern rugs that imitate it to shame. The Pazyryk is a miracle of rare device, which is why some distant ancestor of Kubla Khan—one of those steppe-nomad warlords who invaded the Western world on so many occasions—wanted to have its company in the afterlife. Where it was made is not known, though there are many theories, just as there are many theories about the origin of piled carpets in general. Where were they first woven? Some say in China, where so much of what we know as civilization seems to have gotten its start. Others maintain that the craft was first practiced by the nomads of the Asian steppe, who brought it with them when they moved west and so introduced it to Iran and Anatolia. The issue of where things began and who influenced whom is vexed, not only by the fact that scholars are given to disagreement but also by ethnic chauvinism. Thus carpet specialists of Turkic ethnicity may insist that Armenians never wove rugs, whereas Armenians are in turn likely to dispute Turkish theories of origin; Iranians may believe in their bones that carpet weaving is a high art that is fundamentally Persian, and that nomadic contributions to it were rustic and unimportant; and Chinese historians may take it as a given that all textile technique came out of the Far East and was imitated by the less advanced cultures in the rest of the world only in later centuries. It's like the physics of outer space: what is seen depends on the point of observation. Although the most ancient piled wool carpets that have survived to our day do in fact come from East Asia, my own view—and I make no claims to scholarship—is that weaving of this sort likely started in many locations: anywhere people had sheep and the nights got cold.

 I have yet to invade anyplace, and no one is building a burial mound for me, but if I were to be entombed with a carpet, the goldfield rug I bought from Robyn on a trade-in back in 2003 is still the

one I would choose. I don't know if it's my "best" rug . . . that judgment will vary depending on the criteria used. (Oldest? Most prestigious? Most unusual?) And I can't really call it my favorite, because as with the poems I compose, the most recent one to come my way is often my favorite of the moment. (The tendency to fall in love with whatever I've just written is so strong that it takes an almost superhuman effort to put a poem away and look at it again in six months for what is likely to be necessary revision.) Regardless, the gold-field carpet with the pink medallions never fails to bring joy. If it qualifies as folk art rather than the high art of the classic carpets made for the Safavid court or the formal carpets made since in Kirman and Kashan, still it is folk art of a very high order. It shimmers when it catches the light. Its many gradations of color are somehow both subtle and spectacular. It's the most beautiful thing I own.

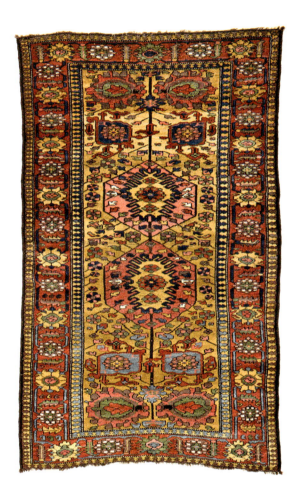

The Gold-Field Kurdish Carpet, 4 ft. 2 in. x 7 ft. 2 in.

THREE

Because You'll Never See Another

The One-Off Northwest Persian

"That was your own bid, sir. You're bidding against yourself."

I put the paddle I just raised back in my lap.

"Eleven hundred looking for twelve; eleven now, do I hear twelve; I've got eleven, I've got eleven, I've got eleven hundred and I need twelve. Where's twelve? Who will give me twelve? Eleven once, eleven twice . . . sold for eleven hundred, number 226."

I've just bought a rug. It's my first auction, a midsize sale run by a house in Stamford that draws from estates in the wealthy towns of the Connecticut panhandle and nearby Westchester County. The first time you do anything in life, you're likely to do it badly, but leaving aside my lack of experience, it's still no surprise that I have misunderstood the auctioneer's patter and tried to outspend myself. A good auctioneer uses cadence and pace to create a sense of urgency, and I have responded accordingly. I'm a little flustered, and I can feel a flush rising in my cheeks. In time, attending auctions will become routine, and their features will cease to be mysterious, but I'll never entirely get over the quiver of anticipated competition. If an auctioneer knows his or her business, an undercurrent of tension designed to stimulate bidding will always be in the room.

I'm at the auction at Gary Clifton's suggestion, at least in part. When I showed him the gold-field carpet I obtained for trade-in and cash from Robyn, I confessed I had no idea whether my final cost amounted to a reasonable price.

"I think I'm starting to recognize a good rug when I see it," I told him, "but I don't know the market, and I don't know how to learn it."

"The market is whatever somebody will pay," was his flat response, "and it's going to cost you money to find that out. Knowledge is expensive. Start by going to auctions and watching what things sell for."

"Which auctions?"

"Any one you want. Go to the preview so you can handle the merchandise and then go again to the auction itself. I don't do that, but you should."

"You don't go to auctions? I thought that was your business."

"It is, but I don't bid live. For me, sitting in auctions is a waste of time. You can wait for hours for your lot to come up, and meanwhile the food they serve is awful, the coffee's burnt, the chairs are uncomfortable, and it's hard to hold a conversation, because the auctioneer's always talking up the next lot. Forget that. I leave preauction bids and find out what happened later."

"Then why should I sit there?"

"Well, for one thing, you wouldn't know what bid to leave, would you? And you don't know the auctioneers yet, either. You'll need to learn them, too."

"Learn them how?"

"Some will treat you better than others. For example, say you leave a bid, the auctioneer is supposed to execute it like you were on the floor. He's supposed to keep raising the price in increments so long as there is live bidding and then give you the lot one step above where the bidding stops if your bid was higher. But a lot of them don't do that, they just take the full amount you put in for."

"Is that right?"

"Yes. And another thing, auctioneers are supposed to honor left bids in the order they come in. That means if two left bids are the same, they're meant to sell the lot to the person who left his bid first. But the dealers are their repeat customers, and nobody's going to check the date and time on the bid sheets. If two bids are equal, many of them will sell to the dealer, not to someone they don't know. As in you. Go see it live, and you'll see what I mean."

It seemed like a good idea, and trying to learn the market is one reason I'm here in Stamford, bidding against myself. Another is that my experience in Robyn's shop has made it clear that, in addition to price, there remains an enormous amount about carpets I simply don't know. How many types of antique oriental rug exist in the carpet cosmos? Which are common, which are rare? What counts as old?

By what features may the myriad types of carpet be identified? How on earth will I ever gain even a modicum of expertise? If I only need to touch a hundred thousand rugs to become an expert, I calculate I have just over ninety-nine thousand, nine hundred yet to go. Auction previews are a good place to start. I haven't given up on books, however, and in contrast to Jim Barnard's reluctance to help, Robyn has been ready with suggestions. No book published in the carpet literature can claim absolute accuracy—the field's too complex, and there are too many unknowns—but unlike the dusty tomes I turned to first, the books Robyn recommends are up-to-date and reasonably reliable. I study *Oriental Carpets: A Complete Guide* by Murray Eiland Jr. and his son Murray Eiland III for hours at a time, and what I discover there will be useful to me ever after. Other authors Robyn sends me to (Jon Thompson, Walter Denny, P. R. J. Ford) are informative also, but trying to learn about carpets from books alone is like trying to learn how to speak a foreign language by memorizing a grammar. If you want to know a language, you have to go where it is spoken, and if you want to know carpets, you have to see them on the hoof. Unlike in a museum, you can handle the lots in an auction preview all you want, and unlike in a dealer's shop, you aren't wasting anyone's time but your own if you ultimately decide not to buy.

So here I am in Stamford, raising my paddle at $1,100 for a rug about which I have no clue. Where it's from, how old it is, what it's called . . . I've no idea. What I do know is that it's got good color, that its wool is attractive to the touch, and that its design is not like anything I've seen in the books and auction catalogs I've been studying. I had intended merely to watch the proceedings, but the rug caught my eye, and when the lot came up, it didn't occasion much competition. The carpet professionals—a group of men who appear to be of Middle Eastern extraction standing in the back of the room and talking among themselves while raising their paddles to bid now and then without even turning to look at the auctioneer—aren't interested in it, and later Robyn will tell me why. What the professionals want are carpets they can sell without trouble, preferably the same day. They want the sort of room-size carpets decorators will always pay for, as well as whatever tribal rugs are most in vogue. An oddity

no one will recognize or anything that needs explaining is of no use to them, so when the other amateurs drop out of the bidding, the lot is mine.

After my winning bid, I walk to the office at the back of the hall to pay for my impulse purchase. Behind me, the auctioneer moves on to the next item in the catalog, and I hear the staccato rhythm of his insistent voice as he fields new bids and searches for others to raise them. The office is a small room occupied by a large desk and a large woman wearing salon-styled hair, big jewelry, and the sort of cat's-eye glasses that were last in style in the 1960s. There are several customers ahead of me lined up to pay, and as I wait my turn she greets some of them by name.

"Billy, how are you?"

"Hello, Missy. Tom still have you chained here to the dungeon walls?"

Auction houses are often family businesses, and it turns out Missy is the auctioneer's sister.

"That's right, I'm on bread and water. Let's see, what did Billy want today? I bet it was that Stickley chair, wasn't it? Yep, here it is. Fifteen hundred, that was a good buy. Cash or check?"

Missy is pulled together and carefully made up, but most of the customers she chats with are very casually dressed. They wear torn jeans and faded T-shirts, worn-out sneakers, and sweat-stained baseball caps. In the antiques business, you work for yourself, and nobody can force you to spend money on your appearance if you're not in the mood. Besides, good clothes would just get in the way. Unless you deal exclusively in "smalls" (inexpensive vintage items you can hold in your hand) or ephemera, the job is part moving man, and dealers dress accordingly. You never know when you'll find yourself carrying dusty furniture out of an attic or basement. Beyond that, you wouldn't want to give whoever you're buying from the idea that you will turn a profit on Grandma's bedside table. Heaven forbid you look like you might be making money.

The people standing in line with me are a ragged bunch, and none of them is in the prime of life. Antique dealing is not a young person's profession, as a store owner in Stonington, Connecticut, once

explained to me. I was buying a south Persian rug I had found in the back room of his shop when he mentioned in passing how disappointed his parents had been to learn he was going into the antiques business at age thirty. "That's something you do when you retire," they told him in dismay. But retired or not, it's rare to find a dealer who is not well into middle age. To appreciate old, it helps to be old. Having reached fifty, I'm aware I'm no longer young, but I'm a babe in arms compared to many of those around me.

When I get to the front of the line, I ask if I can use a credit card. I hadn't anticipated making a purchase today, and I don't happen to have all those hundreds I've just spent sitting idle in my pocket.

"You could," says Missy, "but I'd have to charge you another five percent. The card companies take their cut. Do you live in Connecticut? If you do, why don't you pay with a check?"

This is unexpected. Missy knows what lot I'm paying for, and a sign on the wall directly in back of her says: ALL CARPETS TO BE PAID FOR IN CASH. I point to the words and raise my eyebrows in mute surprise.

"Don't worry about that. You live in state, I'll take your check. Just write your phone number on it and show me your driver's license."

It turns out how you pay depends on who you are. If you're an Anglo and your ID says you live in the area, an auction house will often take a chance on you, even if you're unknown. If you're a non-Anglo immigrant, though, and particularly if you come from out of state, you'll have to pay cash on the barrelhead for the carpets you buy, whether anyone knows you or not. This is obviously unfair and no doubt illegal, but the different treatment is the result of bitter experience. Too many checks have bounced. It's not just that the people in the carpet business who have arrived from other countries may have their own standards of behavior in commercial matters (they sometimes do); it's that many of them live hand to mouth and will do whatever they must to get by. Even if they intend to pay, they may well be kiting a check. If they can turn their purchase around quickly and put the proceeds in the bank, the check might go through; if not, the auction house will never see the money. And so there's the sign on the wall.

My rug costs me not only the hammer price but also the buyer's premium, which in those years was typically 15 percent at a small auction and perhaps 18 at a major house. The premiums have risen since then, and most auctions now charge the buyer at least 20 percent and often 25 or even more. (They charge the seller a premium, too, which varies depending on the desirability of the item consigned and the ability of the consigner to negotiate. Fifteen percent would be typical.) In Connecticut, there's also a state sales tax, which has gone up and down over the years but was then 6 percent. Most dealers and many collectors have an ID number that exempts them from owing sales tax on their purchases, the theory being that they are buying an item in order to resell it, and tax is to be collected only on the ultimate transaction to a retail customer. I have never obtained one of these exemption numbers, though. I've sold many rugs in the course of twenty years, but rarely for anything but cash, and I've never sold so many that it was worth my while to establish a business on paper. People with sales tax exemption numbers are required to keep financial records and file statements regularly, and even if it costs me money at auctions, I can't be bothered with that.

My $1,100 hammer price plus premium plus tax comes to $1,354.90. I pay Missy with a check and show my receipt to the staff on the loading dock. Having collected my new acquisition, I'm walking toward my car when I see the group of professionals I had noticed earlier gathered in the parking lot next to a van. The carpets they have bought with cash are lying on the pavement next to them, and they are in animated discussion. I pause to look at which lots they wanted, and while I watch, I see money changing hands. One or two of them notice me noticing them, but they show no reaction at all. They might have been glancing at a tree, and I think how based on experience, ethnicity, and language, theirs is a club someone like me will never belong to. I'm curious, of course, and would like to know what they're up to, but it's not until I get back to Chester and next talk to Gary that I find out.

"Oh, that was the knockout round," he tells me.

"What's that? Sounds like a sports event."

"That was the auction ring. They bought the rugs cheap and then

held another auction among themselves. It's illegal, but it's impossible to police. I've done it plenty of times."

"How does it work?"

"The idea is, they don't want to bid against each other, they're going to keep the money to themselves. One of them bids enough to buy a carpet they all want, and then they decide later which of them wants it the most."

"How?"

"They write down in secret what they're willing to pay and put the scraps of paper in a hat. Then the one who wrote down the highest price pays off the original bidder and pays out the difference to the other people who had paper in the hat, and the carpet is his. If there's a tie, the losers are paid their share, and the winners bid again. It all happens in a few minutes, it all happens in cash, and no one can ever prove anything. Auctioneers hate it, but there's nothing they can do. It's part of the business."

Auction rings are indeed part of the business, and in later years, when I become a familiar face in my corner of the rug world and the dealers and pickers come to realize that I might bid against them for carpets they want, I'll be invited from time to time to join in a group purchase and the subsequent knockout round. But the wariness stemming from a sense of being an outsider goes both ways. I prefer to hunt by myself.

After my first experience in Stamford, I follow up by attending auctions all over Connecticut and its contiguous states. New England is sometimes called "the nation's attic," because it's the part of the country that was rich enough in centuries past to acquire fine furniture and the objects of expensive decor, and those objects still come up for sale. Gary is originally from Ohio, and he moved to New England precisely because of his interest in antiques. "That's where the old stuff is," he told me. "You won't find a fraction of it anywhere else." The hunting ground is not so fertile as it once was—dealers often lament the passing of the good old days when antique carpets turned up everywhere and were so common and underappreciated that they could be purchased for a song—because an enormous amount of material has been snapped up by buyers from around

the world. In the early years of the twentieth century, America imported oriental rugs in great numbers, but a century later the tide has shifted. Europeans now decorate with antique carpets more than Americans do, and the rugs that were once likely to be auctioned in this country now cross the block in Germany or Austria. The old stuff goes where the interest is, and I know dealers in New York City who send stacks of carpets overseas almost every day. Even so, though much has been lost, much remains. I wasn't around for the good old days, and I'm not prepared to shop internationally, but I still find carpets close to home that I'm willing to bid on. The nation's attic isn't exhausted yet.

In the course of several months, I accumulate enough rugs that I have to figure out what to do with them. My urge to acquire is unabated, and I want to keep attending auctions so as to learn as much as I can, but it soon becomes clear I won't be able to keep all I buy. For one thing, I don't have that much money. If I wish to continue spending on carpets, I'll have to earn a little, too. For another, not every old rug is so interesting that it's worth its keep. As mentioned, carpets need to be conserved and insured, and they take up space as well. Our little house is already full to bursting with books and paintings and photos and knickknacks, and the carpets I now have rolled up under beds and stashed behind couches threaten to transform a cozy clutter into an unlivable chaos. I decide to see if I can deaccession a few.

I pack up some rugs I'd like to sell and throw in a few I want to have washed or repaired, and I take them all down to Robyn's shop. I find her with customers, two middle-aged women who are thinking of buying a large carpet for their dining room, and while she deals with them I sit on a stack of rugs to watch the proceedings. The women are considering a Kirman that dates to the turn of the twentieth century. Kirman (or Kerman, in modern usage) is a city in south Iran, and the carpets produced there are about as formal as formal carpets get. Their floral designs are elaborately planned, they are woven with great precision, and the exceptionally white wool of the local sheep makes an ideal medium for dyeing. A good Kirman doesn't come cheap, however—this one is tagged at $15,000—and the homeowners are hesitant.

"It's absolutely gorgeous," I put in, speaking up from the corner where I'm perched. "It's got fantastic dyes."

Whether I'm assisting the sale I don't know, but I figure it can't hurt my relationship with Robyn to help her if I can. In any case, what I'm saying is true. Kirman is famous for its vividly saturated dyes, and carpets from the area are known for their many shades. Even my casual eye can count twelve different colors in the first-class specimen the homeowners are looking over, and a close examination would no doubt show more.

"I'd buy it myself," I add, "but I'd have to buy a dining room to put it in first."

The women ignore me, and they remain hesitant. It's Robyn they want to hear from, and she knows what to say, telling them the same thing she tells so many customers.

"Take it home and live with it for a while. If you don't like it, you can always bring it back."

There's some more discussion about price and potential discounts—Robyn's shop always seems to be running a special 10 percent off sale—but taking the carpet home on trial is what happens, and in my volunteer capacity as a rug-shop boy, I help to fold the big carpet in thirds and roll it up for transport. Robyn maneuvers it onto a handcart (again, anything involving carpets involves a lot of lifting) and wheels it out to the homeowners' SUV, and when she comes back she's in a good mood. The Kirman truly is beautiful, and there's an excellent chance that once the women have it in their dining room for a while they will grow attached to it and buy. Even if they don't, the carpet they are considering is expensive enough that if they ultimately opt for something a bit cheaper, the result will still be a profitable sale. Robyn is beaming as she steps back in the door and turns her attention to me.

"You brought rugs! What have you got?"

Before I try to sell her anything, I show her the ones I want washed or worked on, with the idea that giving her my business might make her more likely to give me hers. When I unroll the unusual rug I bought in Stamford, Robyn stands up and stands still. I start to tell her about it.

"I think it might come from a village north of the Hamadan plain, I saw a photo in a book and it has the same border—"

"Wait a moment," she says, raising a hand. "I'm still absorbing."

We stand side by side in silence and gaze.

The cottage-craft rug measures about four feet by seven and presents a radical contrast in its drawing. The wide border, pink and light blue on an ivory ground, is curvilinear and carefully worked out, so much so that it was almost certainly copied from a pattern purchased in a town bazaar. The pattern consists of Shah Abbas palmettes and a flowering vine, a combination found often in Persian carpets ever since the Safavid court productions of the sixteenth and seventeenth centuries. The main field of the rug, though, is anything but curvilinear. Instead it is aggressively geometric and has nothing to do with court carpets. Pink and brown on a dark blue ground, it shows a series of stiff cross shapes flanked by chevrons and diamonds and other angular motifs. The juxtaposition of different design traditions is close to incoherent, but somehow it manages to work. In fact, it's fascinating. And it's one of a kind.

"What do you think it is?" I ask after a few moments.

"I don't know," says Robyn.

"I thought it might be Kurdish, with that brown and the medachyl."

And maybe the rug is Kurdish, though the truth is that at this point in my learning curve, "Kurdish" is my fallback position for almost any rug I don't recognize.* As fallback positions go, it's not bad. Kurds of various sorts have been responsible for an astonishing number of carpets woven in an astonishing variety of ways. This rug has a medachyl motif as its outermost border, a design made of reciprocal keyhole shapes that is quite common in rugs made in northwest Iran, where many Kurds live.

"Could be," responds Robyn when she's finally finished absorbing. "But whatever it is, take a good look, because you'll never see another."

* I am not alone in this. As the dealer and scholar Alberto Levi has said: "When I started collecting, I wanted everything I found to be Kurdish."

She's right about that. I'll see thousands of carpets in the years to come (if not a hundred thousand, certainly a great many), but I'll never again encounter one anything like this. The rug's bright and harmonious colors would be attractive regardless of design, but its status as a one-off adds interest. Truly unique carpets are rare.

The rug has some minor moth damage, so I ask Robyn to wash it with some white vinegar, which discourages those voracious insects; and I ask her to have her repair man, an Afghan immigrant named Ali, stabilize its corners, which have begun to fray. Then we turn to the other items I've brought.

"Would you like these washed, too?"

"No, I thought these might be for you."

"What do you mean?"

"I mean I ran across some things at an estate sale I thought you might be interested in."

"You're going into business?"

"Well, I just thought they might be right for you. They seemed like your kind of thing, so I thought maybe you might want to, you know, buy them."

"You're going into business. All right, let's see."

All the rugs I'm hoping to sell today are Persian: a runner from the Zagros Mountains that has a series of green and yellow octagons marching over a brick-red ground; a nineteenth-century Ferahan carpet about ten feet long with an allover Herati field motif of blossoms framed by strapwork and serrated leaves; and a brightly colored flatweave with a geometrical design that was made by a member of the Qashga'i tribal confederation somewhere around Shiraz.

I unroll the rugs, and Robyn looks them over quickly.

"How much?"

I'm not sure what to say. Knowing the difference between what dealers ask and what they accept, however, I figure my starting point needs to be at least twice what I want to get in order to allow for her counteroffer. So I tell her $2,000, $4,000, $1,500. But no counteroffer comes. She doesn't even respond.

It turns out Robyn is unusual among dealers in that she doesn't bargain the way most people in the business do. Whether buying or

selling, many carpet professionals are constitutionally incapable of accepting the first price they hear, but not Robyn. She either pays the asking price or she doesn't, and the people she chooses to do business with soon come to know that, although I don't know it yet. Eventually I'll learn to start with my bottom price in selling to her, something I never do with other dealers. And she and I will reach an unspoken agreement whereby if I'm buying, she won't ask me to pay retail and I won't ask for too much of a discount. My bargaining with Robyn will never be as protracted or cutthroat as it can be with others, but that's in the future. Today, I don't get anywhere.

"You're not interested?"

"No," she says, "but you've got a good eye. If you've got some free time and some disposable income, you could learn to be a picker. Or you could be a mixer. That might be safer."

"What's a mixer?"

"A mixer locates carpets one dealer has had sitting in her shop for too long and takes them around to sit in other places where they might do better. I haven't got time for that, but if you do, you could make some money. Not much, to tell the truth, but a little. And you could meet people."

It's the meeting people that interests me. When I was a young man crazy about rock music, I joined with some friends to form a band that played for a song in the low-level venues of lower Manhattan. When I became entranced by vintage wines, I earned my living for several years as a sommelier. Deeper involvement yields better understanding, and working in a field, you have access to insider's knowledge. You find out what things are really worth, who is respected and who isn't, what the standard markups and percentages are. Plus, when it comes time to buy, you get the insider's price. Robyn's proposal means that even if my ancestors weren't carpet dealers and I haven't had the opportunity to touch a hundred thousand rugs, I can still get into the business in some capacity.

A mixer. I like the idea and agree to it right away.

She looks through the many rugs piled in her shop and selects three of them for me to start with: a Kazak with a lot of teal blue

in it, a Hamadan that has red blossoms on a white ground, and a small gray-and-gold Senneh covered with rows of pine-cone-shaped botehs.

"If you can't sell them on the spot, and you probably won't, then I don't mind you leaving them on consignment. Just make sure you've got good documentation."

There won't be much profit in consigning, particularly since a lot of the rugs I'll be taking around won't be mine. The shop owners will get roughly 40 percent of the agreed-upon price for whatever items are eventually sold, and I'll get 60. From that, I'll have to subtract Robyn's lion's share, since the carpets are actually hers. What's more, there's no telling when or even if a sale will occur. I may wait for months or even years to make a few hundred dollars. But in spite of the thin margins, consignment is a common arrangement in the rug world, because it offers advantages to all concerned. For the shop owner, it's a way of expanding stock without spending money or incurring risk. For the consigner, it's a way of offering something for sale without the uncertainty of putting it up for auction. If Robyn sells unwanted inventory through an auction, she might get lucky and occasion competitive bidding, but she might also get unlucky. Auctioneers don't like high reserves, so her minimum return will be quite low, and of course auction rings are part of the business. If she sends me out to leave her rugs with other dealers, though, she knows she won't be selling below her cost. She may have to take the unwanted carpets back after a while, but she won't be taking a bath.

Robyn has more to say about how mixers operate, and I listen with half an ear while I go on thinking my novice thoughts. What I think is that regardless of whether I succeed in helping Robyn, I've already achieved something for myself. Just as she declared, I've gone into business. I believe I'll have some business cards printed up. I'll open a dedicated bank account. I'm a rug dealer now.

"Now, remember," she tells me, as we roll up the carpets she has chosen for my initial foray, "when it comes time to collect, it's either the rug or the money, and don't let them talk you into anything else. No trades, no partial payments, no postdated checks. When you

leave a rug, you want the date, the consignment price, and a detailed description all written down on the dealer's receipt, and you should put the receipt on top of the rug you're leaving and take a photo of it. That way, at least you've got something to show, something you can threaten to take to the police. It's the rug or the money, but if you're new, they may try to yank you around."

It's good advice, but good advice is usually recognized in retrospect. You have to learn by experience.

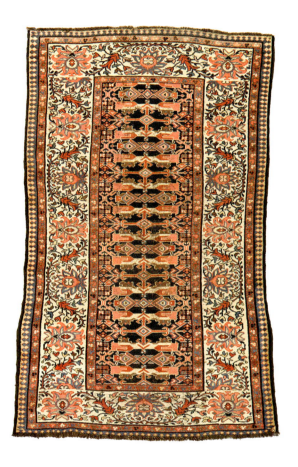

The One-Off Northwest Persian, 4 ft. 2 in. x 6 ft. 8 in.

FOUR

A Handshake Business

The Old Derbent Kelleh, Part I

I ask twice, but the name is still Ryan Whale. His shop is on the second story of a dim building in downtown New London, and even taking a rug to the window, it's hard to see it well. Not that it matters. None of what he has to sell is very interesting. Still, he's in the carpet business and depends on it for his livelihood, so I figure there are things I can learn from him. Besides, he seems straightforward, and his wife, who helps him in the shop, is attractive. I sit down for a chat.

Ryan Whale looks like an Irish club fighter. He's short and stocky, with a powerful build, and has a neck as wide as his round head. His close-cropped hair is sandy blond, his flat features are characterized by a seen-it-all expression, and even though he appears to be still in his twenties, his gray eyes already have bags beneath them. I see no scars or bruises or broken nose, but this man was born with a battered face.

Ryan comes from Massachusetts, but his wife, Penelope, has a soft southern accent. As petite as he is sturdy, she has a pale complexion and dark eyes, and her shoulder-length hair is jet-black. She doesn't know much about carpets, but in dealing with customers, the two have arrived at a division of labor: Ryan provides the know-how, and Penelope provides the charm.

"Isn't that a nice one!" she says when I unroll Robyn's Kazak. "Ryan, we should get it for ourselves, don't you think?"

"They're not hard to come by," he answers. "I could buy one every day of the week if I wanted to pay the money."

"Not every day," I say, keeping the tone light. "Maybe just Tuesdays."

"Tuesday and any other time I feel like making a phone call. You know Hagop? He'll send me one tomorrow."

I've never met Hagop Andonian, but I know who he is: one of the most established dealers in New York, with a shop on East Thirtieth Street between Madison and Park.

"Hagop would charge you the moon. And he probably thinks he's too high-class to consign a carpet in the sticks. This is where he finds rugs, not where he sells them."

"These aren't the sticks, honey," says Penelope, wagging a finger at me. "The sticks are just outside of Shelbyville, Tennessee, and believe me, I know."

"He'd send me carpets," continues Ryan. "I used to work for him. But they'd just sit around until I sent them back."

"So you don't take consignments?"

"Yeah, I do, but you don't want to leave that Kazak with me. You need a place that sells to rich people. You want people who spend for the hell of it."

"So where do I find customers like those?"

"Not in New London. I only wish. But I know a guy on Long Island that's got a great location. John Caesar."

"Where's his shop?"

"The South Fork, Amagansett. There's money all over out there, and he does a tremendous business."

"Thanks. I'll try him. But what's Penelope going to do for a carpet if you don't buy her this one?"

"Oh, just cry myself to sleep," she says, throwing up her hands in mock despair. "Just cry myself to sleep. That's how a girl knows she got married."

To which Ryan shows no reaction beyond a small smile and a slight shake of his head.

"He's right on the highway," he says, "you'll see the sign. Tell him I sent you. Tell him I said to treat you right."

So a few weeks later, when I've got a day free on the calendar, I gather the rugs Robyn left me and add a few of my own and set out on my expedition to John Caesar and his wealthy clientele. I decide to make a stop along the way and see if I can't save some money.

Amagansett, currently the most fashionable village in Long Is-

land's fashionable Hamptons, is not far from Connecticut as the seagull flies, but it's a long way away by car. Or it would be if one had to fight the traffic west to New York and then fight it east again on the Long Island Expressway ("the world's longest parking lot") all the way out to the island's two culminating peninsulas, the North and South Forks. Conveniently, though, there's a ferry that happens to depart from New London and runs across to Orient Point on the North Fork, and even more conveniently, the operations manager of the ferry company happens to be married to my wife's cousin. His name is Dick Sise, and, most convenient of all, he loves oriental carpets.

It being a Saturday when I stop by the old farmhouse in which Dick lives with his cheerful wife, Peg, I figure I'll find him at home. Where I find him is in his basement. The house is Peg's by inheritance and dates to the nineteenth century, and it is a large and rambling wood-frame affair that consists of many wings in various stages of decay. Dick is as handy as they come, but the endless maintenance required by the extensive structure is a never-ending project that consumes his free time. Right now, he is standing in rubber boots in the several inches of water that regularly runs over the uneven gravel that serves as his cellar floor, and he is regarding a snarl of aged wiring with a baleful eye.

"I should have redone the electricity in this house years ago," he says when he sees me coming down the stairs. "We're lucky the whole place hasn't burned."

"You look like something out of *Les Misérables*," I tell him. "It's like the Paris sewers down here."

"Yeah, except we might have more rats."

"Come on, every old farmhouse is going to have some mice."

"I think this one has wolverines."

"Well, leave them alone for now. I've got a rug you might like. Come see."

I've brought along a worn runner, something too frayed for most customers and yet interesting all the same. Dick loves carpets, and a visceral attraction to them is something we share, but

he's never studied up on them and couldn't tell you their names or places of origin. Even so, he has an eye for color and design, and he responds to a good rug when he sees it. From time to time, when I've run across one that has "condition issues" but is nonetheless pretty and genuinely antique, I've bought it cheap and passed it on to Dick at cost. The ten-foot runner I have for him now has strong natural dyes and a repeat cruciform motif that gives it a primitive appearance.

"What do you think it is?" asks Dick, his eyes lighting up.

"It's Persian, something from up around the Azerbaijan border. These days they're calling anything like this Shahsavan, but who knows? The rug can't talk."

Shahsavan, meaning "those who love the shah," is the name given to a loose collection of tribes, a group of herders, soldiers, bodyguards, and sometime bandits whose territory lies four or five hundred miles west of Tehran. The extent to which these nomads wove piled rugs remains a contested issue, but there is fashion in carpet nomenclature, too. The term has become popular among dealers and auction houses, who use it to add ethnic appeal to any fairly rustic rug from the northwest corner of Iran.

"I love it. What do I owe you?"

"How about a trade, Dick? Round trip on the ferry today? I need to go to Long Island."

"Hell, I'll just give you a season's pass. I should have done that a long time ago."

I don't argue. The ferry tickets are expensive, and my margin on consignment will be small.

"Well, thank you. The rug's still free."

"What's on Long Island? You going to see your sister?"

I'm not, but it's a reasonable guess. The east end of Long Island is where I grew up, and my sister still lives there in the family home in Sagaponack, near Bridgehampton. When my parents were alive, I used to return regularly, but now that they're gone, I go much less often. The area has changed so much, it makes my heart sick even to think about it. "Kansas by the sea" is how folks used to

describe the area back in the 1960s, but today Sagaponack's fertile plain is studded with enormous houses, and the 180-degree view of the nearby ocean that used to be visible from my family's porch has been steadily whittled down and blocked off. The fishermen and farmers who were once our neighbors have been replaced by movie producers and television broadcasters, and the local store that sold cornmeal out of a barrel now sells T-shirts and bumper stickers. I try to be philosophical about what has happened—all things change, and you can't blame other people for liking what you liked yourself—but nonetheless I've chosen to live elsewhere. If things have to change, I'd just as soon they did so while I wasn't looking.

"Not this time," I tell Dick. "I'm going to see if I can't sell a few rugs. I hear there's a shop over there that might take some on consignment."

"We've got some big carpets from Peg's parents that we never use. Maybe you could sell them, too."

"I doubt they're worth much, Dick, but I'll take a look."

Homeowners often have unrealistic ideas about the value of their carpets, and it's best to discourage such illusions from the get-go. Dick Sise, though, is more realistic than most.

"Yeah, they're probably too beat up," he agrees. "But there's a bunch of them out back. You might as well see."

I follow Dick's lead through a couple of doors and down a hallway and up a flight of stairs. I notice that today he is walking with a slight limp. Dick wrestled in school and still has the muscular body of a former athlete, but it is a body that has been used hard. He copes with his many aches and pains by means of gritted teeth and a liberal application of bourbon, but the bourbon doesn't happen until the end of the day. Right now he moves uncomfortably through a succession of progressively less inhabited spaces until we come to a dusty room on the second floor of an unused and unheated wing of the house, where he locates several crumpled carpets heaped amid broken toys, half-empty filing cabinets, old sports equipment, moth-eaten clothing, and many other outmoded and crumbling objects.

We drag the carpets down the stairs and into the sunlight and spread them out on the grass. They were all pretty rugs once. One is an early twentieth-century Kirman, and two others are Kashans from the 1930s, but all three are in terrible condition, and in fact one has strips of electrical tape glued to its back in an unsuccessful effort to repair a wide split.

There's a fourth carpet, though, and now I'm happy I came.

"Dick, I think we got lucky."

"That one?"

"Yeah, I know, but I think someone might buy it. It's an Ushak."

"It's ugly as hell."

"There's no accounting for taste. These sometimes go for a lot. Home decorators are looking for them."

"You're kidding."

"You weren't cut out to be a decorator, Dickie Sise. I noticed that about you right away."

Ushaks do in fact strike many people in the business as ugly, but they have a use for them all the same. The name is that of a town in western Turkey that produced carpets for the Ottoman court four or five hundred years ago, but in more recent times it has been the source of roughly woven room-size rugs showing simplified versions of Persian patterns against backgrounds that are often bland. Beige, khaki, oatmeal brown. Decorators like these Ushaks because their muted colors don't argue with whatever look they are trying to achieve. Homeowners like them because the decorators tell them they're in fashion. Dealers like them because they sell.

The one lying in front of us now is dyed a sort of dirty apricot and has the skeletal outline of a medallion drawn in a pale pink. Remarkably, it's still in pretty good condition. Drab as the Ushak is, it's an excellent find.

"You might be coming into some money here, Dick."

"Really? Well, make sure you get your share."

"No, there's no charge. You're giving me the ferry pass, and anyway, you're family."

I don't plan to take a percentage, but I still expect to get some-

thing out of it. I figure the consignment arrangement I'm hoping to make just improved, because this is a rug a dealer will want in his shop.

Dick helps me to shake the decades of dust out of the carpet, and then I roll it up and add it to the ones in the back of my car while he phones the ferry office about my pass.

"Time for me to go, Dick, it's going to be a long day. Say hello to Peg."

"I will, whenever she gets back. She's off at another horse show. I don't see her much since she started to ride."

I've heard his jesting complaint before, but I play along.

"When was that?"

"Oh, about thirty years ago."

"Well," I say, thinking of Spencer and myself, "it's good for a marriage if people have hobbies. A hobby's kind of like private time, it means having your own space psychologically. If each person has their own interests, it helps to keep things fresh."

"I tell Peg she'd be more interested in me if I wore a bridle."

"What does she say to you?"

"That I'd be more interested in her if she came with an instruction manual."

"Well, you can't say she doesn't know you. Thanks again for the pass, Dick. I'll let you know about the rug."

The ferry trip from New London to Orient Point takes about an hour and a half, and it's an excursion onto wide water. The route crosses the open end of Long Island Sound, where a relatively protected inland sea meets the huge Atlantic Ocean, and the tidal rip through the channel known as Plum Gut can be very strong. I've made the trip when there were eight-foot waves in the Gut, but on this May morning the tide is slack and the water is calm. The sky is almost cloudless, the sunlight dancing on the gentle swells is brilliant, and the salt air of the sea breeze invigorates. Gulls wheel overhead and bank away, their harsh cries stabbing through the insistent sound of wind and wake, and small craft—recreational yachts and fishing boats—stand off to keep clear of our sea lane. To the

west, the almost parallel coastlines of Long Island and Connecticut stretch toward their distant convergence at New York City, while in the east several flyspeck islands rise up and grow small as the ferry glides by. We pass Plum Island, where government programs for animal disease research have bred endless rumors about laboratory accidents and germ warfare, and then dock alongside a row of pilings at the company terminal on Orient Point. The bow of the ferry yawns open, chains rattle as the ramp level is adjusted, the metal hull groans against the metal pier, and then I take my place in the row of cars streaming off the boat onto dry land. An hour's drive takes me around the head of Peconic Bay to the main artery of the South Fork, the Montauk Highway. There the traffic moves slowly, as it usually does in the Hamptons, but at last I come to Amagansett and a sign advertising fine rugs and low prices: JOHN CAESAR ORIENTAL CARPETS, AFFORDABLE BEAUTY FOR THE ELEGANT HOME.

It's quite an operation.

I park next to a truck from which two men who look Hispanic and say nothing are hoisting rolled carpets on their shoulders and carrying them into the building. The building itself was once a barn, and the main entrance is through sliding twin doors that have been left open to the warm spring day. Inside, the ground floor is a single room, perhaps twenty feet by sixty, and the large space is filled with rugs, many more than I saw in Robyn's shop. Off in one corner, a small man who I presume is the owner is making his sales pitch to some customers, and he notes my arrival with a brief glance before carrying on with his spiel. Most of the stock consists of room-size carpets, nine by twelve or eight by eleven, and though I stand six foot five, the carpet stacks rise as high as my waist. Looking around, I count seven of them, and to my surprise I find Penelope Whale sitting on one.

"There he is!" she says when she sees me. "I told Ryan you'd show up sooner or later."

"Miss Shelbyville. What are you doing in Amagansett?"

"We closed the shop in New London last week and brought all our rugs here, and now Ryan's selling for John. That's John over there."

"I guessed. Where's Ryan?"

"With some homeowners in their home. He's doing great. He's brought in over twenty-five thousand dollars already. That's more than John's been selling himself, and John's good. Listen to him go."

We fall silent, and the patter comes to us from across the room. The voice has the incisive tone of a radio talk-show host.

". . . now, you have to understand that these are not the machine-tufted, mass-produced rugs you'll find in other stores, and there's no glue in them holding everything together. These are unique works of art, and they're made with individually hand-tied knots, you wouldn't believe how many. The one you're looking at has over three million knots in it, and I could show you some with even more. That's why these stand up to wear, and it's why they hold their value. Grandma's wall-to-wall floor treatments aren't worth a dime today, but her oriental carpets are heirlooms, right? And the cost-to-quality ratio in a fine oriental is fantastic, because they're not really that expensive. When you consider what it takes to make one, a carpet like this is a steal."

It's not Robyn's way of selling a rug, or Jim Barnard's either, but it's effective. Before long, the carpet is carried out to a car, and a check is changing hands.

"You're going to love that Tabriz, I know it," says the successful salesman to his departing buyers, "and if you ever need it cleaned, come on back, we do a great job. And remember, if you decide you want another, the next one's an additional ten percent off. I appreciate my repeat customers, especially ones like you. You've got good taste."

When the car drives off, the small man comes over to Penelope and me, and she makes the introductions.

"Yeah, Ryan told me about you. I hear you've got some old rugs. That's great, we could use some. Most of what we've got here is new."

John Caesar is short, very short, and I instinctively sit down next to Penelope so as not to tower over him. He wears tinted glasses and has long hair that is salon styled and carefully combed, and he must have been handsome before the accident. As Ryan will later inform me, John was driving a car years ago that crashed and burned. The

glasses and carefully arranged hair hide some of the scarring around his eyes and ears—one of his ears is almost entirely missing—but there's nothing he can do to disguise his odd mouth. It's just misshapen enough to be disconcerting, and I have to tell myself not to stare. The physical damage caused by the accident is there to see on John's face, but what the psychological damage has been is anyone's guess. I'll hear it said from others that his daughter died in the fire, but I'll never know if the rumor is true. Only he could confirm it, and it's not a subject one brings up.

"You told those people they bought a Tabriz?" I ask him after we shake hands. "Looked like an Indo-Tabriz to me."

Identifying a rug accurately when you meet people in the business is always a good beginning. It shows you have some degree of experience and won't be taken advantage of.

"Tabriz, Indo-Tabriz," says John with a smile, "the customers don't know. It's like when they order a glass of Chablis, it's just a name. And besides, what do they expect for three thousand dollars?"

So I was right. Recently, I've been buying dozens of old auction catalogs and have begun learning from their illustrations how to identify the standard types on sight. I'm getting better at it. In this case, the palette was the tip-off: a pale green and a bright pink juxtaposed directly with red shouted Indian subcontinent.

"Well, I'd expect something more."

"That's you," he says. "These people have no idea what they're doing. I mean, sometimes I sort of feel sorry for them. They think they're getting a deal at three thousand dollars, and if I buy in quantity, I'm getting the carpets shipped to me for three hundred dollars apiece. It's almost unfair."

"Almost?"

"Almost. Every once in a while, though, someone walks in who wants something better, something that's actually old. So what did you bring?"

I show him the three rugs Robyn has given me, along with Dick's Ushak and a few pieces of my own, one of which is from the village of Tafrish on the Hamadan plain. The Tafrish has a field of lapis lazuli blue and a design of realistically drawn birds arranged in diagonal

lines. It has gleaming wool, too, so bright that I suspect it got a lanolin bath at some point or was sprayed with silicone. But I keep my suspicions to myself.

John checks the rugs carefully, turning each one over to examine its back six inches at a time and folding the previously checked portions under as he goes. It's plainly an excellent way to discover any cuts or patches or repiling, and I make a note that I should slow down and go through this painstaking process myself when I'm buying carpets in the future. If a rug is truly old, it will almost certainly show some damage or evidence of repair, but it can take patience and a sharp eye to see where the work was done.

"They're all good rugs," he says when he's done, "and I can use them. So how much do you want? Don't be afraid to ask a good price, our customers have plenty of money. Go ahead and make a profit."

"OK, but I want to leave room for you to mark up your stock. You need to make a profit, too."

"Mark up my stock? I'm not buying them, if that's what you mean. That's not how this business works. In this business, nobody pays till the customer pays. You put whatever price you like on them, and I'll make whatever I can on top of that."

Consignment arrangements usually specify a given price and the percentage split, but I figure as long as I get mine, John can get his any way he pleases. He hands me a printed form with the same words on it that I saw on the sign outside: JOHN CAESAR ORIENTAL CARPETS, AFFORDABLE BEAUTY FOR THE ELEGANT HOME. I write brief descriptions of the rugs I'm leaving and put down what I think is a healthy return for each: $3,500 for Robyn's Kazak, $4,000 for Dick's Ushak, $900 for my little Tafrish. I end up consigning seven rugs in total, and John signs the form with a John Hancock–size signature.

"You're going to be glad you came here. You'll be making money."

"How about you write me a check to hold until I come back?" I venture. "Just so I'm covered if something happens."

"What are you saying, if something happens? Look, I won't take it personally, but that's not the way this business works. It's a small world, and everybody knows everybody, and if you screw up, nobody wants to know you."

"Yes, but we don't know each other yet."

"This is a handshake business. It's all built on trust. If Ryan hadn't told me about you, you and I wouldn't be talking now. But we are talking, and I'm telling you the people who do business with me make out fine. Come back in a few weeks, and we'll see where we're at."

So it's not the careful and clear-cut transaction Robyn had recommended, but the fact is that few deals in the rug business are strictly by the book. In any case, when I return a month later, it turns out John was right. My Tafrish has sold on consignment, and John wants to buy Dick Sise's Ushak himself. What he doesn't want is to pay the price I had specified.

"It's worth three, tops. It's not a very good Ushak."

"Then how come you want it?"

"It's not a very good Ushak, but it's still an Ushak. Three thousand."

"I thought you said you weren't buying. Four was where I needed to get to, not where I was starting."

"OK, call it thirty-five. That's as high as we can go."

"We? Who's we?"

He points to a squat man who is talking on his cell phone at the other end of the room.

"Donnie there has a customer for it, but the rug's in my shop, so we're in on it together."

And that's when I meet Donnie Zahabian. As I'll find out, anyone who has anything to do with carpets anywhere around New York knows Donnie.

The extensive Zahabian clan was one of the many Jewish families that left Iran after the 1979 Islamic revolution, but Donnie arrived in the States at an early age and grew up eighty miles west of Amagansett, in Great Neck. He speaks Farsi with his mother and father and English with everyone else, except when he's dealing carpets. Doing business, he uses both languages, shifting back and forth depending on his audience and on how much information he wishes to conceal. His curse words, though, are always in English.

"*Braa frsha keh bradh shdh dh hzar dlar ma khwahad?* Fuck off," he says now, ending his phone call. "He wanted ten thousand dollars for a rug that's been cut. You believe that? So who's this?"

Donnie has close-cut black hair and wire-rim glasses, and even though it's May, he's wearing a black leather jacket zipped up to his chin.

"This is the guy with the Ushak," says John.

"Nice to meet you," says Donnie. "Three thousand."

"I told him thirty-five," says John.

"It's not a very good Ushak," says Donnie.

"It's still an Ushak," I say. "Thirty-eight."

We agree on $3,600, and John writes two checks, one in my name for the Tafrish, one made out to Richard Sise. With the checks in my pocket, I decide to stick around for some talk—after all, meeting people is part of why I'm here—and the conversation ranges in many directions. If I thought we were going to discuss knot counts and dye lots or breeds of sheep, though, or anything else having to do with my current mania, I was wrong. I keep bringing up carpets, but these guys have other things on their minds.

Donnie talks jewelry.

"How'd you get into rugs?" I ask him.

He tells me that many of his relatives went into the diamond business upon coming to this country, and "most of them did very well," but he found out it wasn't for him.

"I was working ten years ago for an uncle who had a jewelry store on Jamaica Avenue, and I went out to have lunch at a titty bar down the street, and when I got back my uncle was shot dead in a holdup. I got out of diamonds that day. Selling carpets, maybe I won't get rich, but I won't get killed, either."

John talks finance. The 2008 economic meltdown is still in the offing, and the financial markets are hot and getting hotter.

"You keep any rugs for yourself?" I ask him.

"Like for investment? Nah. You're investing, buy gold, you can't lose. Every dollar you put into gold now, you'll have two dollars before you know it. And it's not just about upside, it's the safe move,

because things are getting crazy. You know what a market derivative is? Some of these what they call instruments, if they were that carpet right there, six square inches would be real money, and the rest would all be leverage. It's nuts."

At some point Ryan Whale comes back from his visit to the homeowners and joins our discussion, too, and he talks currency values.

"You bought any interesting rugs recently?" I ask him.

"What I buy is euros. They're better than dollars now. I buy them with cash, always less than five thousand, so the bank doesn't have to report it. I get it in big bills, and I stash them away in my safe-deposit box. Best nest egg you could have."

The conversation is not what I had anticipated, but it is instructive in its way. What I'm learning is that these are dealers, not collectors, and first and foremost they are businessmen. I'm motivated by my interest in carpets. They're moved by dollars and cents. The money talk does make me feel I've been taken into their confidence, though, and I'm enjoying the sense of being part of a fraternity, but eventually it's time to leave. I still have a long drive in front of me, and westbound traffic on the Montauk Highway slows to a crawl in the afternoon, as an endless stream of pickup trucks files out of the high-rent Hamptons back to the towns where the workers driving them can afford to live. So it's time to be on my way, but the day has been a success, and before I go, I offer to leave another carpet on consignment.

"Is it an Ushak?" says John. "We can always sell those."

"No, but you'll like it anyway. Wait and see."

What I've got is a nineteenth-century Caucasian rug, very attractive and unusual. It's an old Derbent kelleh.

Kelleh, strictly speaking, is a word used for carpets of Persian origin. It indicates a size, typically a carpet five or six feet wide and at least twice that long. Because much of the Caucasus was part of the Persian Empire in centuries past, the term is sometimes used for Caucasian rugs of that dimension, too, such as those made in the port city of Derbent in what is now Russian Dagestan. Derbents are not usually well thought of, in part because weavers in that area came early and often to synthetic dyes, and thus in many cases the

colors they used have not aged well. Their rugs tend to be dull, but there are exceptions to every rule, and the one I've brought along today isn't dull at all.

It's thirteen feet long, and the dark blue of its dramatically abrashed field is framed by several borders in warm red and white. The center of the rug shows a row of deeply serrated medallions arranged on a vertical axis from which spring long branchlike extensions, and the field is filled with green and yellow leaves, polychrome blossoms, and a scattering of minor decorative motifs. The basic layout is one seen from time to time in Caucasian prayer rugs, and it is sometimes said to be a tree of life rising amid adjacent birds. More likely, what I've got is a distant and much simplified descendant of the long rugs made in the Caucasus two or three centuries ago that had lattice and sunburst designs and were derived in turn from elaborate court carpets produced for sultans and shahs. (As a rule, when designs move from courts to the countryside and evolve through centuries of imitation, they tend to gain symmetry and lose detail.)

The rug is beautiful, and it's a rarity, too. For one thing, it's single-wefted, as Derbents may be, but as virtually no other Caucasians are. For another, its end finishes are fully extant. End finishes come in many kinds (the thick braided band of a Yürük rug, the chevron-pattern flatweave of an Afshar, the kilim apron and long knotted warps of a Baluch . . .), and they can tell you a lot about provenance, but in an antique carpet they are very often missing. In this case, however, the brown wool warps visible at the top and bottom of the kelleh have been tied into an elaborate macramé that has survived miraculously intact. Beautiful.

Beautiful, but not without drawbacks. As mentioned, the dyes used in Derbent were often problematic. The gorgeous colors that carpet aficionados love derive from nature, not the laboratory. They are made from plant matter—leaves, roots, bark—or from scale insects such as cochineal. Synthetic chemical dyes don't show the subtle variations in tone that natural dyes do, and while the modern ones that use chromium are fast to light and water, the anilines that

came on the market in the second half of the nineteenth century tended to bleed and fade.

My Derbent has many strong vegetal dyes, but it contains at least two that are clearly synthetic. One is an aniline lavender that was light fugitive and has faded to a grayish white; the other is the red used in the borders at one end of the rug, which has altered over time to become a muddy brown. Both these synthetics were among the first to be introduced to the Caucasus, and they testify to the carpet's age, but they are synthetics all the same and impact its value. Moreover, in one corner of the rug there is a patch about three inches square. The fugitive dyes and the patch are why I was able to buy it, though it was still expensive by my humble standards.

The rug cost me just under $4,000 in an auction in Bedford, New York.

I bring it into the barn and unroll it across one of the waist-high stacks of $300 Indo imitations.

"Oh, now that's pretty," says Donnie, stretching a hand out to feel the wool. "Somebody is going to want that."

"Put a healthy price on it," John Caesar tells me, as he's told me previously. "Our customers have money, so make sure you get yours."

"What are you going to ask for it?"

"That depends. Just put down what you want to get."

Once again, the deal won't be spelled out in detail, but I'm getting used to that. It's a handshake business. The price I pick is $5,000, and as before, John signs the consignment form with a flourish. Then, after cheerful goodbyes, I get on the road.

Driving away, I'm happy. It's been a good day. I've spent many hours "playing with rugs," as Robyn calls it; I've made a couple of hundred dollars on the Tafrish; and to top it all off, I find the traffic on the highway isn't quite so bad as I had expected. Hell, things couldn't be better. I put Chris Smither on the sound system and sing along (". . . someone said they saw me, they said I was swinging the world by the tail . . ."), and after another drive around Peconic Bay and the return trip across the Sound, I go straight to Dick Sise's farmhouse. I get there at 6:00 p.m., which is to say the cocktail hour.

Dick has a glass in his hand when he answers the door, and he looks a lot more comfortable than he did rummaging through the unused rooms of his home a month ago when I saw him last. It feels good to give him the check and see the amazement on his face.

"Thirty-six hundred!" he says. "Jeez, I guess Peg will be buying more tack."

"Wouldn't you rather put it toward a new boat?"

"Wife first, boat second," says Peg, coming to the door herself.

"That doesn't sound like a New England attitude," I tell her, giving her a hug.

"It's not," she says with her ready laugh, "but it's why we get along. You want to stay for spaghetti? You and Dickie can look around in the attic for more carpets while I get things ready."

"No, thanks, Peg, I'm going to push on. I told your cousin I'd be back for dinner."

"So call her up and tell her to come eat here with us."

"Another time, maybe. I'm bushed."

Peg and Dick are warm hosts, but I want to share my tale of triumph with my own wife. The invitation has given me an idea, though, and on my way home I call ahead to tell Spencer I'm thinking of cooking an Italian meal for us, *spaghetti alla bottarga*. When I walk in our house a half hour later, I find she has opened a bottle of Friuli chardonnay to suit the food and has set a large pot of water on to boil. She lays the table while I go into action at the stove. The food preparation—dried fish roe, bread crumbs, red pepper flakes, and parsley tossed in an olive oil and water emulsion—doesn't take long, and soon we clink glasses as we sit down to eat.

"You should have seen them when I handed them the check," I say between bites. "They couldn't believe they had that much money just lying around in a back room. What a day!"

"Sounds like you had a good time, George."

"I'm having a great time. I'm swinging the world by the tail."

Spencer doesn't exactly laugh, but, looking at her calm face in the candlelight, I think I see a smile.

"Well," she says, "in that case don't let go."

But you can hold on all you want, and the world will get away from you anyway. A week later my cell phone rings. It's Ryan Whale.

"John says to tell you that Donnie Zahabian has your Derbent now, so you'll need to get your money from him."

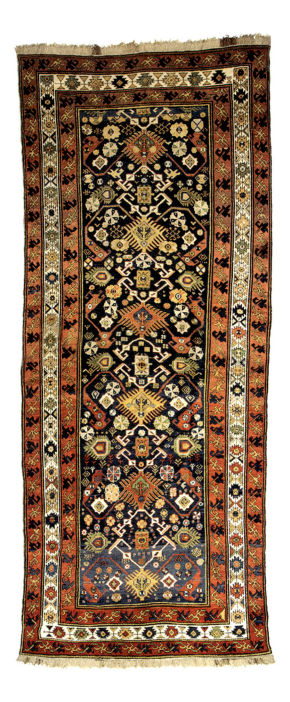

The Old Derbent Kelleh, 5 ft. 2 in. x 13 ft. 3 in.

FIVE

The Rug or the Money
The Old Derbent Kelleh, Part II

There's a sick feeling in the pit of my stomach as I call Dick Sise, but much to my relief I find out the check I gave him for his Ushak cleared. I hadn't got around to banking the money for my Tafrish as yet, but I rush to do so now, and as I fill out the deposit slip I look the check over. It's drawn on a national payment service, and there's no name or address or phone number printed on it. The scrawled signature might be many things—Jon Shifkin? Jay Zorkin?—but whatever it is, it doesn't match the JOHN CAESAR written in large letters on the consignment sheet I have. And looking at the sheet again, I realize there's no address or phone number printed on that, either. All I see is the colorful title of a business, and I'm willing to bet that as far as the government is concerned, that business goes by another name entirely. Dick Sise got his money, but I still feel sick. My Derbent has gone off with Donnie, the other rugs I've left on consignment are clearly at risk, and I've got no real proof of anything. All I've got is a piece of paper with some generic descriptions and a name that isn't a real name. It's nothing I could take to the police. It's certainly nothing that would stand up in a court of law.

After stewing overnight, I call "John Caesar" in the morning, but he doesn't answer and his voicemail box is full. I consider asking advice—what would my neighbor Gary do?—but I'm embarrassed by my own naïveté, and in any case I realize there's little help anyone can give me. It's up to me to salvage the situation, and the first order of business is to retrieve whatever I can, and that means moving quickly. I cancel a couple of appointments and drive again to Amagansett.

When I get to the shop (AFFORDABLE BEAUTY FOR THE ELEGANT HOME), I find the owner directing his silent assistants as they excavate

carpets from one giant stack and shift them to another. There's no sign of Ryan or Penelope Whale. I say nothing to anyone and start hunting for my consignment rugs, and surprisingly, they're all still there. All except the Derbent. I take what I find out to my car—at least I won't have to tell Robyn I lost her Kazak—and come back inside for the confrontation. This time I don't sit down to bring myself to John Caesar's level. I don't ever want to be at his level again.

"You owe me five thousand. That was the agreement."

"Donnie Zahabian owes you, not me."

"My deal was with you, it wasn't with Donnie. The rug or the money, John, the rug or the money. Cash. I don't want your check."

"I'm not writing any checks, and I'm not paying cash for anything. Donnie has your rug. You need to be talking to him."

Flat refusal. I turn my back on him and go to a window and look out at Amagansett while I try to decide what to do. Vans and pickups alternate with a plenitude of Mercedes, BMWs, and the occasional Porsche as they move slowly up and down the highway. Across the road and beyond the chic storefronts, I can make out some of the area's large shingled houses rising above their privet hedges and swimming pools. Should I physically assault the man? Not my style, and there are witnesses. In any case, throwing punches doesn't seem likely to bring me any closer to $5,000.

"What's Donnie's number?" I say, turning back to him.

He gives it to me, but I'm not sure I believe him.

"You dial it," I tell him. "Get him on the phone."

Donnie answers, as he might not have had the call come from me, and John puts me on.

"Donnie, you've got my carpet. I need my money, or I need it back."

"That big Caucasian? I didn't know it was yours."

"What do you mean, you didn't know? You were right here when I brought it in."

"Yeah, but then John told me you owed him, and so the rug was his. And he owes me, and he gave me the rug instead, so now it's mine."

"Look, this is all bullshit. I don't owe this guy for anything. The

rug or the money, Donnie, you know that's how it works. Pay me or bring the rug back."

"I figured you'd be getting your money from John."

"You want I should go to the police and blow this thing up?"

I'm sure the police wouldn't be interested, but it's something to say.

"No, don't do that. Just calm down."

"I grew up around here, Donnie, I know people. I've got a friend at the *Easthampton Sta*r. You want them to write about this?"

Even to myself I sound like a jerk, but I'm being jerked around and don't know what else to say that might get results.

"Hey, I'm not trying to pull anything. I didn't know, OK? So just calm down, you can have the rug back. But not right away."

It's not what I want to hear. I can feel myself growing tense with adrenaline.

"Why not right away?"

"I can't get it for a while. It went to Turkey."

"What?"

"It went over there to get that patch rewoven, and they're going to repile the bad dye in the border."

"It went there, like it decided on its own? Who sent it?"

"There's somebody wants it, but they want it to look nice, so it got sent overseas. It'll come back, don't worry, but it's going to take time."

This is not what I wanted to hear, but it's not all that surprising. Dealers often ship carpets overseas, usually to Turkey or Pakistan, where skilled weaving comes cheap and good wool is abundant. Carpets with "issues" go for restoration or repair, and there's a difference. Restoration means returning a textile to its original condition as faithfully as possible. Repair means fixing it up so it looks better. Removing tattered borders instead of reweaving them, substituting vibrant dyes for faded synthetics, swapping out some of the colors entirely in order to make a drab rug look bright . . . such procedures are the equivalent of Gary Clifton "improving" his antique furniture. Museum curators and purist collectors deplore the practice,

which distorts or eliminates the evidence of a rug's history, but dealers are unmoved by their objections. If there's money to be made by obscuring evidence, the average dealer will do so in a heartbeat, but of course the repair work and the shipping take time.

"How much time?" I ask.

"Who knows? Six months, a year. Look, here's what I'll do, and I'm only doing this because you're friends with Robyn, and I do a lot of business with her. I'm going to write you a check to hold. I'll postdate it six months, and if the rug isn't back by then, you can deposit it. Just let me know before it goes in the bank."

It's not much, but I've got no leverage, and it's better than nothing.

"So when do I get this check?"

"You want me to send it to you?"

"No."

"All right, I'm driving up to Connecticut to see Robyn next week. You and I can meet then."

"Next week when? Give me a time."

"Saturday, but it depends on how long I'm with her. I'll call you when I'm done, and we can meet after."

And that's as much as I get: the idea of an appointment and the prospect of a postdated check. I hand the phone back to John Caesar, and I don't even say goodbye as I leave the premises. Angry at others and angry at myself, I go back to Connecticut to wait for a possible call. I've gone from feeling like an insider to feeling like an idiot in short order, and there's not much I can do but kick myself and hope for the best.

Saturday next week is ten days away, and in the meantime I drive down to Robyn's shop to take her back her rugs and tell her what happened. She listens sympathetically (she can afford to, she's not out any money), and rather than saying "I warned you," she says how disappointed she is to hear about Donnie.

"He shouldn't have taken that Derbent without checking with you, and he knows that. I'm surprised. I remember when he was just a nice kid, just a young guy learning the ropes."

"Well," I say, "I guess he grew up."

"If you want to call it that."

"This carpet dealing, Robyn, the more I see of it, the less I like it. What a business."

"No, it's just like any business. The one where everybody is fair and nobody cuts corners and you never have to compromise, that's the business you don't really know about yet. Anyway, maybe I can help. When Donnie comes in next, I'll talk to him about it."

Which is nice of her, because it's a messy situation, and she's under no obligation to get involved. Maybe she feels badly about sending my innocent self into the fray. Maybe she wants to impress on Donnie that he shouldn't try anything of the sort with her. Mostly she's proving to be a good friend.

Eventually the appointed Saturday arrives, and I sit with my cell phone, ready for a call that doesn't come. As the hours pass, I start phoning Donnie's number, but he doesn't pick up until the late afternoon.

"Hello."

"Donnie, where are you? We're supposed to be meeting up."

"Actually, I'm running late. I'm on the highway driving home, we'll have to do it another time."

I explode.

"Listen, I haven't done anything all day but sit around so I'd be sure to have time free. You told me don't go to the police, you'd give me a check. So where is it? What, I'm supposed to go to Great Neck and camp out on your doorstep? Come on, just do what you said you would do."

"All right, all right, calm down. Look, I'm running late, and my wife's not going to be happy, but if you want we can meet on the road. I'll wait for you in the Branford rest stop, and like I told you, I'm only doing this because you're friends with Robyn."

The rest stop on I-95 is an inconvenient thirty miles away, but I get there in half an hour and locate Donnie's battered van (standard equipment for a rug dealer) parked among the Chevy Suburbans and Subaru crossovers and idling eighteen-wheelers. I step out of my vehicle and into his and wait while he finishes talking on his phone and goes back to eating fast food. Six-inch Subway, teriyaki chicken.

"My wife wants to kill me," he says between bites. "We're supposed to go to my in-laws for dinner, and the babysitter hasn't shown up. She's pissed already, and now I'm going to be late."

"Blame it on me," I tell him. "Say you had a customer that didn't show up on time. You marry someone in the business, that's going to happen. She shouldn't be surprised."

"Yeah, but she's still pissed."

"Well, there's nothing you can do about it. You have that check?"

He wipes his hands on a paper napkin and throws it over his shoulder into the back of the van, where the thick cylinders of six or seven room-size carpets, rolled and trussed, are piled every which way, like logs fallen in a forest. Then, with some reluctance, he extracts a blank check from his wallet and fills it out in my name.

He hands it to me.

"Robyn says I shouldn't treat you like just anybody. She says you're a decent guy, that you're a gentleman."

I'm not sure I like the description.

"What's a gentleman mean?" I ask, looking at the date on the check, six months into the future. "Someone you don't have to pay?"

"I keep telling you, don't worry about getting paid, the rug's coming back."

"OK, but when it does, then what? Who pays for the repair?"

"We can talk about that when it gets here."

"Let's talk now. I never asked for my rug to be sent away."

"Wait till you see it, you'll be happy. It's amazing, what they can do. They find these old bags and kilims, and then they take them apart and use the antique wool for the reweave. You won't even be able to see where the work was done, it's that good. And it doesn't really cost much."

"I didn't ask for it to be repaired, so why should I pay anything?"

"Because you want the rug back, that's why. Anyway, don't worry, it won't be expensive. Most of what you're paying for is the muscle."

"The muscle?"

"You send a nice carpet over there, and you want to see it again, it has to go with somebody who can look after it. The guy with the

muscle costs more than the person with the sewing needle. But none of it costs very much, not for your kind of rug."

"Why's that?"

"It's got a flat back and big knots, it's easy to work on. If it was a Kashan or a Bijar, something with a really tight weave, that's different. Carpets like that cost a lot to repair, because you need a specialist. They don't even send those out. The top guys get brought in from overseas, and they'll sit in a room for a couple of months making five thousand dollars a week. But that's for the very best carpets, something worth serious money."

"So you're saying my carpet's cheap."

"I'm saying it's not worth thirty or forty thousand. But it's still nice. Where'd you get it?"

I decide to play coy. If Donnie thinks I might be useful finding rugs that he can't, maybe he'll deal with me honestly out of self-interest.

"Somebody's attic," I say. "Hey, you saw what I brought into John's place. I've got a good eye, I can bring you quality stuff. Let's get back to even, and then we can do business. You'll make money, and I'll make money."

Donnie looks down at his hands for a moment and wipes them on his pants. Then he looks up at me, starting the engine.

"A guy like you, George, you're never going to make money at this. Believe me, not ever."

Not if I do business with you, is what I want to say. But I don't. I climb out of the van and start crossing my fingers for six months.

While I wait and hope, things happen. The first is that John Caesar's check for $900 bounces. Evidently there wasn't enough in the account to cover both Dick Sise's Ushak and my Tafrish, and I'm glad Dick cashed his check first. The mess remains my own, and by and by I take another day and make the journey to Amagansett once again. This will be my fourth round trip, which is a lot of time and expense for the amount of money at issue. I don't care. I'm not about to be cheated without protest. I aim to wave the worthless check in front of John's damaged face.

When I get there, John is doing what he does best, selling a $300

carpet for several thousand. I think about embarrassing him in front of his customers, but he doesn't embarrass easily, and in any case costing him a sale isn't going to get me paid. I sit down close by and listen.

"Now, this one," says John as his assistants fold back a large carpet to reveal another beneath it, "is a real beauty. It's a Mahal. Actually it's not a Mahal, it's even better than that, it's a . . . it's a . . ."

He turns to me.

"What's it called if it's a Mahal only better?"

What it is is a carpet made last month in Pakistan, as its gray cotton warps attest, but saying as much won't help me. Then again I don't wish to participate in a lie, so I choose my words carefully.

"If a large carpet actually comes from Iran and was made in the Arak area, it might be called a Mahal, and a Mahal that somebody wants to speak well of is sometimes called a Sultanabad."

"A Sultanabad!" exclaims John. "See, George knows. A Sultanabad, that's even better than a Mahal. This one's special, it's a work of art, it's all hand-knotted, and it took a lot of time to make it, it took incredible skill. You wouldn't believe how many knots it has, it's got millions. I'm sure you understand, this kind of craftsmanship is extraordinary, but the amazing thing is, it doesn't really cost that much, and what's more we're running a sale, ten percent off . . ."

And so forth. Eventually John closes the deal and his customers leave with their Indo-Mahal, and I can't say I feel good about the transaction. It's caveat emptor when you go to buy rugs, and I wasn't the one who did the defrauding, but I did stand by and watch.

"OK, I'll just write you another," he says when I show him the returned check.

"What, so it can bounce again? There's a bank fee involved, John. Your check gets returned, and I go further in the hole. Give me the cash."

"I'm not paying anyone cash. You can have a check, it'll be good."

"It'll be good, says who? You don't pay cash and your checks bounce, that means you're just blowing me off. You're going to do that over a few hundred dollars? You do, and I'll start making a scene in front of people. Just pay me. It's easier."

"Look, I'll tell you what. You see that rug on the wall? What do you think it's worth?"

It's an early twentieth-century Shirvan with a field consisting entirely of closely packed blossoms arranged in diagonal lines. The dyes appear vegetal, but they are dull and dark even so, and the overall effect of the muted color and repetitive design is unexciting. Still, it's a pre–World War I Caucasian with no obvious synthetics.

"I don't know. Depends who's buying. Two thousand, maybe twenty-five hundred."

"Right, so here's what we can do. You give me a thousand, and when you sell it, you'll have your money and more besides. Anything you make, that's yours to keep."

"You expect me to give *you* money? A thousand dollars, what, are you kidding?"

"All right, so let's call it five hundred. That's fair."

"That's not fair, that's ridiculous. I don't want some *farkakte* deal, give me the cash."

I worked as a copywriter for ten years in New York City, where a sprinkling of Yiddish salts the speech of commerce, and in times of financial duress those pungently exasperated words come back to me of their own accord.

"Cash, John," I tell him again. "Just give me the cash."

He turns suddenly and pulls the Shirvan off the wall, where it had been pressed onto a row of tacks at the ceiling line, and he folds it into a square. Before I realize what he's doing, he tosses it at me, and I catch it instinctively.

"OK, take it for free and get out of here," he tells me. "Take it and go."

Which I eventually do, because something is better than nothing, and at least this way I won't have to come back. I hope never to see this man again. Aside from the Ushak sale, my dealings with him have been nothing but painful. My Derbent's in Turkey, and my attractive Tafrish has been exchanged for a mediocre Shirvan, a rug that might be worth more in theory, but which I'm not sure what to do with. I could leave it someplace on consignment to sit for who knows how long, or I could sell it at auction for whatever it might bring, but I hesitate to do either. The suspicion lurks that this rug, too, is stolen. Why would John give me something of his own when he could just rob somebody else?

As it will turn out, decades will come and go and I won't ever get rid of John Caesar's Shirvan. Twenty years later, it will still be in my home, rolled up and wrapped in Tyvek and stored in back of a couch. I'll run across it from time to time when I'm looking for some other carpet, and it will always remind me of how foolish I've been on occasion. It's like the skull on the desk of a medieval monk, a symbol not of my own end perhaps, but certainly the end of my innocence. Call it a four-by-seven memento mori. It's not a bad rug, really. I can't stand to look at it.

It takes more than one bad experience to discourage an inveterate collector, though, and so another thing that happens while I'm waiting for Donnie to bring back my Derbent is that I continue to introduce myself to other dealers and shop owners. Driving at random around Connecticut, I stop in any antiques store that looks likely, and I'm sure to stop if I see carpets displayed or a sign that says WASHING ORIENTAL RUGS OUR SPECIALTY. The people I meet in this way are a colorful group, independent and often eccentric. They live by their wits, and they often live not much better than hand to mouth. The majority of them are small-time, only a step more established than I am, and while they all have survived due to their grasp of the market and their instinct for the genuinely antique, few of them have studied carpets systematically or gained more than a passing acquaintance with the conventional wisdom (what rug scholars refer to dismissively as "hearsay picked up in the bazaar"). I soon realize that, particularly if a carpet is a bit unusual, I'm likely to know more about it than most of the people I encounter. Not more than Jim Barnard or Robyn Del Vecchio, certainly, but more than most.

* * *

One day on my rambles, I meet a short, thick woman named Yildiz who goes by Dizzie and is married to an American named Ulrich. Born in Turkey, Dizzie has an immigrant's drive and energy, and she has managed to make a living by selling tables and chairs that are only a little better than used furniture. I discover that her shop also contains a lot of carpets, however, and not just machined ones

manufactured a few decades ago but older handwoven pieces as well, many of them Anatolian. Dizzie is friendly and good-humored, but she wants one thing understood from the get-go.

"I didn't marry him for a green card," she tells me the first time we meet. "I had the card before I ever saw him."

"I didn't say anything about a green card," I protest.

"No, but that's what you were thinking, wasn't it?"

"Um, how'd you wind up in the antiques business?" I ask, not wishing to dwell on my possible prejudices.

"You come here as a foreigner, you have to do something. It's not like anybody was going to hire me to manage a bank. I didn't want to clean houses, so I sell furniture. Everybody needs it."

"What about all the rugs?"

"Chairs, tables, lamps, those are bread and butter, but I'm a Turk. Rugs are in my blood. My uncle had a repair shop back in Izmir, and when I was a little girl I used to watch him work. You couldn't tell where he made a repair, he was that good. I still have contacts there, so if you've got a carpet that needs to be fixed, just tell me."

It's a sore subject. I change it.

"You ever think about ditching the used furniture and opening a carpet store? I bet you'd be successful at it."

"I would if I could, but at this price level there's not enough money in it to feed a family, especially if your husband's an artist."

It's a single-income home. It turns out that Dizzie has hitched herself to an amateur painter, and although Ulrich helps her out by lifting sofas and toting chairs, the business he dreams of is owning a gallery. As it is, his work is displayed in their shop in a room of its own, and walking into it, I get a surprise. The paintings don't seem any better than average, to my eye anyway, but they are certainly striking. Each of them shows a short, thick woman sitting naked on a chair or lying on a bed or standing to display herself with her arms behind her head. The paintings are small, the brushstrokes are blurry, and the woman's face is not rendered clearly enough to identify, but I still leave the room knowing a great deal more about Yildiz than I did on arrival.

* * *

One day I meet Frank Berra and his wife Mary, whose store on the ground floor of their home specializes in watches and jewelry but has a corner devoted to carpets. She seems quiet and sweet and a bit melancholy; he seems emotionless and detached. Frank is a Vietnam veteran and has health difficulties as a result, problems with his hearing and heart, and initially I take his stolid affect to be a personality disorder, some sort of PTSD that is a consequence of his combat experience. When I mention rugs to Mary, though, he lights up and joins in, smiling and laughing and touching my arm now and then when making a point. He turns out to be a carpet enthusiast, but he also needs to make money, and I'll learn that he starts every conversation hoping to make a sale.

"Look at that Kazak, it's really a good one, you could get two or three thousand for it at auction, no question. Say at Skinner's in Boston? They'd love it. And you don't see too many of them these days, it's not like it used to be. Real old Kazaks are getting rare, and they aren't making any more of them. The tribe doesn't even exist now."

The rug he's trying to sell me is an antique Caucasian of some sort, but it has synthetic dyes, and I'm not interested. Skinner's wouldn't be, either. Possibly it could be called a Kazak, Frank's not wrong about that, but the Kazaks have never died out, because the Kazaks never existed. That is, there's no Caucasian tribe by that name. The word was perhaps once a term for a nomad, though no one's really sure, and there is a town in Azerbaijan called Qazax where such nomads may have settled. Regardless, these days *Kazak* is not a term narrowly defined, and auction catalogs may use it for any old rug woven somewhere in the southwest Caucasus. I consider explaining this to Frank, but now that he's started, I find it's hard to get a word in edgewise. Besides, on reflection, I'm not sure I want him to know any more about rugs than he already does. It would just cost me money. I'm beginning to think like Jim Barnard.

Frank likes discussing rugs, and once the ice is broken, he likes conversation in general. At some point it comes out that I have a small business importing olive oil from Italy, and when he learns that, he wants to reminisce about the old country every time I see

him. His grandparents came from a village near Naples, and he still has relatives there, and he and Mary have been back to visit.

"You don't drop in for an hour or two, George, they'd be offended. You go for days, and they take care of you the whole time. You can't pay for a thing, not even a candy bar, they're angry if you try. You have to meet all the cousins, it doesn't matter how distant, and you get introduced to all their friends, and soon everyone in town knows your name and you can't remember any of theirs. Everyone wants to ask about America and find out if you like Italy better, and even if you don't speak a word of Italian and nobody understands what you're saying, they want to talk and talk and talk. Last time we went there, we stayed for a week, and at the end they didn't want us to go. I had to tell them I had a doctor's appointment here in the States, and even then it was all we could do to get away. But we had a great time, I'd go back tomorrow, it's so pretty and the people are really nice, and let me tell you about the food . . ."

His cousins aren't the only ones who want to talk and talk. It's all I can do to get out the door. Maybe it's genetic.

*　　*　　*

One day I meet Maureen and Judy, who sell rugs by the side of the road. Maureen is thin, reserved, and attractive in a conventional way. She is the mother of young children and comes and goes according to school bus schedules and soccer practices. Judy, who is a few years older, is an extroverted woman with a *jolie laide* appeal, and she is the one most likely to approach the passersby who stop to look at the colorful textiles draped over the stone walls that flank Maureen's driveway. As roadside wares go, the rugs Maureen and Judy have to offer are not bad, handmade orientals that are at least vintage if not antique. (In theory, a vintage rug is a minimum of forty years old and an antique is at least a hundred, but the terms are frequently abused, as the age of a carpet is exaggerated almost as a rule. You can't get arrested for it.) Looking over the display, I decide that the two women have enough old rugs for sale that perhaps I can sell them something of mine.

"This stuff is pretty nice," I tell Judy. "Where do you get your stock?"

"Different people. There's a guy from New York who comes by once every couple of months, and he's got good prices."

"Not really," I say. "If you're paying him half or even a third of what you've got these tagged at, you're paying too much. You could do better with me. Come take a look, I've got a couple of things in my car." What I have are two Chinese Art Deco rugs from the 1920s that I found at a garage sale in terrible condition. Ragged, worn in places right down to the foundation, and spattered with cement, they were in such bad shape that I bought them for $30 apiece. Most Art Decos are dyed in soft hues—sapphire and plum, pale green and peach—but these ones are mostly light brown. Still, they were cheap, so cheap I figured I could do something with them. First I borrowed some hair clippers, the sort used on poodles and marine recruits, and I shaved the rugs until the cement crust disappeared. Then I sewed up the edges and ends to the best of my inexpert ability and set about overdying the worn areas to disguise the exposed foundation. I rubbed the visible warps and wefts with brown shoe polish, and I soaked the rugs with espresso several times, and when I was done they weren't what you'd call beautiful, but they weren't awful, either. The doctored rugs didn't look bad, and they were still cheap. Gary Clifton would approve.

"These are eighty or ninety years old, maybe even more," I tell Judy, "and you can have them for just one fifty apiece. Two fifty, if you buy them both."

"They're not in great condition," she says after a brief inspection.

"Oh, they're not virgins, that's for sure. But they're really old, and old rugs are going to have some wear. They look pretty good, and I'm not asking much, considering they're genuine antiques."

Only a slight exaggeration. You can't get arrested for it.

"Maureen, what do you think?" asks Judy.

"I think two hundred," comes the laconic reply.

I pause for a moment. At that price, I won't be earning much of a return, but the fact is, I'm operating at the bottom of the market. If I don't sell these improved rugs to Maureen and Judy for a couple of hundred dollars, I doubt I'll be able to get more from anyone else.

Besides, working on them has been a fun project. That I was able to take carpets more or less out of a garbage can and sell them for anything at all is a reward in itself.

"Why not?" I say. "We'll call it an introductory offer."

* * *

I meet others in the business, too. Rich Hegazy, who like so many in the business comes from a family of Middle Eastern immigrants and whose father collapsed on a carpet while making a sale and ended his days in a nursing home, swearing at the staff in Arabic. Lawrence Kearney, who dreamed of becoming a poet and even managed to get a book published but instead became the carpet specialist at a prominent auction house. Becky Cohen, who at the age of sixteen developed a flower child's fascination with tribal artifacts and lost her virginity on a mud-covered kilim she had brought to the Woodstock music festival. Scott Dinetz, who traveled through Asia on the proceeds of small-time drug smuggling and came home to deal in textiles rather than narcotics. Like me, each of these new acquaintances is situated somewhere along the path that leads from innocence to experience, from ignorance to expertise. They all encountered carpets at some point and decided to make them a significant part of their lives. Competitors and/or friends, sources and/or customers, I feel kinship in their company, the way I used to feel around wine merchants and oenophiles when I worked as a sommelier. In a sense these individuals are my compatriots, fellow denizens of a small world.

My circle of acquaintance in the rug world is steadily expanding, but all the while I'm meeting people, I keep tabs on Donnie, hoping my Derbent will be repaired and returned. It's never quite ready. The six-month mark grows ever nearer, and there's no sign of my rug, but I make it a point to stay friends. I call Donnie up from time to time, and when the two of us get together, we sit in his van like before, and I listen with good humor to his anecdotes about adolescent forays to topless bars, his complaints about Long Island's property taxes, his disparaging gossip about others in the rug business. On one occasion, parked in a shopping mall behind a big-box discount store, he tells

me a story concerning a Milanese carpet scholar, the author of several fancy monographs and a consultant to major museums.

"I had space in a building on Thirty-First Street a few years ago, and one day over my shoulder I hear people walk in the door speaking Dari, and one of them says: 'Oh, we have to buy this rug.' Now the carpet they're talking about is on the floor in front of me, and it's the strangest thing you ever saw. It's Indian, and it's got a green field like pea soup, and in the middle there's this gigantic elephant that's actually pink and has a girl riding on it all dressed in sequins, like she's maybe in a circus. I mean, a pink elephant, my God, why did I ever buy that? OK, so these people are talking in Dari, which is what they speak in Afghanistan, and for most Iranians it's a foreign language. But the thing is, Dari's not that different from the Farsi spoken in Mashad, and my mother's Mashadi. That means I can understand it a little, and when I hear the guy saying he's got to buy this crazy rug, I don't even look. Instead I shout to someone in the back of my shop: 'Roll up this carpet and wrap it for shipping, it goes out tomorrow morning.' And then I turn around, and who do I see but Alessandro Segre himself, all dressed up in a fancy suit and tie. Italians—even the rug guys dress like they're lawyers. Anyway, he's in New York getting carpets on consignment, because his brother's a dealer and wants to run a fake going-out-of-business sale back in Italy. How Segre knows Dari, I couldn't tell you. He's old enough, maybe he used to do business in Afghanistan, there was a time when lots of people did. Anyway, we start talking in English, and of course I don't let on I have any idea what he was saying earlier. For a while we make polite, and then we get down to business. I give him some items for his brother's bullshit GOB, and at last he asks about the elephant rug. I tell him it's already sold. He tells me it's still in my shop, how much do I want, and I say I promised it to somebody else. He says money is money, how much, and I come up with an astronomical price, because after all I'll be breaking my word. So we go back and forth, and I play hard to get, and in the end I sell him this ugly carpet for eighteen thousand dollars. Can you believe it? It cost me less than two, and even at that I was wondering how on earth I'd get rid of it, but it turned into the best deal I ever made. And you know what, the man left happy."

"Did you ever find out why he bought it?" I ask.

"Yes, I did, and that's the best part. A couple of years later, I'm talking to another Italian, and he tells me. It turns out Alessandro Segre invests some of his money in Bollywood, he's a movie producer, and the reason he's in movies is he likes to make time with the actresses. So he was backing a film where a girl rides an elephant, and he bought the carpet to give to her. Boy, was that lucky for me."

"You think it worked?"

"You mean, did he get the actress? Who knows, but if he did, I hope she was worth it. Eighteen thousand dollars!"

I enjoy hearing Donnie tell his tales, and I think he likes having me as an audience, but the day comes when our conversations come to an end. Six months pass, and there's still no sign of my Derbent. It's time to put the check I'm holding in the bank, and I have to make up my mind whether to tell Donnie beforehand. In the end, I decide not to. I'm pretty sure I've been getting the runaround, and I suspect if tell him, any money that might be in the account will vanish. So I make the deposit unannounced. The check bounces anyway.

"Why didn't you let me know me first?" says Donnie on the phone. "It's your fault, I told you to tell me, so I could make sure it went through."

"Yeah. Well, what happens now? I need my money."

"Forget the money. The rug's coming back."

"You keep saying that, Donnie, but tomorrow never comes."

"What?"

"Look, you keep the rug, and I'll take the cash. Just pay me."

"OK, you were stupid, you didn't do what I said, but I'm going to write you another check, and I'm only going to postdate it a month. Just run it past me before you make the deposit."

The second check would probably have bounced, too, but it's a check I never see, because from now on Donnie is very hard to get in touch with. He agrees to another meeting at a highway rest stop, but this time he doesn't show up. He stops taking my calls, and just like with John Caesar, his cell phone mailbox is always full. At this point, it seems there's nothing to be done except to swallow the theft of

an expensive and unusual rug. I don't even have a worthless piece of paper to hold, and I'm all out of ideas.

Fortunately, though, I know Robyn Del Vecchio, and she knows what to do.

She helps me organize an ambush.

"He shouldn't behave like that," she says when she hears me lamenting my loss. "I told him you were my customer, he should have some respect. All right, I've got a plan. He's bringing me carpets this weekend. I'll call you when he's here, and we'll talk to him together."

Robyn's shop is at the end of a drive that has a hedge on one side and a wall on the other. There's no turnaround, and anyone driving in has to back out. When the weekend comes and Donnie arrives, Robyn calls me and speaks quietly: "He's here, he's just coming inside now, come quick."

I rush to my car and drive fast, and within fifteen minutes I pull in at Robyn's shop and park behind Donnie's van. Until I leave, he can't. He's trapped.

Donnie looks stunned when I walk in the door. He responds mechanically to my cheerful greeting and deliberately nonconfrontational small talk. I hear his wife is expecting again, when is she due? I hear he's moving his business out of Manhattan, how much cheaper is the rent? I hear his mother's been having some medical trouble, how is she getting along? The questions are inconsequential, but they show I have informed myself about him. It's a nice way of saying, "I know where you live." Which I do. Baker Hill Road, zip code 10023. I hear he's enclosing a porch there, does he need a permit?

There are two large carpets opened at Donnie's feet, both of which he had been hoping to sell to Robyn. One is a 1930s Sarouk that is naturally dyed but of no great distinction, and the other is a mid-century Heriz that has a few synthetic dyes but a pleasing appearance nonetheless.

"Donnie," I say after I've gone on for a while, "let's settle up. You owe me five thousand dollars, so I'll take these two carpets and we'll call it even."

He looks at me. He looks at Robyn. He looks at the rugs on the floor.

"Not both," he says finally. "Not both."

I turn to Robyn.

"What do you think I could get for them?" I ask her.

"Retail? The Heriz would go for more. I'd want to sell it for, oh, about forty-five hundred."

Hearing that, I choose the Heriz, and that's where my dealings with Donnie Zahabian conclude. In theory, the combined value of John Caesar's Shirvan and Donnie's Heriz covers much of my expense, but the fact is, I've swapped an exceptional carpet for two average ones, and average ones are much harder to move. Worse, as fashions evolve through the years, the clean and spare look (not to say empty and sterile) achieved by decorating with lacquer furniture and naked floors will become increasingly popular, and the market for unexceptional orientals will decline. Eventually, I'll wind up selling the Heriz to a friend and charge only $2,500 for it.

Nonetheless, thanks mostly to Robyn and in spite of my own foolishness, I've received redress, although no one who knows carpets would like my end of the deal. One man in particular wouldn't. Not long after, crossing over to Long Island to visit my sister, I notice a new rug shop on the North Fork and stop in for a look-see. Sitting at a desk in the back is the owner, a short, stocky man with a seen-it-all face. It's Ryan Whale, gone out on his own again.

"Did you ever get anything out of Donnie and John for that big Caucasian you had?" he wonders after we've caught up a bit.

I describe what I was given as compensation, and he just snorts.

"Someday somebody's going to kill those guys. I'm sorry I got you involved. They're flat-out thieves. Here, take a look at these."

He opens a drawer and pulls out a sheaf of returned checks, riffling through them to show me how many. There are easily fifteen or twenty.

"They're all John Caesar's. I don't even know why I keep trying to cash them, they're never any good."

"So then why do you? I mean, why keep dealing with him?"

"Because you can only do business with whoever is actually in the business. John's a crook, but his shop's in a great location. The number of carpets he turns over in that place is phenomenal, and people can smell the money. It's like trading with China: nobody trusts him, but everybody wants in on the action."

Everybody but me. I'm done trying to sell rugs to John or Donnie, and in the future I'll be much more careful when consigning carpets to anyone. Once bitten, twice shy, as the saying goes, but that's not the end of the story.

A decade later, sitting on a terrace in Italy with my smartphone in hand, I'm scrolling idly through the online catalog for an upcoming auction in the States, and suddenly there it is. A thirteen-foot Caucasian carpet with red and white borders, deeply serrated medallions, and fully extant macrame finishes. The more I look at the photo, the more certain I am. It no longer has a patch in one corner, and there's no muddy brown in it anywhere—evidently it did go away for a facelift—but otherwise it's identical to the rug that was stolen from me in Amagansett. Just to make sure, though, I contact the auction house and inquire whether this Caucasian happens to be single-wefted. It so happens it is. No question, it's the same rug.

The catalog estimate is high, more than $5,000 before premium, but by a stroke of luck the lot doesn't sell, and I make a postauction bid. My offer is accepted, and I end up paying $4,000 in total, which combined with my original cost makes this the most expensive carpet I've ever purchased. Subtract what I got for the commercial Heriz, and it's still a lot of money, but that doesn't mean I'm not happy. It isn't often in the rug business—not often in life—that you get a second chance when you've been a babe in the woods. It's an unexamined life that contains no regrets, and by definition most of them can no longer be helped. (If I had remained in New York City instead of moving away to a small town, would my career as an author have benefited? . . . If I had been tougher mentally and more dedicated to training, could I have achieved something more as an athlete? . . . If I had been less self-absorbed in my youth, might I have stayed on better terms with ex-lovers and former friends?) Here, though, was

an instance in which the past could be repaired, a bad decision that could still be reversed. During the ten years in which I thought the rug was lost, it grew ever more desirable in hindsight, and I realized that part of my mistake was putting it up for consignment in the first place. The old Derbent kelleh is the only carpet I've ever bought twice, and I'm not about to buy it a third time. It's lying in front of me as I write these words. This time I aim to hold on to it.

The Old Derbent Kelleh, detail of the reverse

SIX

Kayseri *Pazarlik*

The Anatolian Prayer Kilim

Donnie Zahabian was right about one thing: I've never turned a profit during my twenty-odd years of dabbling in the rug business. During that time, the overall market for oriental carpets has declined, so that even if I sold all the carpets I've lovingly collected, I doubt I'd break even. But my amateur dealing has saved me lots of money in other ways, because it taught me how to negotiate, and not just when buying cars or real estate. I've bargained when hiring a lawyer. ("How about a fixed price if you win and less if you lose?" *"I'm not used to having discussions like this with my clients."* "You've led a sheltered life.") When renting a room in a B & B. ("Why don't you give me the full suite at the single-room price?" *"But it's not a single room."* "It still needs a guest." "Well . . . all right . . . *my mother would be proud of you, sir.*") Even when paying for a funeral. ("That's only one parent, so why don't we agree on the cost for the next one now?" *"You want a two-person discount on caskets?"* "Unless you can promise me no one else dies.")

 Buying and selling carpets, I've learned just how much in day-to-day living is negotiable. The new world of online sales has obscured that fact—although the use of price-alert apps effectively means your software negotiates for you—but bargaining remains a useful skill. What follows is a step-by-step account of how one bargain was struck.

* * *

As I clutch the scarred banister to carry my burden up to Dave Blumenthal's Kilim Store in downtown Hartford, I think the stairwell doesn't look any better than it did before. It's still unswept, and the

treads are still patched with unpainted plywood. I discovered the place by accident a year ago, when some flatweaves draped over a table set out on the sidewalk caught my eye. Wondering momentarily why somebody would leave merchandise unattended on the city streets, I stopped to investigate and soon saw that the stuff on display was not good enough to constitute much of a risk. All the same, the medieval approach to signage had done its job: I noticed the name on the nearby door and made my way inside.

The shopkeeper I discovered turned out to be congenial, someone as interested as I am in both old textiles and bygone events. Dave Blumenthal is a rumpled man in his mid-sixties, an academic often dressed in a wool tie and a corduroy jacket. Part-time professor of Near Eastern history, he speaks Turkish fluently and both deals in and collects Turkish flatweaves.

The Kilim Store is situated on the second story of a tired building that is way overdue for renovation. The shop is a single dusty room with grimy windows, and Dave rents it on a month-to-month basis. He's been renting month-to-month for years, however, and by now the premises are a crammed chaos. There are folded flatweaves stacked along two walls, folded carpets stacked along another, rolled rugs standing in the corners, rugs heaped on the room's one metal chair, rugs overlapping one another on the floor, cushions and trappings and bags tossed about every which way. The only furniture besides the chair is a cheap pine desk with a cluttered surface from which papers spill to lie scattered on the dull linoleum floor amid balls of twine, spools of wire, plastic tags, shipping labels, pencil stubs and inkless pens, empty coffee cups and stained paper napkins, torn envelopes and forgotten letters, battered books, dog-eared photos, and a snarl of bungee cord in various lengths, which last Dave uses to tie up articles for transport.

I liked the shop the moment I saw it, and I liked the shopkeeper, but the merchandise on offer was a mixed bag. Dave is most interested in old kilims, but what he mostly sells are brand-new piled rugs made either in Afghanistan or in the surrounding regions to which thousands of displaced Afghans have fled. He also offers recent pieces from China that look almost identical to the blue-and-

white Peking carpets of eighty years ago, but which cost only a few hundred dollars. (You have to look at the back to tell the difference: new Pekings are double-warped, whereas the old ones have no warp depression at all.)* None of these contemporary rugs does anything for me; and yet in with all the new material in Dave's shop there are a few genuine antiques, and that's why I have come back.

Having explored the shop before, I know what I'm after today. Unless Dave has sold it since my last visit, among the stacked flatweaves will be an old prayer kilim dyed in brilliant hues of leaf green and brick red and several medium shades of blue. The kilim I'm after has a charming and unusual design: horizontal wavy lines in the main field, yielding to two large diamonds in succession that indicate the rug's directional orientation before arriving in turn at a pair of vigorous white kochaks, the so-called ram's horn motif traditional to the prayer rugs of Turkic nomads. On either side of the diamonds are roughly drawn hands, crude red fingers outlined against the blue and green ground. The little kilim is made with very heavy wool, and its dark brown warps are plaited into flat braids that finish each end. It is high-quality work and is highly unusual, a piece of folk art crafted with gusto and skill, and I'm already in love with it. I hope to buy it, but of course I don't ask about the object of my affection immediately. I ask about everything else.

I'm looking to buy, but I'm also looking to trade. In a previous conversation, Dave told me that one reason he collects flatweaves is that they are still affordable, whereas he never sees piled weavings in his price range that are truly antique. (Needing less time and material to make than knotted carpets and arguably requiring less technique, textiles constructed of warps and wefts alone—such as Turkish kilims—were for a long time undervalued. They were so little thought of that in decades past, before plastic became available, stacks of carpets would be shipped from the Middle East wrapped in old kilims for protection. Those days are gone, and the best antique flatweaves are now museum pieces, but even so they will generally be less expensive

* For an explanation of warp depression, see the glossary.

than piled carpets of equivalent age and quality.) Remembering what Dave had said, I've brought a couple of carpets with me that I think he might go for: a 1930s Persian prayer rug from Kashan with some obvious repairs and a small turn-of-the-twentieth-century Kirman showing a lot of cochineal purple. I've also brought a large 1920s flatweave that is possibly Shahsavan and has some losses along both sides, but which I figure ought to appeal to the owner of the Kilim Store. The Kirman rug is naturally dyed, whereas the other two pieces have a mixture of organic and synthetic colors, but all the pieces are attractive. Even so, I've owned all three for a couple of years without being able to move them, and none of them is really my type.

I reintroduce myself and dump my burden on the floor.

"The problem with this business," I say, "is the schlepping."

"Ah, the man with the olive oil. How's that business?"

I don't always tell people I'm a writer, much less a poet. Doing so can confuse the situation and create an atmosphere of unease. Instead, I often tell people I meet in the rug business about the little company Spencer and I have that imports olive oil from a farm outside of Florence. It piques interest and promotes conversation. So Dave and I talk olives and agriculture and Italy, and then we move on to his specialty and talk history. Dave passes the time between customers as most academics would, in reading. At the moment he's in the middle of a one-volume history of genocide, and he's enthusiastic about the book.

"If you like that sort of thing, it's really very good."

"If I like genocide?" I say. "You bet."

"It's actually quite interesting. Reading history is like watching Greek tragedy: the events described are horrible, but the audience is somehow uplifted in the telling. This book starts with the genocides of classical times and goes on to later exterminations like the African slave trade. It's very well done. I recommend it."

He's taken the bit about Greek tragedy from Aristotle, but I don't say as much. Nobody likes a know-it-all.

"So tell me," he asks after a few minutes, "what do we have here?"

I've left the rugs I brought along unopened on the floor while we

were talking history. I haven't even mentioned them. It's worked. Dave is intrigued.

"You said you didn't own any good piled rugs because they were too expensive, so I brought you a couple to look at."

I roll out the Kashan, and Dave likes it right off.

"Oh, that's pretty. What is it?"

Describing the rug matter-of-factly, I do my best to seem merely informative rather than promotional. I show Dave how finely the rug is woven—over three hundred knots to the square inch—and I show him how delicate the thin cotton warps are. I detail what elements in the flower-filled design make this prayer rug a classic Kashan, and I turn the rug over to expose the light-blue wefts that are typical of that town. I indicate where prior to reselvedging the edges had rolled under, as happens often with Kashan rugs due to the tightness of the weave, and I also point out a couple of cobbled repairs, small holes that were patched rather than rewoven. My strategy in selling a rug is to confess any drawbacks right off the bat. It builds trust, and it means that by the time one gets to negotiating price, the failings of the rug—and any truly antique rug likely has failings—will already have been accounted for.

What I don't mention is that the rug has been tinted. I found it filthy in the back room of an antiques store, and when I washed it, it turned out to have a case of the measles. That is, the warps had been spliced in many places, and lots of the cotton knot heads were visible on the surface, a defect resulting in a scattering of bright dots that spoiled the rug's complexion. So I paid a repairman in Long Island City fifty bucks to have the knot heads dyed. I hoped they were dyed with indelible ink, but *caveat emptor*.

I roll open the Kirman, too, and I unfold the Shahsavan kilim. Dave doesn't much like the Kirman—its profusion of insect-dye purple looks garish to him, an assessment I can't disagree with—and he says little about the kilim other than to ask if it comes from southern Iran. It doesn't, but I compliment him before correcting him.

"You're right, that border would be typical of the kilims made around Shiraz; but this one is northwest Persian, I think maybe

Shahsavan." I talk up an unusual feature: the kilim's green stripes were obtained by juxtaposing blue and yellow strands of wool. The eye combines the two hues to yield a composite color, even though the piece doesn't contain any actual green at all. Dave doesn't appear particularly interested, though, and we move on to other things.

He shows me a stack of three-by-five "Baluch" pieces in mixed flatweave and pile, probably Baluch in name only and woven in some godforsaken (or God-afflicted) refugee camp in Pakistan. He sells them for $250 apiece, and I figure they cost him no more than $50. Then he opens a couple of larger carpets for me, dark red and blue rugs that have generic Turkmen designs and have been treated with wax or some sort of chemical to make them shine with an insistent luster. They look reasonably well constructed. In whatever miserable circumstances, somebody somewhere still has enough skill to produce a well-made rug.

"Aren't these wonderful," he says. "Feel the wool. I think they're great, and they aren't expensive."

I don't respond with much excitement. About the most to be said for the faux Turkmens is that they don't cost much more than the carpets for sale at Home Depot, and yet they are made by hand, articles of individual craft rather than the mechanical output of mass production. They are good buys for the average consumer, but they aren't of interest to a collector.

"Do you have anything old and collectible?" I ask.

I know that he does, but I let him turn up the piece I want on his own. Before he comes across it, he shows me other rugs. First is a Central Anatolian flatweave that is obviously antique but is not very appealing. Its colors are perhaps vegetal—even natural dyes can look bad, particularly if they were poorly applied—but the piece is greatly faded, so that the overall effect is of a wan khaki. I express polite uninterest, and we move on.

We turn to another piece, clearly very old and of very high quality. It has a great variety of strong and glowing vegetal dyes, and it is large for a prayer kilim.

"Isn't that fantastic?" says Dave. "That's a Bayburt. It's an old, old rug. A lot of people have tried to buy that one from me."

"So why didn't you sell it to them? That's your business."

He laughs.

"The price," he says. "It's expensive, and it's too good to let it go cheaply."

So now he's warned me: I'm not to expect any bargains.

He asks me if I wish to look at some larger kilims, the sort that are often eleven or twelve feet long and made of two strips sewn together. I decline. Such pieces, usually assigned to the Konya area if they are genuinely antique, are among the most expensive Turkish kilims. They are too big to be conveniently collected, by me at any rate, and even at auction they would be outside my price range. Sold at retail, a good one will go for $10,000 or more, and that's more than I'm ready to spend. I don't aim to pay Dave retail for anything, but I don't need to waste our time. The negotiations will take a couple of hours as it is.

Dave goes back to the stack of prayer rugs, and suddenly there it is. The little kilim with its wavy design still looks good to me. It moves me both intellectually and emotionally, the way truly exceptional pieces occasionally do, communicating bravura and dedication, improvisation and joy. I can feel the strong character of the weaver speaking across great gulfs of cultural difference and elapsed time. Gazing at the kilim, I'm suddenly reminded of a wine I drank once with Spencer and seven or eight of our friends. We had pooled together to buy a bottle of Rhône at auction that had been vinified in 1832, and as I tasted the small sample in my glass (it was dark amber with a mahogany core and had a nose like a damp autumn day) I realized that the person who made it had quite likely been born under the *ancien régime*. What we have of the past is usually no more than a faint trace of life as it was lived, but there are moments when ancient days seem to come fully alive and you feel you are shaking hands with history. A bottle of old wine can do that for you. An antique kilim can do that, too.

While I look the piece over with a deadpan expression, Dave sells me on it a little, telling me how unusual the design is, saying that he bought it in Ankara and thinks it comes from that area, but that none of the Turkish dealers he has shown it to can say for sure where it

was made. His efforts are unnecessary, though of course he doesn't know that. This is a kilim I want.

It's time to get started.

"So how much for the Bayburt," I ask as casually as I can manage.

"Eighty-five hundred."

"Well," I say, smiling, "it looks nice in your shop. I guess it will stay here."

"It's too good to just give it away," says Dave, warning me again.

"Uh-huh. Well, then, how much for this one?"

I point with my toe at the item I want, lying open at my feet.

"Thirty-five hundred."

"I've been to your shop three times, and every time the price is different. Last time it was four thousand, the time before that it was twenty-five hundred—"

"No, it . . . wait, you've only been here once before."

"This is my third time, Dave. The price keeps changing. Maybe I should come back and see if it changes again."

"Thirty-five hundred."

But he doesn't deny that the price has been changeable, and he doesn't absolutely deny the possibility of $2,500. The truth is, I don't remember if the asking price was really that low previously. But Dave isn't denying the possibility.

"Dave, come on, you're in the business, haven't you seen what's been happening to prices recently? With the economy the way it is, everything's coming down. I'm serious. Just look at the kilims here."

I've come armed with a recent auction catalog, knowing that the kilims in the sale fetched relatively modest prices.

"This was a first-class auction, and none of these pieces is new, they all have natural dyes. Here, look at this one. Twenty-two hundred. And that's an old rug. And it's bigger than yours."

"It's not as good," answers Dave reflexively. But he's curious about the catalog, taking it from me and paging through it.

"Well, then, what about this," I say, showing him some photos I've brought along, too. "Take a guess what this one cost me."

The photos are of a mid-twentieth-century Turkish kilim I pur-

chased in an estate sale. I didn't bring the piece itself because I didn't want to be tempted to include it in a trade.

"Erzurum," says Dave. "About sixty years old, maybe more. I don't know, how much?"

"Three seventy-five." It had actually cost me $445, but close enough.

"A *metsieh*. You know what a *metsieh* is? That's Yiddish for a bargain. You did well."

I'm familiar with the word, but I don't say anything. I just wait.

"OK," he says. "You've beaten me down. So make me an offer."

"What I was thinking was to make a trade."

"No." Flat and immediate. "I need money here. My wife was an investment banker, and she's just been laid off. A lifetime as a poorly paid scholar, and now I face the indignity of being the only breadwinner in the family. Anyway, I have to make money, I can't do a trade."

It's the winter of 2009, and the world's economy is falling apart. Bankers all over are out of their jobs, and prices in many sectors have collapsed. In the rug world, business has ground to a halt. Nothing's moving. People don't have the money they had only recently, and they aren't making inessential purchases. That includes antique textiles, of course. You can't eat an oriental rug.

The economic collapse represents an opportunity of sorts, at least for those who still have some cash. In theory, one ought to be able to build a substantial collection in such times, a modest version of the great museum holdings that were assembled during the Great Depression. But just like other people, I have seen my savings halved over the past few months, and the decline in rug prices is causing me problems. I've been operating on a profit margin of only 10 or 15 percent, because I buy at small auctions rather than from widows and orphans, and because I sell to dealers rather than to retail customers. A small margin of profit is fine if prices are strong and one's object is only to dabble. But when prices fall radically, they fall below my cost. A dealer who marks his stock up 100 percent or more can afford to sell at a steep discount. I can't, and that is another reason I am anxious to trade, even though what Dave wants is money.

"No, listen," I say quickly, holding up my hand. "My idea is that I give you some cash, or I give you a check, or I give you both, plus I give you a collectible rug, and I give you an old flatweave too. That way, after you sell this piece to me, you still have something you can use to get money from somebody else who comes through your door."

I say it all in a rush, offering him everything, because I don't want the notion of a trade to die before it gets born. Once a trade becomes established as part of the deal, we can squabble over the details.

"So what are we talking about, the rugs, and how much?"

I pause to think. The rule of thumb in bargaining—assuming a dealer is reasonable and his prices are fair—is to expect to pay between half and two-thirds of the asking price, but things aren't so cut-and-dried here. Too low an initial number, and the trade never gets off the ground. Too high, of course, and I don't leave myself room to raise my offer in the bargaining that will ensue.

"How about the Shahsavan, the Kashan, and five hundred dollars."

"No, it has to be more. I mean, how much did that Kashan cost you?"

We both know I won't tell him that.

"No," he says again, "this kilim's special. There was a dancer from Pilobolus who tried to buy this one from me a couple of times."

"So why didn't you sell it?"

"The price!" he says, laughing like before.

"I've never seen Pilobolus," I say, deliberately digressing. "They're that group of acrobat dancers, right? I sometimes feel sorry for dancers. They get to have those beautiful bodies, but then they grow too old for their art while they're still middle-aged."

"I'm a rug salesman," says Dave. "I can't afford to feel sorry for anybody."

"Not even me, huh?"

"Especially not you. So what's your offer?"

"I already made an offer."

"But I can't accept it."

"But you said I beat you down."

"Yes, but . . . OK, you're right, you made an offer, I should be making a counteroffer."

There's money involved, but the negotiation is also a ritual that

has its form to be observed, the way a tennis game involves competition but nonetheless has an etiquette. Our bargaining is a sort of scripted performance, one in which Dave and I, neither having been brought up in a Turkish bazaar, are playing our parts in imitation rather than by instinct.

"All right, then," he decides, "the Shahsavan, the Kashan, and twelve hundred. Oh, but we should be having tea, shouldn't we? Do you want any tea? How about coffee? I'll go get it."

"I don't like to drink caffeine after lunch. If I do, I don't sleep at night."

"Then how about herbal tea? Or decaf, how about decaf? The place is right downstairs."

I don't really want anything to drink, but I can see that Dave is eager to bring me something. Again, it's part of the ritual. I don't want to disappoint him, so I ask for hot chocolate. Chocolate contains some caffeine, of course, but it's still early in the afternoon, and I don't much care for herbal tea.

"You want me to come with you?"

I'm not sure if he's comfortable leaving me alone in his shop.

"No, no, stay here. Enjoy yourself. If anybody comes in, sell them a rug. You're the only person I'd trust to get the right price."

It's obvious flattery, but a good flourish and a good move on his part. After all, even when people know they're being flattered, they still like it.

Dave is gone for a while. In his absence, I explore the various stacks of rugs and discover that I've already been shown the most interesting pieces. I glance at Dave's desk, but there's no point in searching it. If there was anything to find, say some information on the kilim I'm trying to buy, Dave wouldn't have left me alone. I spend a few moments looking out the dirty windows into the bright afternoon sun of mid-March. On the sidewalk below, spring comes to Maple Avenue: panhandlers still bundled in parkas try to intercept college students clad now in little more than T-shirts and shorts.

Eventually I clear off the one chair and sit down with my own information, the notebook I keep with records of transactions and my inventory of rugs and costs.

I find that the possibly Shahsavan kilim was purchased at a small auction and cost me only $395, but I've spent another $100 getting it washed and treated against moths. I had left it in an antiques store for several months on consignment, and after I picked it up I discovered the gauzy white traces of moth eggs on it. Like any collector of woolen textiles, I'm terrified by the prospect of an insect infestation, which is why I sent the dangerous item out to be cleaned rather than bringing it into my own home to cope with it myself. Altogether then, I have about $500 in the flatweave.

The Kashan prayer rug I bought for $1,000, but I've spent a further $500 getting it patched and reselvedged, plus the $50 for tinting the exposed knot heads. That means I now have too much money in it for it to be attractive to dealers, which is why I'm reduced to trading rather than selling. I add it all up, and I see I have offered Dave over $2,500 in rugs and cash. It's already more than I wanted to spend.

"I'm sorry, they were closed downstairs; I had to go a couple of blocks."

"It must be hell," I say, "working in a bazaar where the tea stalls keep irregular hours."

"Oh, it is," says Dave without missing a beat. "Not only that, I keep clapping my hands for my helper, and he never appears. Any self-respecting rug shop should have an assistant. If it weren't for rug shops, the unemployment rate in the Middle East would be through the roof."

"Have you spent much time over there?" I ask as we settle down to drink our beverages.

"I used to go to Turkey every couple of years, but I don't recommend it now. Turkey is going through what you might call a difficult period. Americans aren't especially welcome."

"But I know lots of people who have visited Turkey. Iran, too. If you worry too much about the politics, you'll wind up not going anywhere."

"True," says Dave. "So where are we on the kilim?"

Back to business.

"You said the Shahsavan, the Kashan, and a thousand dollars, but I—"

"No, I didn't."

"But I don't want to pay that much. If you need more cash, I could do the Kashan by itself and a thousand."

I stand up and start to fold the Shahsavan flatweave, thereby removing it from the deal.

"The problem with your Shahsavan is that customers don't see the difference between it and one of these. And these only cost a couple of hundred dollars."

He shows me a new kilim, probably Egyptian, that is woven with a Persian design and has been left in the sun to bleach. New kilims by the thousands get their colors softened by lying out in the vast fields of "rug farms" in Egypt and Turkey. A few months of intense sunlight will produce a simulacrum of antique patina, though an examination of the interior of the weave will reveal the harsh original hues.

"Well, if you can't use this, I understand." I continue folding. "That's the problem with flatweaves in general. They're too easy to imitate, and it ruins the market. But you can't expect me to sell you an old kilim for the price of a new one. I couldn't do that."

"No, I'm just saying. . . . Look, I have to figure out what this deal is worth to me. If I wanted to sell that Kashan in my shop, how much could I ask?"

He wants me to tell him what he doesn't know, and in a way I will. But knowledge is expensive.

"Dave, it's a much better piece than you think. This is the kind of rug that Iranian rug dealers really value. If it had full pile and all organic dyes and didn't have the patches, you'd be talking five or six thousand dollars at auction. Retail, even more."

And if it were in perfect condition and truly antique—thirty years older, say—maybe it would go for that much. As it is, I'm allowing myself a little license. This piece would probably sell for around $2,500 retail.

"OK, but it's not that rug, so what is it?"

"So less. Look, make the deal and then have this rug appraised. You'll thank me."

"You know, you and I ought to take a trip to Turkey together. I could unleash you in the souk."

"I thought you said not to go there now."

"Oh, I don't practice what I preach. OK, so if I agree to a thousand, then the difference between us comes down to this Shahsavan kilim, right? Now we're beginning to get somewhere."

He reopens the kilim I've just folded up, thereby putting it back in the deal. If he's willing to come down to $1,000 to get it back in play, that means he likes it. I now realize he's wanted it all along. He's been disguising his objects, the way I have, though he's done a better job of it so far. The seller, of course, has a built-in advantage in this regard, because the buyer must indicate at least some interest in a piece simply to initiate a transaction. Now, however, Dave has made his interest plain, and it's my turn to play hard to get.

"Look what you've got your antique kilims marked at here in the shop. Why shouldn't you give me half of that, or even a third? You know, Dave, you ought get this kilim from me while you can. It's not like you can go out and order one from a catalog."

"No, but I can call up some Armenians in Manhattan and get twenty of them up here tomorrow."

"Not this nice," I say. It's my turn to answer reflexively. "Feel how heavy this one is—it's got so much wool in it—and I told you the green stripe construction is unusual. Anyway, with the cash and the Kashan, I'm giving it to you cheap. It's practically free, and you know it."

"All right," says Dave. He stands up and takes a step toward me. "Let's say seven fifty and the Shahsavan included."

My first instinct is to haggle further, to counter with $600, $650, but I stop myself. The bottom line is, I'll have to give Dave some raise on my first offer, or the trade will never come to pass. Sheer pride would see to that.

I step forward myself and extend my hand.

"OK, it's a deal."

And we shake.

Dave sits down again, crossing his legs and leaning back on one elbow, sinking into the almost postcoital mood that can follow the consummation of a successful sale.

"So what do you do besides olive oil and rugs? That can't be everything."

"I read," I say, so as not to say "write." "My problem now is that I've got the house so full of books I can't use them. When you run out of shelf space and start stacking books in the corners, that's the end. You can never put your hands on the one you want."

"You're like my wife, she has box after box of books she'll never touch again. Over five thousand of them."

"What kind of books?"

"Cookbooks. A dealer told us once that my wife has one of the largest collections of cookbooks in the United States. My hoarding instinct is nothing next to hers."

I'm momentarily speechless. I do a little cooking myself, but cookbooks don't do much for me. Then again, my own mania for rugs must surely leave most people unmoved. Other people's passions for collecting are like other people's religions, absurd to those who lack the faith. And as with any faith, logic is not what drives the devotion. Collecting is its own form of irrational behavior, but the impulse to accumulate—the collecting gene—is very common. It's almost part of the *Homo sapiens* genome. Like pack rats and magpies, humans are gatherers, and one could argue that even monks in their asceticism are proof of this, since one of the natural urges they seek to suppress is the instinct to acquire. People who respond to this innate urge will collect almost anything: stamps, coins, paintings, jewelry, books, china, glassware, furniture, old cars, old clothing, vintage this and antique that . . . I read recently about a man who collects the empty crack vials he finds on city sidewalks! We are so given to gathering that we will even hoard objects of no value whatsoever, like out-of-date newspapers or empty bottles or useless bits of string. Finders, keepers, is the rule. We don't like to let things go.

"Your wife has five thousand cookbooks?" I say when I find my tongue. "So what sort of food does she like to cook?"

"Desserts," says Dave. "And the hell of it is, I'm a diabetic."

No sugar in his tea for Dave. I think how human affairs seem to have the habit of irony, how just as our private obsessions will often

leave those closest to us cold, so too our talents and generosities are often inaccessible to those we love. I'm lucky in this regard, because Spencer and I have continued to meet each other halfway through many years of marriage, and we make a point of being sympathetic to one another's interests. (What she loves most are animals, domestic and wild. Our home in Chester backs up against deep woods, and she spends time every day observing the habits of the many creatures that live there.) And, of course, well-made art exerts its own influence. Spencer would never have become a rug collector on her own, but the presence of fine carpets in our home is gradually transforming her into an appreciator of sorts, almost by osmosis. Rugs are my mania, not hers, but she is not immune to their beauty.

Dave starts to fold up what has become his possibly Shahsavan kilim, and now he discovers the losses along the sides. (This in itself is proof that he does not depend on his rug business for his primary income. A fully professional dealer would have noticed any "issues" right off.) He starts to say something and then just shrugs. A deal is a deal, and it's done.

For any but the most expert eye, it's par for the course to make such discoveries after a purchase. For better and for worse, oriental rugs reveal themselves slowly. And in fact, when I get home, I too will discover an "issue" with the kilim I've purchased. I can't figure out why, but a small spot, about an inch square, seems to have been painted white. The spot is too small for such treatment to constitute a crude repair—besides, the white in such weavings is made of un-dyed wool, and thus it is not a color that fades or corrodes—and if there were an inorganic dye present, surely it would not be confined to so small an area. It's an apparent defect in the piece that I had not seen initially and will not immediately understand. Then, when I take the kilim to show off to other acquaintances in the business, I learn something. I'm told that sometimes precious metals were brocaded into prayer rugs that were intended to be especially fine. In this case, the apparently painted spot lies at the center of the rug, at the apex of the large triangles, and it indicates where a worshipper ought to place his forehead in obeisance. The kilim isn't painted at all. Instead, it has been ornamented with yarn wrapped in silver foil,

and the tarnish of many years has given the metal a white and powdery look.

Such close examination will come later, though. Right now, it's time to make off with my trophy.

I stand up, and I notice I'm slightly dizzy and a bit flushed.

"It must have been hard bargaining," I say. "I think I'm sweating."

"Kayseri *pazarlik*," responds Dave with satisfaction and some self-amusement. "That's the most difficult kind. That's what Turkish rug dealers call a really knock-down, drag-out negotiation."

The merchants in Kayseri, in central Turkey, have a reputation for canny trade practice, and their bargaining (*pazarlik*) is proverbially tough. The bazaar in Kayseri is the setting for countless Turkish jokes and tall tales about greed and sharp dealing. Trade with a merchant from Kayseri, the saying goes, and you'll be lucky to walk away with the skin you arrived in.

In fact, each of us has done reasonably well in the transaction. I've spent more than I had envisioned—the little kilim I've just purchased has cost me $2,795 in total—but most of my cost has already been absorbed several years ago, and I've put rugs I don't want to good use. I've used mediocre pieces to obtain something truly special, and my out-of-pocket is only $750. And in terms of bargaining, Dave moved farther from his starting position than I did, so I can't complain.

"Ooh, look how good that is," says Dave as I pause before departure to admire my purchase. "I've got seller's remorse already."

But Dave has done well in the transaction, too.

"Hey, you got a rug worth two or three thousand retail, you got a really unusual old flatweave you'll tag at another thousand at least, and you got seven fifty on top of that. All for a piece you know very well you would have sold for twenty-five hundred in cash. Be happy."

He smiles a little and doesn't deny it.

"A good trade helps both people," is all he answers.

He's right. Too many people in the rug business think they have to win every trade. But one-sided deals are not easy to make, and when they do take place, they only poison the well. The kind of transaction

that leads to repeat business and an economically productive relationship occurs when each participant is willing to take the interests of the other into account. Dave and I are likely to do business again (in fact, within a couple of weeks he asks me to bring him some old pile weavings, since he doesn't have any in stock), and we wouldn't if one of us felt cheated.

Kayseri *pazarlik*. Hard bargaining. There is real pleasure in the back-and-forth of the deal, in the ritual of competition, in skillfully returning serve, as it were. Because like a tennis match, bargaining bazaar-style is a social occasion. And as with tennis, one wants a capable opponent to raise one's game. In my amateur way, I am beginning to understand why the grizzled Middle Eastern merchant weeps at the death of an old woman with whom he has exchanged nothing but practiced imprecations and pretended outrage for forty years.

Kayseri *pazarlik*. Sharp dealing. Of course, our little session hasn't really been anything of the kind. It's been too friendly for that, too straightforward. Neither one of us has been deliberately underhanded or strayed too far from the truth. Neither of us has judged the other purely in terms of weakness to be exploited, opportunity to be seized. And we haven't been sufficiently money-hungry, either, financially desperate, or instinctively a cheat. Neither has been ruthless. Neither has been ready to steal.

Kayseri *pazarlik*. You don't have to go to Kayseri to find it.

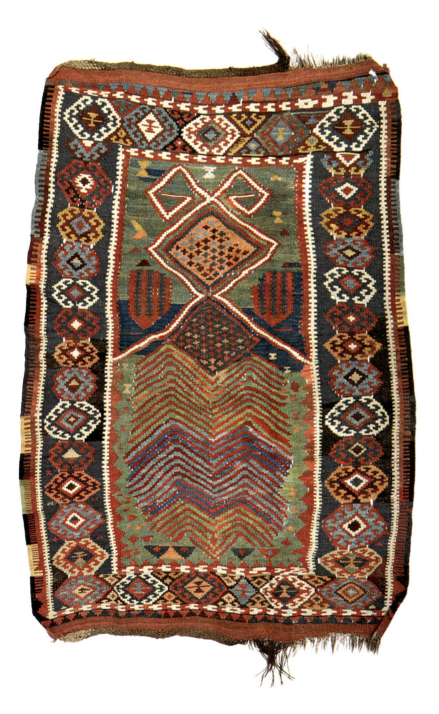

The Anatolian Prayer Kilim, 3 ft. 6 in. x 5 ft. 4 in.

SEVEN

The God That Was Stolen from Me

The Flawed Khamseh

I'm in Becky Cohen's antique shop on the Connecticut shoreline talking about whisky and dogs when a little man with a big nose and large belly walks in. Becky is a highly educated and persistently lonely woman, no longer young, and the hardened exterior she shows to customers asking for discounts and landlords asking for rent yields upon acquaintance to a girlish manner and an almost desperate wish to make friends. She would like to cut down on her time spent drinking single malt by herself, but her closest companion is an enormous Airedale called Swinburne. Becky specializes in rare books and names all her pets for English authors.

The man who walks in is quiet and unassuming, but Becky rushes to greet him as he comes through the door and throws her arms around him.

"Bennie!" she exclaims, bending down to give him a hug. "Where have you been? It's been weeks. Here, there's someone you should meet. Bennie, this is George."

Bennie has thick glasses, and he peers through them to look me over.

"Ben Behzadi. Pleased to meet you."

It's an Iranian name, and as with many Iranians, the man has a dignified and somewhat formal manner. He speaks with a slight accent, though the intonation is unplaceable. It doesn't sound Iranian, it doesn't even sound foreign. It just sounds like he's from somewhere else, and it would sound like that wherever he went.

"Nice to meet you, too," I say. "Becky tells me some of these carpets are yours."

"Yes."

"How about that one?" I ask about a rug that has caught my eye.

"Yes, that's mine. Are you interested?"

"I don't know, what is it?"

"It's a Persian carpet. From Mashad."

Now I am interested, or in any case curious. Mashad is a city in eastern Iran that is famous both for its Imam Reza shrine—an enormous mosque that is the site of religious pilgrimage—and as the home of Ferdowsi, the author of Iran's national epic, *Shahnameh*. (Scenes from this poem are often pictured in Persian carpets, and quotations from it are sometimes seen in woven inscriptions.) A caravan stop along the Silk Road and a significant population center since ancient times, the city has long been a center for textile production, and it remains a major source of Persian carpets today.

A major source, but not one I know much about. Most of the nineteenth- and twentieth-century carpets that come from Mashad are room size, dark in tone, and crowded in design, and they've never appealed to me. Ben's rug is smaller, though—it's throw-rug size—and it isn't dark at all. It's thin and worn, and I don't wish to buy it, but here is an opportunity to learn. If its size and palette are anomalous, how can it be identified?

"Is it on cotton or wool?" I inquire, kneeling down to examine the little rug more closely.

"It's a wool rug," Ben answers patiently.

"I know that," I say, almost snapping at him. "I'm talking about the foundation. Are the wefts wool or cotton?"

"Oh," he says. "I'm not sure, George. What do you think?"

"I think it's on cotton, but maybe not. Why don't we light it on fire and find out?"

"You want to burn Bennie's carpet?" exclaims Becky incredulously.

"Just a little piece of it. Look, here's a place where the wefts are coming loose. We'll cut off a tiny bit."

As I go on to explain, wool, cotton, and silk, as well as the synthetics that sometimes masquerade as silk, all react differently when subjected to flame. They can be distinguished either by odor or by the appearance of the ash. Burnt wool smells like burning hair, which

after all is what it is. Burnt cotton smells like charred paper. Burnt silk has little odor, but it leaves an ash like a cigarette, whereas nylon and rayon shrivel up like burnt plastic.

To Becky's amusement and with Ben's forbearance, we run the experiment, using Ben's BIC lighter to set a snipped strand on fire and drop it into the elephant-hoof ashtray that sits on Becky's desk. The results are inconclusive.

"Well, I guess it doesn't smell like hair," I say. "It's probably cotton. Maybe we should burn some more and make sure."

"That's OK, George, we don't need to. I know it's Mashadi, that's what matters."

"How can you tell?"

"It's got a tight weave, and the medallion's almost round. Mashadi can look like Kashani, but Kashans have longer medallions. The pendants are different, too."

"Different how?"

"Kashan ones are sort of more pointy."

"Huh. Well, if this is a Mashad, it's definitely on cotton."

"If you say so."

"That's what the books say, anyway."

"I wouldn't know, George, I wouldn't know. You tell me."

And so begins our friendship, a rapport built on instinctive affinity and mutual usefulness. I have book knowledge, or at least I am gaining it, and Ben has hands-on experience. "I've done everything," he will tell me later, on one of the many afternoons we spend together. "I've been a picker, I've sold rugs door to door, I've sold them on commission in department stores, I've worked in carpet warehouses, I've run GOBs, roadside sales, everything." I haven't done any of that, but I have accumulated dozens of oriental carpet books, a personal reference library. If it's true that book learning won't help you any more with carpet appreciation than it will with language fluency, still it won't help you any less. It provides a foundation. A thorough reading of the most reliable scholarship enables a carpet enthusiast to adopt a disciplined approach to identification and dismiss fanciful assertions regarding age, provenance,

and iconography. For example, if one knows from manufacturing records that chrome dyes were not introduced to central Iran until the 1920s, then a Kashan containing them cannot have been made earlier, no matter what the seller might say. If nineteenth-century photographs exist to prove the case, then Shahsavan nomads did in fact travel with piled rugs, regardless of their inconvenient bulk as compared to flatweaves. If what many dealers call a mahi motif (*mahi* is Farsi for "fish") closely resembles the serrated foliage often seen on antique Middle Eastern ceramics, then except on rare occasions and in spite of its name, it was probably intended to represent not fish but leaves.

The carpet literature can be quite helpful, but it can also be quite expensive, because print runs are small and because the volumes typically contain lots of illustrations on thick paper. (Having plenty of photos with which to compare items purchased or considered is another reason to own rug books.) Even used, some of them go for hundreds of dollars, and it has taken me many hours of hunting online to find affordable copies in reasonable condition. Assembling a carpet library has become an object in itself, another outlet for my collecting instinct. When I turn a small profit on a rug, I'll often put it into a book, and I've asked my family to consider giving me desired titles for Christmas and birthdays. The birthdays go by, and I now own many dozens of carpet books, just as I do many dozens of rugs. Ben doesn't have the inclination or the money to spend hours searching for books online. Moreover, he doesn't read English easily, and so whatever assistance scholarship has to offer is beyond his reach. Or it was until he met me.

We find we are useful to one another, and we discover we like each other, too. Ben proves to be a contemplative man whose politeness has room for a sly sense of humor. ("Do you think that's a fair price for mercerized cotton?" I wonder one day about a faux silk carpet we are trying to sell. "That's your department, George," he says, "but it's what we should ask.") At first we meet in Becky's shop, where the three of us pass hours in conversation and join forces to help her make a sale when the occasional customer turns up. Becky is happy for the company, and we spend so much time there that eventually

even Swinburne comes to accept us. It doesn't happen right away, however.

"Becky, get a grip on your Shetland pony," I call out to her as I walk in the back door from the parking lot and the powerful Airedale erupts into barking.

"Swinny, stop it and go lie down," she tells him, seizing the heavy chain collar on his neck and pushing his bulk toward his dog bed like a pig farmer shoving a hog.

I'm partial to dogs, but Ben gives Swinburne a wide berth. Dogs are unclean in the Muslim faith, although that's not the issue for Ben, who is thoroughly secularized. It's just that he prefers domestic animals of less intimidating proportions. Swinny and I will get to the point where he allows me to pat him vigorously on his chest—it sounds like I'm thumping a wine cask—but the big dog can sense Ben's nervousness, and they never get beyond a grudging tolerance for one another. Perhaps because of that, or perhaps simply because we wish to concentrate on rug business, Ben and I start to meet elsewhere.

We meet in parking garages and rest stops. We rendezvous in vacant lots, we lounge on village greens, we stop for lunch together at roadside delis and taco stands. Now and then we'll find ourselves at the same auction or estate sale and sit together to alleviate what is all too often, just as Gary Clifton had warned, a boring experience. Ben and I never meet at either of our homes, however, each of us instinctively wary of mixing private life and rug business to that extent. Such reluctance is typical of the carpet trade. Many of the business cards I am handed carry names and phone numbers but no other information, and the same will be true of those I have printed for myself. Revealing anything else might be dangerous. The more your address becomes public knowledge, the more likely it is to reach unethical ears, and the greater the chance is that you'll come home one day to find your carpets missing. Jim Barnard is not the only dealer who wishes no one knew where he lived.

Ben usually has rugs to show me, ones that people in New York City have given him on consignment to sell however he can, and I sometimes have rugs to offer him, ones I haven't been able to dispose

of elsewhere and hope he may be able to sell in the city. It's a commercial alliance, but within the parameters of such a relationship we become companions, and as time goes by we begin to make purchases together, dividing our risk and pooling our knowledge. We pool our ethnicities, too. That is, if we're in a fancy antiques shop in a genteel town, Ben's OK because he's with me; and if we're in a half-empty warehouse in Queens talking to dealers of Middle Eastern extraction, I get better treatment than I might receive otherwise because I'm with Ben. It's a carpet-trade equivalent of the cooperation between white and black in three-card monte known as "salt and pepper."

The advantage I derive from Ben's company is plain to me from the start, but I don't fully grasp the advantage to him until one day when we're standing outside an upscale store in Westport. Carpets are what Ben knows best, but he's willing to deal in any object that will generate a profit, and on this occasion he hopes to sell a pair of waist-high glass vases that are lapis-lazuli blue and came from one of the thrift shops he rummages through regularly. Glass vases are nothing I know anything about, and I wonder how I can help him. Before we walk in, I ask: "Ben, what do you want me to do here?"

"Just be my friend, George, just be my friend."

American indigene that I am, I hadn't realized how high the social barrier is that an impecunious Middle Eastern immigrant faces and how serious an impediment a foreign background can be in day-to-day business dealings. If you're trying to sell something, it helps if the buyer trusts you implicitly, and trust is hard to establish when suspicion intervenes. That's not a problem I encounter often, at least not in Westport, Connecticut, and I stride confidently through the door with Ben happy to be at my heels.

Inside, the owner is busy with a customer, and so Ben and I wait for fifteen minutes, standing among display cases and vitrines that gleam with Steuben and Lalique and chatting quietly, obviously at ease with one another. *Just be my friend.* At last the customer leaves and the storeowner turns to us. He nods at Ben, who has been here before, but I'm the one he speaks to.

"How are you today? Anything I can help you with, just let me know."

At which point I introduce myself. I compliment him on his shop, I share his annoyance at the endless road repair on the highway outside of town, I commiserate about the spiraling costs of shoreline real estate, and then I tell him that we've got some fantastic glass he should really take a look at. Ben brings the tall vases into the store, and now it's his turn to talk. He says nothing about a thrift shop, of course, and he claims that the vases are French and seventy years old. (You can't get arrested for it.) Ben keeps talking, but the owner isn't listening very closely. He stands a vase on each side of his desk and pauses with his head cocked. Then he sets a platter on top of one of them and puts a bowl of flowers on the platter and steps back to regard the effect.

"That's a nice touch," I say. "They do look elegant. If I could afford a house around here, I'd decorate with them myself."

There's a bit of back and forth, and finally Ben yields some on the price, and we all shake on the deal as the money changes hands.

On the way back to the car, Ben counts the cash again and offers me a fifty.

"Nah, I didn't do anything."

"Yes, you did."

"Forget it."

"Thank you, George. You were good. You're a good closer."

I smile. Coming from an itinerant rug merchant, it's high praise.

When we're not prowling shops together, Ben and I sometimes spend an afternoon in a public place, where we lay our carpets on the ground to attract attention. We find railroad parking lots are particularly good for this, and as we wait for the successive waves of passersby that come and go according to the train schedule, we stretch ourselves out upon our wares to gaze up at the sky and converse. Over time, I tell Ben much of what I've told in this account, speaking of my childhood on the South Fork of Long Island and my accidental beginnings as a carpet enthusiast. I reminisce about playing softball on summer evenings in the cow pasture that adjoined

our home, about spending long hours beside the Atlantic Ocean on what must be the finest white-sand beaches in the world, about swimming in the gigantic waves that followed the hurricanes that periodically made landfall a quarter mile from our front door. And I explain as well about my great-grandfather's posting to Jerusalem and the Ferahan-Sarouk that first drew me into the endlessly intriguing world of oriental carpets.

Ben tells me about his background, too, describing how his family left Iran by going through the mountains with a band of Kurds.

"There were two ways of getting out: a plane or a donkey. If you were rich and could afford the plane tickets, maybe you could bribe somebody at the airport and take some of your belongings with you, maybe even some carpets. But if you didn't have that kind of money, you had to go overland, and you left with nothing. The Kurds didn't charge much, but anything you tried to bring, they might take, and besides, they didn't have room for us to carry a lot of baggage. My family went with some people who were going up into the highlands for the summer. We got passed from group to group and wound up in Turkey."

"So you migrated with nomads, Ben, just like in the books! What was it like?"

"It was fun. I was only a little boy, and I loved seeing all the animals and the trucks. Sleeping in tents, sitting around a fire, I had a great time. If I could come back and do it again, I wouldn't mind being a nomad. It's an easy life."

"An easy life! Ben, they have an incredibly hard life. They're working all the time."

"No, I'm telling you, I was there. They just walk along with the sheep and then sit around and tell stories. They don't work at all."

"Come on, the women work twenty-five hours a day. They cook the food, they raise the kids, they tend the fire, they churn the butter, they spin the wool, they sew the clothes, they get married at thirteen, and they're old when they're thirty. How they have time to weave rugs is beyond me."

"That's not what I saw, George. Maybe the women work some, but the men just lie around."

"You didn't see what they do because they didn't want some city kid getting in the way. The men have to make sure the animals don't get lost or stolen. They have to fight to get good pastures and barter for truck parts and gasoline and anything else you can't get from a sheep. They have to deal with angry farmers and government officials. On top of that, it's a dangerous life, and man or woman, there's not a lot of medical care. You fracture a leg or lose too much blood in childbirth, you're just out of luck."

"They're happy people, George. Sometimes I envy them. When the rent comes due, and I don't even have enough money for cigarettes, I wish I could live like them."

Ben and I are each convinced we're right and aren't to be persuaded otherwise, yet in a way neither one of us is entirely wrong. From all accounts other than Ben's (such as the anthropological treatises of Lois Beck and Fredrik Barth or the vivid books written by Freya Stark and other intrepid travelers), a nomad's life is perilous and exhausting. Moreover, there is ocular proof: you can see in old photographs and documentaries just how much wear and tear a tribal way of life entails. Moving herd animals from pasture to pasture in search of green grass has been practiced in the Middle East for millennia, but it has never been a simple undertaking. Transhumance sustains life in regions where climate and geography preclude a society based primarily on agriculture, and thus almost by definition the landscape nomads inhabit is harsh and their means of survival are exiguous. Nomads pitch their tents on the borders of civilization, and their seasonal migrations take place between the desert and the sown, that is, in areas that lie between absolute aridity and reliable fertility. To be a nomad is to struggle. It's a marginal existence.

All the same, Ben is correct that such populations are not unhappy with their condition, or at any rate that they wouldn't want to change it for any other. It may be that in spite of its physical demands, a nomadic existence affords a sense of freedom, that it offers independence from the discontents of civilization. One might even speculate that since gathering in a band and walking in search

of sustenance has been a basic human activity ever since our ancestors climbed down from the trees, nomadism answers to an age-old impulse to be on the move. Be that as it may, nomads rarely abandon their migrations unless they have no choice, and even if obliged by law or economic circumstance to stay in one place, they will return to nomadism given the opportunity. If they can't move at least twice year to find green grass, their animals will die, and when that occurs the spirit seems to die in them as well. In the 1930s many Iranian tribes were forced to settle by Reza Shah, who distrusted their independence, and the photos taken of them then resemble those of Amerindians confined to a reservation: what you see is not exhaustion but despair.

"Is that Heriz for sale?"

The voice that interrupts our argument belongs to a well-dressed woman with a brisk walk and a confident manner. I know her, and she knows me, though she doesn't acknowledge the acquaintance.

"Hello, Doris. How's Josh?" I ask, standing as she approaches.

She ignores the question.

"Is the Heriz yours? How much is it?"

"It's Ben's here. You'll have to ask him."

She turns to him, lifts her fashionable dark glasses, and raises her eyebrows in inquiry.

"It's a Serapi, actually, a very fine rug," says Ben, who has made his assessment of Doris's clothing and will price his carpet accordingly. "I can sell it to you for only seven thousand, but that's because I'm a private dealer. I don't have the overhead that comes with a store."

"No, thank you," she says decisively and walks off toward a Lexus LX nearby. "It's not a Serapi, by the way," she calls out as she gets into her car, "it's just a Heriz."

"I thought she had money to spend," says Ben ruefully as the Lexus drives off.

"She's got plenty to spend, believe me. She owns real estate all over around here. She had an idea what she was looking at, that was your problem."

"You know her, George?"

Doris is known to many in the area, because her husband Josh is an artist of international reputation. A shy man, he spends his mornings in his studio and his afternoons listening to music in a small room packed floor to ceiling with classical CDs. I sat there with him once, listening to Sibelius, when I took a case of olive oil to the house and he was the only one home. But that was a rare sighting. Josh isn't seen around town much, and Doris, who is anything but retiring, protects his privacy. It is she who interacts with the world at large. He paints the pictures while she pays the plumber, hires the gardener, orders the food, buys the furniture, and so on. She doubtless buys the carpets, too, but not from Ben.

"I've met her. Doris grew up in Italy, and people understand rugs there. She knew it wasn't a real Serapi."

"But it is."

"No, it's not, Ben. Come on. Big knots, standard design, chrome dyes, it's run-of-the-mill."

"Every Heriz is a Serapi when you're selling it, George."

I laugh.

"You're right. Every salesman is a customer satisfaction coordinator, every garbageman is a municipal waste engineer, and every Heriz is a Serapi."

"Of course," says Ben. "Just like every Kashan is a Motashem, and every Malayer is a Mishan."

Soon we're both laughing.

"Every Tabriz is a Hali Jalili, every Kirman is a Lavar."

"Every Mahal is a Sultanabad."

"Every Sarouk's a Mahajeran."

And so on, entertaining ourselves. Rug dealers will talk up their merchandise, and almost any type of oriental carpet may have a name attached to it that in theory denotes superior quality. There are some rugs that actually deserve their supplementary superlative, but many don't. There's title inflation in every field.

Ben is quick to tell his customers he doesn't have a shop, which is true, but he is not entirely without overhead. Among other expenses, he pays rent on a storage facility where he keeps the carpets

he currently has on hand along with whatever items he has scavenged from Goodwill. Once we get to know each other, he gives me the code that lets me into the lot so I can drive right up to the space he's rented. I'll often find him sitting in front of the open bay and smoking one of the many cigarettes he goes through while working on his rugs. On one occasion, he's overcasting the ends of an antique Ferahan-Sarouk that has a large medallion outlined in red.

"Nice carpet, guy."

"Hello, George. It was in a yard sale, can you believe it?"

"It looks pretty good."

"It's really good. I think it's nineteenth century, maybe the 1880s."

"Maybe. But the books say that big medallions like that weren't woven until the beginning of the twentieth century. They were a way of simplifying design."

"I think it's older."

"Maybe. The books don't think so."

"The books aren't always right, George."

"No, but neither is anyone else."

It's not unusual for Ben and me to disagree about a carpet's age. In fact, such debates are a sure sign of connoisseurship. Connoisseurs quibble, particularly when there's no way to win the argument, which is often the case where a rug's date is concerned. Every carpet lover wants his or her carpets to be old, and age estimates reflect that desire. As the late scholar Jon Thompson warned, one has to guard against "the almost irresistible tendency to date things you like early, and things you don't late."

Regardless of just when it was woven, though, the rug Ben has found in a yard sale (of all places . . . what kind of ignoramus would sell something like this cheap?) is a fine discovery, and I take it from his lap to look it over for myself. A big part of its appeal is its big medallion, and I note that, as is not uncommon with Ferahan-Sarouks, the shape is edged with a sawtooth pattern that might be read as a flickering flame. It's been a long time since Islam supplanted Zoroastrianism, but myth is nothing if not persistent.

"What do you think, Ben? A symbol of Ahura Mazda?"

"Ahura Mazda. How do you know about Ahura Mazda, George? The god that was stolen from me."

"I thought there was no God but Allah."

"That's what they say. I tell them not to talk about it to me."

There is fanaticism in every religion, and there are plenty of religious zealots in Iran, but with that said, Islam has never been accepted there in the same way it has in countries where Arabic culture dominates. When the armies of the Prophet invaded Persia, they encountered a civilization that was highly developed and a populace that was ethnically Indo-European rather than Semitic. It was inevitable that Persia would adopt the new faith only on its own terms, and the Sunni-Shia divide that separates Iran from most of the Muslim world and was made law under the Safavids formalized a long-standing rift. The divide is theological and political, but most of all it represents a gut-level instinct for individual identity. (If you wish to truly offend an Iranian, confuse him with a Saudi.) Persian culture has proved stubborn. Shia Islam, with its love of mysticism and its sense of historical injury, is central to Iranian identity, but the poetry of Hafiz, with its love of wine, women, and song and its essentially epicurean spirit, is beloved also. I'm generally dubious about what some scholars call "the ancient language of carpet iconography," the notion that the motifs commonly seen in oriental rugs—the stars and octagons, the arrow shapes and stylized animals—carry an age-old mystical significance that can still be interpreted. What these symbols may have meant, if anything, seems beyond recovery, and yet looking at the sawtooth pattern in Ben's rug, it's hard to resist speculation. Islam in Iran is an overlay, and perhaps Ahura Mazda has not altogether disappeared.

"What are you, Ben, a fire worshipper?"

"No, but I'm not a very good Muslim, either."

"How'd that happen?"

"It just did. You see enough of the world and think things over, it gets hard to believe in the stories. And I don't like imams. I don't like what they've done to my country. What about you, George?"

"What about me . . . well, I was baptized and confirmed, I was an acolyte and a crucifer, and I used to go to church five days a week. But

I'm done with all that. I still like reading the Bible, I just don't like to do it in company."

"Why not?"

"Because too many preachers talk down to you, as if they're the parent and you're the child. And because I really can't stand proselytizers. They knock on your door and want to tell you about Jesus, and it's like they're describing their favorite superhero. Save it for somebody else."

"We have them in Islam, too. It's called *da'wa*. I tell those people not to talk to me if they don't want to doubt their own ideas."

"You don't like evangelists either, huh?"

"I don't trust people who are sure they know what God thinks."

"Amen."

"Amen."

I find Ben congenial in many ways, and there are stretches when I meet with him every couple of weeks; but there are other intervals in which he vanishes for months at a time. When that happens, I'll call his phone number and instead of getting Ben I'll get his mother, who speaks almost no English. Like most immigrants (and hence like a lot of people in the carpet trade), Ben has both an American name and the foreign one he was given at birth, and when I ask for him, his mother replies simply: "Fereydoon not here." Maybe that's all she knows how to say, or maybe she is protecting her son, because the most obvious explanation for Ben's disappearance is that he owes a lot of money. "Someday somebody's going to kill those guys," said Ryan Whale about my deal gone wrong in Amagansett, and while the carpet business is not lucrative enough to attract the involvement of organized crime, still many people in it are not at ease with law enforcement, and many of their transactions are off the books. If they intend to seek repayment, they won't do it in small claims court. I've never heard of anyone in the trade actually getting his legs broken, but Ben's periods of invisibility are not unusual.

In the intervals when Ben goes to ground, I'll drop in on Becky now and then to see if she has news of him. She generally doesn't, but I'll spend time with her anyway, keeping her company for an hour or two while Swinburne pokes his muzzle in my lap and his

owner scrolls gloomily through the websites that have made the profit margin in the antiquarian book trade increasingly thin. The World Wide Web has created worldwide inventory, and comparison shopping is just a click away. Except for the rarest of rare books, dealers are always in danger of having their prices undercut, and what was once a genteel occupation has become a highly competitive business.

"Look at this!" says Becky. "A first-edition *Prelude*, and it's listed for only one twenty. OK, it's been rebound and the condition isn't great, but still. No, I haven't heard anything about him. I asked around, but nobody knows. Maybe he went off to stay with his wife."

"Ben's married? Are you sure? I've known the guy for four years, and he's never said anything about a wife."

"That's because you're a man and have no intuition. A woman has a feel for such things. She can sense it."

"What, were you hoping he'd make you wife number two?"

It's a rude remark, but I'm irritated to discover that Becky knows something fundamental about Ben that I didn't.

She turns and gives me a light slap on the cheek.

"That's not nice. Bennie wouldn't do that. He loves his wife."

"So if he's married and he loves his wife so much, why was he living with his mother?"

"He says he loves her but she's crazy."

"Every man says that about his woman."

"No, I mean he says she's bipolar."

But that's the extent of what she knows, and I don't get the full story until Ben resurfaces. Six months go by with no sign of him, and then one day there's a message on my cell phone asking to meet at a Chinese restaurant next to Long Island Sound, and when I pull in the parking lot there he is, eating his lunch out of a cardboard box."

"Where in the world were you, Ben? A witness protection program?"

"Hello, George. That's what everybody says, witness protection. I was just visiting relatives, that's all."

That's not all, of course, or he would have left word, but I don't push.

Instead I tell him what Becky told me.

"Becky thought you might have been staying with your wife. I never knew you were married."

He takes a last bite of fried rice and tosses the empty box in a bin. "Let's go for a walk on the beach."

It's a windy day in early April, and the beach is almost deserted. We zip up our jackets and turn up our collars and walk for a while, and eventually we sit down on a concrete jetty and look out at the water.

"Her name's Nazrin. We got married young, when she was only twenty, because we loved each other. We still love each other, at least most of the time. We can't live together, though. It's too dangerous."

"Dangerous? Dangerous how?"

"It's not her fault, George, but she does crazy things."

"Like?"

"She hates the way her medication makes her feel, and when she's not on medication, she gets completely paranoid and attacks people. One time she went after me with a knife. Or sometimes she thinks I'm trying to hurt her. She'll call 911 and say she's afraid of me, and then the police come and assume it's domestic abuse. I can't live like that, it's too dangerous. I'd wind up in jail."

"And you can't make her stay on her meds?"

"She knows she should, and she will for a while, but the stuff makes her feel awful. She gets sick to her stomach and has diarrhea, and the drugs make her fat anyway, and she hates that. Eventually her hair even starts to fall out. So she'll skip a pill every once in a while, and then a few more, and then all of a sudden she's crazy again. The last thing was, she thought I was trying to kill her and ran away. She didn't come back, and I wound up filing a missing person report, and there was a search. It turned out she'd been living in the woods and eating out of garbage cans, like an animal. She was a mess, in really bad shape, all dirty with her glasses broken and her clothes torn. When I saw her I just cried."

"Wow. I'm sorry, Ben, that's got to be tough."

"Yes."

"I'm sorry. But if you can't live together, who takes care of her?"

"Me, or at least I try. She lives near my mother, so I can look in on her. She's got a brother, and he looks in on her, too. It's the best we can do."

"How long has it been that way?"

"By now, almost fifteen years. I cry a lot, George. When she's not crazy, we cry together."

Genuine schizophrenia is a brutal disease, and anyone caring for a bipolar loved one carries a heavy weight, and yet for all his tears Ben is not a lugubrious man or obviously melancholy. Thankfully, a profession is like a hobby in that it provides a consuming distraction. The carpet business is Ben's way of earning a living, but hearing his story, I understand that the various activities he has engaged in, all the things an itinerant rug dealer does, the picking and mixing and selling rugs on the fly and all the driving around, have been his refuge, too. And if so, so much the better. As we walk back to Ben's van to look at whatever he's brought with him this time, I think of the poet John Ashbery's words: "We need all the escapism we can get, and even that isn't going to be enough." A fascination with oriental carpets won't make life's problems go away, but at least for a while it can push them to the back of your mind.

Ben has rugs to show me any time we meet, but I rarely buy one. He and I work together to sell to others, but he's not Robyn Del Vecchio or Jim Barnard, and what he has to offer is only rarely of good enough quality to tempt a serious collector. Once I buy an old bag face from him, a plush Kurdish piece with pistachio borders and a cherry-red field. Another time I trade him five rugs for one, giving him a handful of Caucasians in various states of disrepair for a single cottage-craft Bakhtiari in good condition. And there is one occasion when the little carpet he spreads out on the asphalt next to our vehicles is absolutely gorgeous, a south Persian tribal rug with an ivory field and diagonal rows of large botehs in baby blue and moss green.

"It's a Qashga'i, George. Beautiful, isn't it?"

"Yeah, it is. But it's not a Qashga'i. It's a Khamseh."

Bickering about provenance is what rug collectors do.

"If you say so, George. They told me Qashga'i."

"Then they told you wrong. Khamseh."

Bicker, bicker, but I'm right. The little rug has a trademark Khamseh border, chestnut-brown with a blossom-and-vine pattern that is so stylized and angular it resembles a row of square compartments. The selvedge is clearly Khamseh, too, a wool overcast consisting of successive bands of all the colors in the carpet, a chromatic table of contents. The dyes are many and deeply saturated, and the ivory background makes the bright palette pop. It's a stunner.

"I can sell it to you for only two thousand, George."

"No, you can't. Not for that much. It's got a blemish."

"What's a blemish?"

Ben immigrated at an early age, and his English is excellent, but there are gaps.

"A blemish is a disfigurement. It's like a flaw. It means there's a problem."

"What problem? Where? What's wrong with a rug like this?"

"You tell me."

He gets down on the rug and examines it closely through his thick glasses, looking it over slowly, front and back and almost inch by inch.

"There's no flaw. There's no problem anywhere."

"Yes, there is. You just haven't found it yet."

"You're killing me, George, you're killing me. I don't see anything that's wrong."

"I'm telling you there is."

"OK, I give up. What is it?"

"Look at the warps, Ben. The weaver made a mistake. It'll never lie flat."

The little carpet is on a wool foundation, mostly, and the frugal woman who made it used a variety of wool for its warps, yarn that was probably left over from other projects. Some of the warps are white, some light brown, some dark brown, some brown and white

plied together; but there is one small section of warps (I count twenty-four) that are not wool but cotton. Textiles are not ceramics, and neither wool nor cotton is entirely stable over time, but the two are unstable in different ways. In the hundred years or so since this rug was woven, and with the multiple immersions in water when it's been washed, the wool has relaxed and the cotton has contracted. The shrunken warps have created a kink at each end, and no amount of blocking or stretching will fix it. A rug with a kink is a rug that will wear badly, and a rug that won't lie flat is an accident waiting to happen. This Khamseh is a beautiful object, but as an object intended for a horizontal surface it can't do its job.

"You could hang it on a wall, Ben, but it can't go on the floor. Who's going to buy a rug like that?"

"Someone who didn't notice."

"Yes, but I noticed. How about a thousand?"

"If you noticed, why do you want it?"

"It's pretty. It can't be furniture, but it could make a nice pet. Let's say twelve hundred."

We settle on fourteen, which makes Ben happy, and agree to meet up again the next week. Before we go, though, he has a question. Prompted perhaps by my vocabulary lesson, he wants to learn another word.

"What do you call a decoy rug, George?"

"A decoy rug? What's that?"

"You know, a rug that looks like something more expensive but isn't really."

"You mean a fake."

"No, not quite. Not something somebody faked on purpose, just a rug that's easy to mistake for something else, something better."

"Like a Marasali that isn't?"

"That's right."

"I don't know, Ben, let me think about it. I'll tell you next time."

But there isn't a next time. Ben drives off down the road to the light a quarter mile away, and the blinking indicator as he turns the corner is the last I ever see of him.

* * *

After a while, when a few weeks have gone by, I give Ben a call and don't even get his mother. Instead I get a message from the phone company saying the number is no longer in service.

As usual, I check with Becky to see if she knows anything about his disappearance, and as usual she doesn't. And then one day I answer my cell, and she sounds like she's in tears.

"Bennie's gone," she says. "He had a heart attack, and he lay down in the street and died. I just found out."

"Oh, Becky, that's awful. Are you sure? How'd you hear?"

"I heard it from somebody who heard it from somebody else. It's the word that's going around."

"Maybe it's just a rumor. Did you see an obituary?"

"No, but that doesn't mean anything. Bennie wasn't the kind of guy newspapers pay attention to, and his mother doesn't speak English. Who would write it? Who would pay for it?"

"Poor Ben. What a kick in the teeth. I miss him already."

Ben vanished completely, as if he never existed, and there's no way to know just what happened. If a death notice for a Fereydoon Behzadi is on file somewhere, I'm unable to track it down, and the websites that charge a fee to search official records yield no information. However it's an uncommon name, in Connecticut at any rate, so I keep looking, and when the internet turns up an N. Behzadi living outside of Hartford, I figure it's worth a try. I pay the price to get a phone number and give the number a call.

"Hello."

It's a man's voice that answers.

"I'm looking for Ben Behzadi. Is this the right number?"

A long pause.

"Who is this?"

"My name's George. He doesn't owe me money or anything. Is this the right number?"

More silence.

"He doesn't owe me," I say again. "I'm not angry with him. Look,

if this is the right number, just tell him George was wondering about him. Tell him I said hi."

There's still no response. I wait for some sort of answer, but after long seconds of silence whoever it is hangs up, and I'm left with a broken connection. And yet . . . the person I reached didn't say I had the wrong number or ask who Ben was or tell me he was no longer alive. Maybe Ben owed so much that he went into hiding and spread the news of his own demise. I'll never be sure, but that's what I'd like to believe. For a long time after his last disappearance, my eyes play tricks on me. I keep thinking I've caught a glimpse of him: sitting in the last row of a country auction, hovering at the edge of the crowd at an antiques fair, stepping into a building in Manhattan's carpet district . . . the small man with the large nose and big stomach is never actually Ben, but I keep hoping it might be.

It makes me sad to think that a man with so much soul and resourcefulness is now gone without a trace, that his love for his wife and his courage in difficult circumstances might as well never have existed. And I'm sad that our friendship, our shared love of carpets and our synoptic way of viewing the world, has disappeared as well. The several years I've spent in his company seem no more substantial in retrospect than the clouds we used to look up at while talking in a train station parking lot. Ben's gone, and I wonder if he hasn't taken a small piece of me with him.

Becky misses him, too, and she often talks about him. When I drop by her shop, Swinny, who is getting on, will perk up when he sees me and stand up stiffly from his bed. He comes over to say hello, and when I give him a thump on the black-and-tan expanse of his chest, he wags the six-inch stub of his tail. Then Becky pours a little Scotch—Oban 14 is her current favorite—and we raise a glass to Ben.

"Becky, you book maven, I've got a vocabulary question for you."

"Shoot."

"What do you call something, say an antique of some sort, that an amateur might mistake for something more valuable than it really is?"

"Why would you want to know that?"

"It was Ben's question. He used to call a carpet like that a decoy rug, and he asked me if there's a better word."

"I don't know. A snare, maybe. Or a pitfall. Or fool's gold, how about fool's gold?"

"Not bad, not bad."

Fool's gold is probably as close as you can get to the idea in English, but these days whenever I come across a rug like that (such as the so-called Transylvanian carpet I saw recently that had the right design and was old but nowhere near old enough), I have a name of my own for it. I call it a Ben Behzadi.

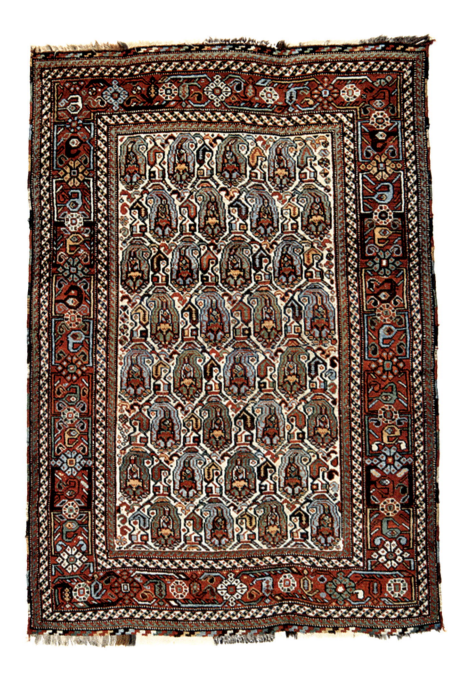

The Flawed Khamseh, 4 ft. 5 in. x 6 ft. 3 in.

A Dealer Story
THE TIBETAN TEMPLE THANGKA

Carpet dealers, like many storeowners, often have time on their hands. They spend long hours in their shops or in booths at antiques shows waiting for customers to walk in, and while their computers and cell phones and sometimes even a book can occupy some of their attention, they are usually happy to be interrupted, particularly by others in the trade. Given an opportunity, they like to tell each other stories, exchanging accounts of fantastic deals, disastrous mistakes, cunning stratagems, legendary characters. Their narratives are often embellished for effect and tend to fall somewhere between oral history and tall tale. Here's one, told to a group of carpet aficionados by a dealer in Far Eastern textiles who was asked about the possibility of finding collectible material in as yet unexplored corners of the globe.

* * *

I've made expeditions to lots of remote places, and twenty years ago I decided to add western China to the list. That was way before the Uighur riots, and tourists could still go there without a problem. All you needed was money and time.

The Uighur region of China is called Xinjiang, and its capital city is Ürümqi. It's a long way from anywhere, but it's well worth the trip. The city lies on the north edge of a huge geological depression called the Tarim Basin, which is now the Taklamakan Desert but was once the site of a flourishing civilization. In ages past, the area was an inland sea watered by rivers running out of the surrounding mountains, and even in historical times there were dozens of fertile oases there, which formed a major center of Buddhist philosophy and art. But all things pass. *Taklamakan* means "place of ruins," or "place that was abandoned," and the name is its own explanation.* Today the rivers have dried up, and the Tarim Basin is six hundred miles of uninterrupted sand.

An enormous amount of the region's cultural heritage has disappeared, and not just because of climate change. A lot of it went to European museums, deposited there in the nineteenth century by the hardy explorers and secret agents who were playing the "Great Game" of Central Asian espionage. Art appropriation was sometimes their primary interest and sometimes their sideline, but either way, ancient manuscripts were snapped up and huge frescoes *were* hacked out of stone walls, and the looted antiquities were carted off to London and Saint Petersburg and Berlin. And yet the Tarim Basin civilization was so rich and the area in which it lay so vast that though desertification and human rapacity have done their worst, the erasure was not complete.

I wanted to see whatever was left, and so I went to Ürümqi and hired a guide. Her name was Song Daiyu.

"Write books, do you?" she said on the first day we met. "I figured you weren't just a business bloke. You're spot-on perfect for a professor."

Daiyu had been to school in England, which made her good guide

* Alternatively, the name is sometimes said to mean "place you go in and don't come out," but this appears to be a colloquial invention without etymological underpinning.

material, and she struck me right off as highly intelligent. Any sort of British intonation is likely to sound sophisticated to American ears, and although I knew Daiyu wasn't posh—she spoke with a city accent, not a university one—her voice had some of the same effect on me. Posh or not, she was obviously educated. She knew about Chinese art and literature, and she knew about European art, too, and when I told her I dealt in Asian textiles, she even knew something about them.

"You mean like palampores? Lots of those enormous houses on the Heritage List have these lovely palampores on the beds."

"Yes, I've sold a few of those. I deal mostly in chintzes and brocades, but I'll go for any antique fabric that might find a buyer. Batiks, ikats, silk kimonos, rank badges, anything."

"So it's whatever you find, is it? Are you buying now then?"

"I could be," I answered. "I mean, I'm always looking. Why, do you know of anything here I might want?"

"If you've got the dosh, it's always worth a try. I'll ask around."

All that stuff about Asian inscrutability is nonsense. There was interest all over her face.

I should say right away that her face was remarkably attractive. So was the rest of her. Her eyes and hair both appeared jet-black, though in fact they were really a deep brown, and she had what looked like a boyish figure until you looked twice. And her skin was amazing. I've never seen anything like it. Where it met the desert sun, it was tanned and tawny, but everywhere else it was pale pollen yellow. Her skin was so clear it was almost translucent, and when people talk about a luminous complexion, I understand now what they mean. The more time I spent with Daiyu, the more attractive she seemed. She was pretty to begin with, but the way you see people depends on how you feel about them. After a few days I thought she was beautiful.

A lot of what a guide shows a tourist in Ürümqi is landscape. There are rugged bluffs behind the city, and their striations glow in the raking light of the westering sun. There are astonishing

rock formations, sandstone spires carved by the wind to resemble monumental modernist sculpture. There are deep canyons where the powerful rivers once ran, and there are the dunes that moved in and now flow to the horizon like unending ocean swells. One sees magnificent landscape in western China, but there are man-made sights as well. There are tombs hidden in sheer cliffs and mud forts on dizzying heights. There are caves to be explored, and in some of them are cavernous rooms that preserve whatever the looters missed, columns and statues carved into the walls and even a few surviving murals that were too large to be removed. Daiyu showed me all of it, and in between excursions, she ushered me around the bazaar.

Given her company, I could expect good prices, but the market wasn't what I'd hoped for. Naively, I had imagined that this end of China would contain a trove of the antique, but I found little that I wanted. I did purchase an old pair of Uzbek boots, dressy footwear stitched together out of red leather and felt, but that was it. After a few days of hunting fruitlessly while dodging merchant touts, I realized I had come to Ürümqi too late. Maybe a century too late, given how much left the area in the Great Game era. The truth is, it's often easier to acquire Asian artifacts from Western collections than it is to buy them where they were made. In Ürümqi in the 1990s, it was hard to find anything except ugly modern pieces and unconvincing fakes. Like the fabled rivers, the easy pickings had dried up.

Daiyu was nothing if not perceptive, and she sensed my disappointment. She felt bad about it, though of course it wasn't her fault, and as my planned itinerary was drawing to a close, she had a startling suggestion.

"What I've heard," she said, "is that if you go all the way to Kashgar and Yarkand and Khotan you can still find old clothing, like wedding shirts and embroidered hats. Other things, too, maybe animal blankets, maybe even carpets. Why don't you try there?"

"It sounds tempting, but I'm due to fly home. Besides, if I went,

I'd need another guide, and they'd never be as good. I'd miss your company."

"Not if I went with you."

I stared at her, amazed.

"My goodness. Would you really do that?"

"Why not? I could use a change, actually. Besides, for a *lo fan*, you're kind of cute."

A *lo fan*, an American savage, someone with a big nose and blue eyes. Why a beautiful young Chinese woman would have any interest in an older barbarian was not obvious, and I told myself to go easy and not get ahead of myself. But then again, there had been her comment about my professorial image. Different cultures have different criteria of erotic appeal. In America, physical prowess is sexy, the sort of physique that could fight off grizzly bears on the frontier. In England, cultivated irony is sexy, and a humorously cynical attitude is prized above bulging biceps. In China, where social status was determined for centuries by one's level of literacy, scholarship is sexy, meaning my thinning hair and soft stomach and horn-rim glasses might qualify as appealing. Daiyu had been schooled in London, but maybe she was still Chinese enough to look at me that way. Even if she wasn't, I was on board for the ride. If she was willing to travel with me, I was certainly willing to travel with her. What did I have to lose?

And so Song Daiyu became my companion in many adventures. As a Chinese national, she could secure the necessary permits (she sometimes pretended I was an American dignitary), and we traveled all over Xinjiang. We went by train and by bus, and we must have made an exotic couple, because we drew long stares from other passengers as we chattered away in English. The trips we took together were not always comfortable, and our accommodations were rarely deluxe, but it was still one of the best times I've had in my life. Our travels were the kind of strenuous shared endeavor that reveals character and creates intimacy, the same way military sieges do or on-location filming, and we grew to know one another well.

We began as confederates in the hunt for the antique, but it was not long before we were lovers.

As we learned about each other, one of the things I discovered was that Daiyu was more adventurous even than I and had more endurance, too. I had come a long way to get where I was, but it was she who decided we should range farther afield. One day, after a particularly dispiriting search through an especially dusty bazaar, she offered this analysis:

"You know what our problem is, don't you? The problem with this place is, it's way too easy."

"Too easy?"

My eyes stung, there was sand in my teeth, and my back ached.

"Too easy to get to," she explained.

"You're right," I said. "All it takes is a train for forever and a couple of bus rides from hell."

"Yes, well, that's just the point, isn't it? There are trains and buses, and anybody can ride. What we need is someplace you can't buy a ticket for. We need to find the back of beyond."

"And just how do we get there if there's no transportation?"

"We give a handful of your lovely dollars to them."

We were sitting in an outdoor restaurant eating dumplings that were somehow both soggy and burned, and a band of Tibetan drovers was leading their pack animals down the street. Several ponies, two mules, and a yak.

"Them?"

"Well," she said, "maybe not actually them, but somebody like them. Have them take us up into Tibet."

"That's crazy. Anyway, I bet Lhasa's fished out, too."

"So we don't go to Lhasa, we go somewhere else. The mountains are full of monasteries."

"You're not serious. You're serious?"

"Deadly. Like I say, there's lots of monasteries, and the government gives them a flaming hard time. We'll show up with a little money and help them out."

"And you'd go with me on a trip like that?"

"I'm game if you are, Mr. Professor."

Her eyes fixed on mine, and I could have looked into them forever.

"Miss Guide, I am totally game."

She smiled as she reached for my hand.

"We're going to need a tent," she said.

As it turned out, we did go to Lhasa, though only to use it as our base of operations, and that's where we bought the tent. Lhasa is a city of many tents. The selection of secondhand equipment sold off by climbing expeditions upon leaving the country was extensive and cheap, and we assembled a kit in just a few hours: a nylon tent big enough for two, a couple of air mattresses and down sleeping bags, plus coats, boots, hats, and gloves. Also some antibiotic pills for dysentery, because I'd played the game before. When you go to the back of beyond, if you want anything better than medieval medicine, you'd better bring it yourself. The pills were only recently expired, and the camping equipment was first rate, and it all cost less than I paid our Tibetans, and they cost much less than I would pay for the plane and the jeep.

At first Daiyu and I climbed onto another bus and went west out of Lhasa to the city of Shigatze, stopping along the way to visit the famous Kubum stupa. That was a sight to see, a stepped pyramid seven stories high topped with a huge architectural drum and a turret with a golden lantern. The adjacent monastery held sculptures and frescoes, and the manuscripts and thangka paintings on display were obviously of great value. Kubum is visited by thousands of people every year, however, and its contents have been documented by the Chinese authorities. None of what we saw was going to be for sale. We had already crossed two passes at fifteen thousand feet, but we hadn't traveled far enough yet.

We pushed on and visited a series of monasteries, and we visited their surrounding villages, too. Daiyu asked questions in all of them, and at last she struck a bargain with three nomads who were on their

way home after trading sheepskins and goat hair for the products of civilization. Michewa, Kipu, and Tashi. The men were still in their thirties, but their coppery faces were already weathered. They wore leggings and tunics, they held their braided hair in place with headbands, and they decorated themselves with beaded necklaces and silver bracelets and silver and turquoise rings. I told Daiyu they were living proof of the land-bridge theory of prehistoric migration. They looked like Cochise or Geronimo.

We didn't get to the back of beyond until we left the trekkers behind.

As with Xinjiang, the political situation in Tibet was not as tense back then as it is now, and there were quite a few westerners hiking through the picture-book mountains and gorges. Most of them were young, in their teens and twenties, though we did meet an astonishing couple in their sixties who were crossing the Himalayas on bicycles. (Germans. They believe fitness is next to cleanliness and way more important than God.) The trekkers were hiking southwest on a route their Lonely Planet guides recommended, and our pack animal train was making its way north, bringing flashlight batteries and metal pots and insulated boots to encampments scattered across the high plains of Changtang, the Great Tibetan Plateau.

It was rough going, but it was a thrilling experience. Our route took us well above the tree line, and you could look for forty or fifty miles and see only bare hills and snowy peaks. The distances were enormous, and mountain ranges that filled the sky and seemed so close they might fall on you often took several days to reach. In contrast to the Tarim Basin, this was a land of water, and though even in summer most of it was frozen in the form of glaciers and snow, there were large lakes as well, ultramarine mirrors that reflected the clouds blowing by in the jet stream only a few thousand feet above us.

Often we rode for ten or twelve hours, and after a dinner of yak cheese and antelope and roasted barley grain, Daiyu and I would retreat to our tent to lie down in exhaustion. The days were full of

warm sunshine, but the nights were very cold, and we slept huddled in our bags from sundown until three or four in the morning. Then we lay awake until dawn and usually squeezed into one bag to make love and snooze. There were nights when the moon was so bright it shone through our tent like the headlight of a train, and I remember holding Daiyu in my arms and thinking: "This is the mother of my children." The first few months of a love affair are as good as life gets on this earth.

Once we arrived at our drovers' camp, we spent a few days with what was an extended family. We still had farther to go, however. It was Kipu who took us on the final leg of our journey, and it was his uncle's piety that prompted the trip. Tibetan nomads are a deeply religious people—the elderly in particular are rarely seen without a prayer wheel or rosary beads in their hands—but their religious practice is mixed with the remnants of Bön, the veneration of topography that preceded Buddhism. Many of the gigantic mountains that rim Changtang are considered sacred and are believed to exert a powerful influence on the welfare of people and livestock. Daiyu noticed Kipu's uncle saying his mantras while carefully oriented toward the northeast, the way a Muslim would pray toward Mecca. He told her that he was facing a mountain and monastery he called Chodron. It's a name Daiyu couldn't find on the map, and that made it our destination.

We set off the following dawn in driving rain that became a hailstorm, but Kipu was entirely unconcerned. The weather on the Tibetan Plateau is so changeable that planning for it is useless, and the nomads of Changtang simply ignore it. Each of us rode a yak, which are hardier than horses and have a surprisingly comfortable gait. They are not easy to control, but Kipu did the steering and we followed behind, our mounts strung through the nose and attached to his. The storms came and went, but a biting wind blew always and the nights continued cold, so cold that when we rose at first light and went to draw water, the small streams we drank from were coated

with sheets of ice. I hoped those streams were uncontaminated, but I was glad I had thought to buy antibiotics. Water boils at lower temperatures at high altitude, and unless the water you use in Tibet has been boiled a long time, there's a good chance you are swallowing amoebas.

On the third day we caught our first glimpse of Chodron, a fortress temple of whitewashed brick that rose for sixty sheer feet and clung to the side of its precipice like an eagle's nest. The building loomed, but it was still far off, and it took us another five hours to reach the base of the escarpment and climb the steep trail to the monastery gate. Kipu rang the bell when we arrived, but the gate was already open. Our little group had been spotted long before as we made our way across the plain below.

A Tibetan monastery, particularly a remote one that has not been overwhelmed by vagabond youths with their brash behavior and shoestring budgets, is always ready to welcome visitors. The hospitality may be frugal, as a matter of both asceticism and available foodstuffs, but a traveler can count on a roof to lie under and a mat to lie on and a share of whatever the monks eat themselves. In our case, barley porridge, yak curds, and water. I was glad once again that I had thought to bring medication for dysentery, because the monks were not offering Coke from the can.

Visitors were welcome, but at Chodron visitors were few, and the fact that I was an American added intrigue. Tibetan monks are supposed to be removed from worldly curiosity, but even the abbot came to look us over. The lama superior was a small and shrunken figure, his shaved head barely emerging from his red wool robe, and he said very little. Kipu was deeply affected by his presence and bowed in reverence, and Daiyu and I followed suit. The lama offered his hand, which Kipu took in his own and held to his forehead, after which the old man clasped Kipu's shoulders by way of giving his blessing. Daiyu and I received blessings as well, and with that the abbot withdrew and we did not see him again.

The monk who occupied himself with our reception was much younger, a bright-eyed, cheerful, and charming man who turned out to be the person tasked with managing the day-to-day affairs of the monastery. His name was Jangbu—"Wisdom"—and after greeting us and inquiring after our health and well-being, he called for glasses of yak-butter tea. Then he sat down on a mat in a lotus position and settled in for some conversation, speaking in what Daiyu said was good Chinese. With Daiyu translating, the three of us talked for hours. They don't run movies in Tibetan monasteries or listen to the evening news, and visitors provide both entertainment and a rare source of information.

The manager monk asked us about our journey and listened with a smile to my intentionally colorful account of the roundabout way that had brought me from Los Angeles County to the Tibetan Plateau. He asked about my profession, and he expressed a polite admiration for what Daiyu told him was my expertise as a dealer in antiques. He asked about the state of Buddhism in the United States and was both interested and amused to hear that there are many Buddhists in America, that Buddhist practice is quite fashionable, and that the temples and meditation centers there are well attended and well supported.

Jangbu laughed.

"Yes," he said, "if you go to India, you will find the same thing, and even the same supporters. The Americans bring their offerings to the Tibetan lamas in Dharamshala, but not so much to the Tibetan lamas in Tibet. However, that is nothing to be sad about. Dharma is everywhere, and here in Chodron we are left alone. To be left alone is excellent for meditation."

"I'm sure it is," I said, "but visitors can be useful, even if they are a disturbance."

Jangbu smiled benignly but said nothing.

"What I mean," I went on, "is that meditation is wonderful, but you need a place to do it. A big building like this one takes a lot of upkeep."

Jangbu tilted his head.

"Even if you seek detachment from the world's illusion," I persisted, "the walls will still need paint. Too bad more Americans don't come to see you. Their offerings might be convenient."

I left it there, and there were a few moments of relaxed silence in which we each pursued our own thoughts.

"It is true," said the manager monk at last, "that Chodron has not achieved nirvana. You might say our roof lacks enlightenment. When the rains come or when the snow melts, it permits water to enter and interrupt contemplation."

I smiled in turn.

"From what I've seen of the weather up here," I said, "I'll bet that happens a lot. But a new roof is going to be expensive. Maybe we could help each other."

And that's where the negotiation started.

I'm not a specialist in Tibetan art, but I'm not entirely ignorant, either. After all, at the time I'd already been dealing in Asian artifacts for more than a decade. What Jangbu proposed to sell me was an antique thangka, one he said had been in the monastery since it was founded in the fifteenth century. It was a painting on silk, about three feet by four, and showed the seated Buddha flanked by saints and surrounded by scenes taken from subcontinental folklore. Textiles are something I understand, and I could tell that the silk was very old. The vibrant red and blue and gold pigments appeared old, too. It looked good, and at first I thought I might go as high as a few thousand dollars, but the more I inspected the thangka, the more enthusiastic I became. I saw that rather than simply being a representative example of a recognized school of art, it had been executed in an individual style, and to my great excitement I found that it bore the signature of the monk who made it. Moreover, I realized that at some point in my autodidactic studies I had seen something similar. Antique thangkas are rarely signed, and a painting by an artist famous enough to make the art books would

be very rare indeed. It had to be worth hundreds of thousands of dollars, possibly even more. I had to struggle to maintain my composure.

As any antiques dealer knows, when someone proposes a sale, you let the seller suggest a price. That way you don't offer more than the owner is willing to take. So I waited for Jangbu to name a figure, and when he finally did, I was disappointed to discover that he had some conception of the thangka's worth. He wanted $100,000. That was an obstacle, but this was a once-in-a-lifetime opportunity, and I was determined to arrive at an agreement. I laughed and offered $15,000.

It took three days to make the deal, but after lots more conversation and with Daiyu's diplomatic assistance during many rounds of amiable haggling, we settled on a price of $28,000. It was more than I had ever paid for anything, but it was surely worth every penny. The only hitch was it had to be US dollars, and it had to be cash.

With the bargain struck, I was eager to be off. I couldn't wait to make the final transaction and have the thangka in my possession, but there was no way the dollars I needed could be sent to me in Tibet. I would have to go to Jakarta, where I had a bank account, and have the money wired to me there as quickly as possible. After my months of travel in remote places, I was ready for home. I felt drawn back to the Western world by an irresistible force, the way a projectile that has reached its apogee yields to gravity and plunges back to earth. Most of all, I wanted to turn the thangka over to the specialists at Christie's and let them research it and promote it and secure the payment of what might be a stratospheric winning bid. Daiyu and I bid goodbye to Jangbu the next morning and rushed to Indonesia.

Rushing, of course, was a relative thing, but I spared no expense. I paid Kipu to take us back from the back of beyond, and then I paid for a jeep to take us as far as Shigatze. After that, it was the bus to Lhasa and a flight to Katmandu and a flight from there to Jakarta,

where Daiyu and I booked into the cheapest hotel I could find that had functional air-conditioning. Indonesia lies on the equator, and as cold as we had been on Changtang, we were just as hot in Jakarta. We spent a week and a half there, living on rice and beer and Imodium, because in spite of my precautions, the amoebas had found us. I lost almost ten pounds, and Daiyu lost weight, too, and we both required medical attention. Maybe the pills I bought in Lhasa were counterfeit.

When the money arrived, I paid the extortionate exchange rate to receive it in dollars, which we divided in half and stowed away in our underwear and socks to smuggle back into Tibet. We didn't have any trouble. The authorities in Lhasa care about cash going out, not about what you bring in, and nobody bothered to check. From Lhasa we pressed on, and we made good time, at least by Tibetan standards. Thirty-six days after we left Chodron, we were at the monastery gates again.

The thangka was still there, and it still looked good, and Jangbu was sad to see it go. He hung it on a wall and performed a little ceremony with incense and prayer, honoring the holy image. I turned the cash over to him, and he bowed. He told Daiyu that my offering was a blessing that would help me on my spiritual journey and would help the monastery for years to come. He also said that it was important not to grow attached to the things of this world. But even so, when he rolled the thangka up and handed it to me, he was smiling through his tears.

For the fourth time I paid our way through Tibet, and my accumulating expenses were not finished yet. Once back in Lhasa, I bought a plane ticket for me and a train ticket for Daiyu. We had decided that I would head to London to put the thangka up for auction, and she would go to Ürümqi to inform her family that she had accepted my proposal of marriage. I bought her a ring in Lhasa, and I hugged her a long time at the train station, even with everyone watching our public display of affection.

With the thangka hidden under the cardboard that stiffened the bottom of my suitcase, I flew to Jakarta again and then used my frequent-flyer miles to fly on to Amsterdam, a city where I have many friends. I paused for a night to celebrate with them, and we had a little party that featured a good deal of Dutch gin. I spread the thangka on a table, and periodically we paused to appreciate it and toast my good fortune. The gin was strong, and the thangka just kept looking better.

"It's exactly like something you'd see in the books," said one of my fellow appreciators.

" I know," I said. "I saw the same thing, and I couldn't believe my luck. What it tells you is that if you're willing to go far enough and put up with serious hardship, there are still amazing things to be found in this world."

And I suppose that might be true, in spite of what happened the next day. When I walked into the specialist's office to keep my appointment at Christie's, there my Tibetan thangka was, hanging on the wall behind her desk in London. Well, not my thangka, exactly, but a poster, a high-quality reproduction, and I realized with sudden dismay that this was exactly what I was bringing to market. A high-quality reproduction.

They say you learn more from your mistakes than you do from your successes, and if so, I've learned a lot, because the cost of my mistake nearly put me out of business. I don't know if what I purchased at Chodron was a very old copy or a very good fake, but the technique was impressive enough that even though it was cataloged as an imitation, the thangka still sold for over $3,000. That was a fraction of what I had paid, of course, and the loss still pains me to think about. It wasn't my only loss, either. Daiyu and I did not get married.

When she called to tell me she had changed her mind and wouldn't be moving to California to join me, she said it was because her family was unwilling to accept the match. Maybe that truly was

the reason; tradition is strong in Chinese society, and a parent's wishes in such matters are expected to be honored. Or maybe Daiyu had second thoughts herself about spending the rest of her life with a *lo fan*. Marriage is always a gamble, and the odds against happiness increase the more disparity there is in a couple's background. Maybe she came to think that our differing cultural assumptions and social reflexes would inevitably cause us to drift apart, that the distance from the Taklamakan to the San Fernando Valley was too great to be bridged. If so, I don't blame her. I don't even blame her for the thangka debacle. After all, I was the supposed expert, so ultimately the error was mine. It's true that hiring her as my guide in Ürümqi was what started me on my way, that I would not have gone as far as Chodron if I had not first gone to Xinjiang, that it was she who did all the talking and interacted with the people we met. There's no question that my own cupidity was amplified by her urging, and I've had people ask me whether she and Jangbu might possibly have been in collusion, whether there could have been a private agreement my lack of Chinese prevented me from detecting. But I can't believe that. When I think of Daiyu now, I think of us lying together in a tent in Changtang, and I'm grateful that I met her.

I recognize that some listeners might hear this story and think I got what I deserved, and that my lust to purchase an ancient painting from an isolated monastery was no more honorable than the wholesale depredations of nineteenth-century Europeans operating in the Tarim Basin. That's an issue any dealer in antiques is faced with, though some worry about it more than others. My own view is that it's a matter of degree. Are you making off with the Elgin marbles, or are you buying an old pair of boots, and where do you draw the line between those extremes? Whatever your answer, the truth is that trying to stop art from going where the money exists to buy it is like trying to stop water from running downhill.

I've never been back to Tibet, and I feel no need to go, but I hear about it from time to time. Last year a young man with clothes like a shepherd and hair like a hermit walked into my shop, and it turned out he had been to Chodron. He hadn't met the aged abbot, who is probably dead by now anyway, and he knew nothing about a monk named Jangbu, but he said he was given dinner and a mat on which to sleep. He remembered that there was a storm in the mountains the night he was there, and that he woke in the dark with water dripping on his face. It was raining hard, and the roof leaked.

EIGHT

The Goldilocks Option

The Rebuilt Shirvan

"Are you George Bradley the poet?"

It's not a question I am often asked, particularly by people in the carpet business. The person who wants to know is a textile restoration expert by the name of Tina Kane. I've left a phone message saying I have a rug that needs help, and she is returning my call.

Two months earlier I was at an auction preview in New Britain, Connecticut, looking at a Shirvan in terrible shape. Large portions of the rug were worn to the foundation, some of it was entirely missing, there were gouges in the borders and a split extending into the main field. On top of all that, there were clumsy repairs that only made matters worse, crude attempts at reconstruction using poor-quality yarn. As I stood staring down at what was not much better than a large fragment, a dealer standing next to me leaned over and said: "Too much work."

He was right, of course. From a purely commercial standpoint, the old rug was too damaged to be salvageable. It would cost more to fix than it could ever be sold for, and none of the people I deal with would be interested in it at any price. But the more I regarded the rug, the more I thought it might be something I wanted for myself. It seemed an early example of an uncommon Caucasian design, though it was one I had now and again seen elsewhere (at the Saint Louis Art Museum, among other places). The versions I'd encountered previously, however, were much less interesting. This rug had lovely old dyes, and its warm red field was decorated with what looked like a tribal design, lozenges framed with blossoms and alternating with arrowhead shapes created by a sophisticated interplay of positive and negative space. The arrowheads were topped by branching latch hooks, and each carried a blossom within it, like a mother carrying

an unborn child. The design was at once more complete and more spacious than the other examples I remembered. It was more clear, more coherent, more harmonious. The rug was in catastrophic condition, but to my eye it wasn't a fragment. It was a relic.

I came back the next day for the auction itself and sat through the tedious succession of lots until the one I wanted came up. I was set to buy, but no one opened the bidding ("too much work"), and I allowed the lot to pass unsold. The auctioneer had tried to start things off at $50, so post-auction I offered $40. In the end the battered Shirvan cost me all of $48.92, premium and tax included.

I took the rug home and left it open on the living room floor for a few days, giving myself time to "absorb," as Robyn Del Vecchio would put it. I began to see many things I had overlooked initially, and among other details (the lozenges in one row had extensions that look like bird beaks; the flower frames in another row were composed of X shapes as well as blossoms), I noticed that some of the latch hooks were topped with small lateral lines. There are carpet scholars who believe that what are commonly called latch hooks actually represent animal heads, and that latch hooks with lateral lines are animal heads with horns. One such scholar is Ron Taylor, a prominent West Coast dealer in tribal rugs. I decided to send him a letter and photo. Several weeks later, his reply came back, and it read in part:

> *I see what you mean about the "horns."*
> *The southern Caucasus is definitely part of the broad "cultural belt" from within which very old motifs were communicated through the centuries.*
> *It's really a unique piece and if it was mine I would check on what it would cost to get it restored.*

The precise origin of apparently primitive carpet motifs is anyone's guess—after all, the rugs can't talk—but it is not unreasonable to believe they represent a tradition many centuries old. Regardless, I was pleased that Taylor had been moved to respond, and I was happy his expert eye had admired my relic; but what really grabbed

my attention was the word *unique*. Unique rugs are rare,* and unique Caucasians are especially rare, and here was the judgment of someone far more experienced than I to the effect that this little rug was special. Eager to act on Taylor's advice, I searched for someone in my part of the world reputed to be a top-quality restorer, with the result that I'm on the telephone this evening talking to Tina Kane.

"The poet?" I say, temporizing.

It's not something I am often asked about, and it's not information I am quick to volunteer. As James Merrill, a man who knew whereof he spoke, once told me: "Being a poet is not easily done, but it's easier done than said." Unless one is speaking to well-read lovers of verse, it's very hard to have anything other than an awkward conversation once poetry is mentioned, and I prefer to restrict discussion of the topic to the truly knowledgeable, those Milton called the fit though few. Like many people, I compartmentalize my interests, and I'm surprised now to find them overlapping. I had expected to be talking carpets, a subject arcane enough in itself.

"Yes. Do you write poetry?"

"Who let that cat out of the bag?"

"I recognized your name. You know my husband, Paul, don't you? He says you and he went to college together."

Paul Kane! Paul is an old friend, a former schoolmate and a fellow traveler in the literary world. An English professor as well as an author and editor of scholarly texts, he has also published several excellent books of his own verse. We used to run into one another at readings and receptions in New York, but we haven't kept up. My wife and I moved out of the city when our daughter was born, and when Spencer inherited an olive grove in Italy, we began to spend time overseas taking care of it. Along the way, the friends we knew in New York became people we saw less and less, remembered

* To be accurate, unique examples are rare among antique rugs of an age that contemporary collectors are likely to encounter; truly ancient carpets are not infrequently the sole survivors of their type and thus may now seem one of a kind.

acquaintances more than current companions. Life swept us along in its river of days, and now twenty years later here was one of those friends found again, resurfacing in the stream.

"Paul Kane? What a wonderful coincidence! If you're Paul's wife, maybe we've met. I'm tall and thin with a thin mustache. Know-it-all manner? Offbeat sense of humor? We've probably met."

"Yes, I believe we have, but I don't seem to have made a big impression. Anyway, let's meet again now. Why don't you bring whatever you have to show me, and we'll all have lunch together?"

Tina and Paul live in Warwick, west of the Hudson River, which is in my part of the world only as broadly defined. It's almost a three-hour drive from where I live, and I'm weary and aching by the time I climb out of the car. In their company, though, I quickly revive. I find Paul, who has a ready laugh and a sense of the absurd, still has a boyish appearance, even if his hair is now thinning and his taste in dress is professionally academic. Tina, whose graying hair looks like something out of a Hans Memling portrait, is a quieter presence. Her eyes are pixie-bright behind her rimless glasses, and her contributions to the conversation are alternately impish and grave. Sitting in an outdoor café, eating the sort of food that testifies to the weekend presence of city people (a Caprese sandwich made with heirloom tomatoes and buffalo-milk mozzarella), the three of us begin to catch up.

"So how come I only learn now that you live around here?" I want to know.

Falling out of touch has been as much my fault as theirs, and Paul could have asked the same of me, but he's too genial for that. Instead he explains that one reason we haven't kept in contact is that, like Spencer and myself, he and Tina are often out of the country.

"We're in Australia a lot," he tells me. "We built a house near where Tina used to live, and I'm involved with quite a few things there. They've got me directing a writers' festival. Whenever I'm not teaching here, we're gone to the antipodes."

"Sounds like you get winter twice a year."

Paul laughs.

"It's the only way to do it. The summers are fierce. That's why kangaroos hop, because the ground's too hot to walk on."

Paul and I banter for a while, exchanging news about friends and colleagues and rehashing our college years. As often happens when poets meet, our conversation turns to talking shop, and we exchange notes on our current projects. I say I'm writing a series of recipe poems, sonnets that will detail the preparation of various Italian dishes and possibly impart a little wisdom in the process. Paul mentions that he is editing an anthology of Australian verse, and we talk a bit about Les Murray, the great poet from New South Wales whose enormous gift for language made its home in an enormous body. (Helen Vendler said something similar about Wallace Stevens, noting that his ungainly physiognomy was a poor match for his refined sensibility.) We agree it's a shame that good poets rarely look poetical. There aren't many so handsome as Byron or Shelley . . . present company excepted, of course.

After some joshing with Paul, I give my attention to Tina, and I learn that she works in textile conservation at the Metropolitan Museum of Art. When I ask how that happened, I hear a remarkable life story that moves back and forth between hemispheres.

Born in upstate New York, Tina moved to Australia at the age of seven and grew up in Victoria, a tomboy riding horses in the hills outside of Melbourne. Returning to the States, she went to college at Berkeley, where she developed a love of poetry, and then moved on to graduate school in New Mexico, where she discovered a love of textiles. In Santa Fe she met Benjamin Barney, a Navajo Indian who was a prominent advocate of Navajo culture and had learned about weaving from his artisan mother. In Navajo culture, it is women who do the weaving, but Barney's mother had no daughters and feared that her knowledge would not be passed on. She decided to teach her son the craft, and he decided in turn to instruct Tina. The fact that a Native American was willing to share tribal know-how and devote time and attention to an Anglo outsider was highly unusual. That he did so testifies to Tina's engaging character, and that Tina could benefit by what she was taught testifies to her dexterity and determination. Weaving is a difficult art to acquire, and most people proficient in it learned as a child. Tina was talented enough to learn as an adult.

Eventually she left Santa Fe, dropped out of grad school, and returned to New York State, where she joined the Chardavogne Group in Warwick, a community devoted to the philosophy of Willem Nyland. Weaving had become part of her life, though, and she continued with it. In Warwick she set up a studio to spin and dye her own wool (among her employees was Paul), and with the yarn she produced, she wove rugs to sell at craft fairs. It was a rewarding activity in its way, but it was not rewarding financially until the day when someone brought her a rug with a hole in it and asked if Tina could fix it. She had never attempted that sort of thing before, but she studied the punctured rug until she understood its structure, and the repair she made was excellent. The grateful owner paid her handsomely for her effort, and with the realization that she had a skill valuable to others, a business was born: Tina Kane Textile Conservation and Restoration.

Tina had started her own business, but she continued to work for others as well. Navajo rugs are flatwoven, and her hands-on experience with them led to a position as an assistant to Marian Miller, a Manhattan dealer in kilims who was one of the people responsible for raising interest in flatweaves among serious collectors. Restoring kilims for Miller, Tina expanded her technical knowledge of weaving yet further, and through Miller she met Nobuko Kajitani, head of textile conservation at the Met. Kajitani was one of the people responsible for turning textile conservation into a genuine profession, and when she saw some of Tina's repairs, she hired her as part of her team. That was three decades ago, and Tina's been with the museum ever since.

"A job at the Met, that's impressive. What's it like?" I ask.

"Oh, like working for the Vatican, I imagine," she says, putting down her sandwich to compose an answer. "Or at least a major university. It's a big institution, and it's very institutional. Nothing gets done without a lot of paperwork. There are protocols to follow and layers of authority to be respected, and there are lots of departments that are all in competition for funding."

"It must be frustrating."

"I love it. I just keep my head down and let other people deal with the bureaucracy. Besides, any amount of inconvenience would be

worth it, because my colleagues are really knowledgeable and really dedicated, and the conservation lab and storage facilities are first-class. Plus, what I get to work on is fantastic."

"What are you working on now?"

"The same project I've been working on for thirty years."

"Thirty years! That's not a project, that's an entire career."

"Well, I hope not, we're just finishing up. It's a tapestry out of the Burgos Cathedral in Spain, thirteen feet high and twenty-five feet wide. We've been restoring it thread by thread."

"But a thirty-year restoration! Why has it taken so long?"

"Because of the condition. It had been cut into pieces and cobbled back together, and it was in such bad shape in general that it was a major decision whether to restore it at all. For starters, we had to take out hundreds—no, thousands—of terrible old repairs, and then we had to wash what was left."

"How do you wash something that big and that fragile?" I ask.

It's not an idle question. Washing woven objects is important to their preservation—the dirt that gets into the interstices of their warp and weft will degrade them over time—but it requires great care, and there's always a danger of an irreversible error. Some pieces are so compromised that the stress of cleaning can damage them further, and beyond that, not all fabrics do well in water. Silk, for example, will often shrivel or stain. Many of the dyes found in old textiles—particularly those used for the color red—are not water fast, and even those that should have been stable may bleed if they were incorrectly applied. Different dyes require different methods of cleaning, and mistakes happen. It's not uncommon to see an antique rug disfigured by dyes that have run, which is why collectors are choosy about who cleans their carpets. Moreover, when a textile is out of the ordinary, the danger increases of a bad outcome due to ignorance. Most people in the business know what to do with, say, a Turkmen bag face, but washing something so unwieldy and unusual as the Burgos tapestry must have been at once a cumbersome and a delicate undertaking.

"There's a big room in the Met basement where we basically built a pond," Tina tells me. "We made a basin wide enough so that we

could wash the tapestry flat. Then when we drained the pond, we were able to dry it where it was under controlled conditions."

"Easy, huh?"

"Petrifying. You worry something will go wrong and ruin everything."

"They're making a video," adds Paul, proud of his wife. "You'll be able to see Tina telling all about it."*

"Here's something I don't mention on camera," she continues. "When we washed the tapestry, we used deionized water. The reason we did is that deionized water is hungry for dirt. It tries to bond chemically with just about any substance, so whatever contaminants are present dissolve in it and get washed away. Of course, before we committed ourselves, we tested every dye individually, but that kind of water is so aggressive that I was still worried. And when we submerged the whole thing, I swear I saw the tapestry shiver. For an instant, it seemed like all the colors trembled. I was holding my breath."

"But nothing happened."

"No, nothing did."

"It was probably optical," I suggest. "You were looking through water, and the water was rippling."

"Maybe. Anyway, it turned out wonderfully well. Now they're clean, the colors in it are just beautiful. It's going up in the Cloisters, and you should go see."

"I will. That had to be a fascinating experience. And it had to be good practice."

"Practice?"

"Practice. If you can restore the Burgos tapestry, you should be able to handle my little rug."

She smiles and folds her napkin.

"All right, let's go back to the studio and have a look."

Tina's studio is on the top floor of the two-story barn that stands behind the house she shares with Paul. On the way in, we pass what

* The video can be viewed online at: http://www.youtube.com/watch?v=Pf3usSyHVXs.

looks like an aboveground swimming pool in their yard, or possibly a gigantic billiard table, but is instead Tina's version of the Met's pond in the basement. It's a raised basin that Paul constructed to wash room-size carpets.

"So I assume you use deionized water," I say with a straight face.

"Actually, yes, we do, but just for the first immersion, to free up the dirt. After that, we use our well water to wash and rinse. It isn't chlorinated, so there's no problem. One thing you do have to be careful about, though, is acid rain. If you leave a carpet out in the rain, the acid in the drops will leave little marks on it like you spattered it with bleach. We have a big tarp we use to cover the basin in bad weather."

The studio, which Paul built as well, is a clean, well-lighted place. Unlike the cluttered shops and chockablock warehouses I've grown used to seeing in the carpet trade, this space is neat and orderly. The single large room is lit by many windows, including a glass dormer that faces north, and a row of track lighting hangs near the apex of the cathedral ceiling. Cupboards along the walls hold all sorts of supplies (balls of yarn, spools of thread, cleansing solvents, application brushes, whisk brooms, scissors, knives, needles), and between them are racks with an assortment of textiles rolled or folded and awaiting attention. Two parallel tables run the length of the room, each covered with a white cotton sheet under a layer of clear plastic, and at intervals beneath the tables electric outlets power the many armature lamps and two miniature vacuums. There are bookshelves, there are file cabinets, there are stacks of archival cardboard boxes and sealed plastic tubs that look like giant Tupperware. Classical music plays on the radio. I see a small stove with a teapot. The total effect is of a science lab crossed with a library reading room. You could repair a watch in a space like this. You could illuminate manuscripts. You could number grains of sand.

Tina introduces me to an assistant, who is working on a Greek island embroidery that lies on one of the large tables, and after some small talk we spread my Shirvan out on the other. Tina, Paul, the assistant, and I stand in a semicircle and examine the rug together. Having looked it over carefully, Tina asks me how I would like her to proceed.

I'm a bit surprised. I had assumed she would tell me.

"I'm not sure," I say. "What would you do?"

"That depends on how much you want to spend and what you want the rug to look like when I'm done," she says, her tone measured, her manner businesslike. "I've had people ask me to repile a carpet wherever it shows wear, and I've had other people ask me to remove all the repairs that were done previously and leave nothing but the original weave. You could just sew it up enough to stabilize the rug. You could reconstruct it entirely so that it looks like new. Or you could rebuild the foundation alone. That way you'd see only the original pile, but you'd have the entire warp and weft available if you wanted to do more in the future. It's up to you."

She's like an ethical physician, describing the pros and cons of various medical treatments but deliberately leaving it to the informed patient to make the final choice.

It takes me a while to arrive at a decision, and what I decide on this occasion is not what I would ask for in the future. The belief I will come to eventually is that in treating damaged carpets of superior quality, the proper approach is all or nothing. Either you use materials as close as possible to the original ones and faithfully restore the fabric thread by thread, no matter if it takes thirty years, or you pretty much leave it untouched. That is, you do what is necessary to arrest further decay but otherwise leave the artisan's work as you found it: what remains is what remains, a fragment is a fragment, and one respects the piece as woven. Above all, humility is called for. With carpets as with any object of art, notions of what is best in restoration are sure to change over time, and one should keep in mind that today's standard practice may be tomorrow's anathema.

Standing in Tina's studio now, though, I have yet to arrive at that philosophy. Instead I choose the Goldilocks option, that is, the middle course of action, and ask her to rebuild the foundation while holding off on anything else. In part, my decision is financial. Having been told Tina's hourly rate and hearing her estimate of the time involved, I realize that even the Goldilocks option will be expensive.

"I'll call you when it's finished. We're pretty busy right now, and Paul and I are due to travel soon, so it will take a while."

She's right about that. It takes three months more than a college semester, which I know because in the interim I go to school.

* * *

School is my neighbor Gary's idea. On a bright day in September, the sort of day New England was made for, I drop by for a friendly visit, and as so often I find him improving an antique. After soldering a cast iron candlestand back together, he has lit a tallow candle and is dripping wax on the joint to cover the bright new metal. ("The wax is on the bottom side, too, which defies gravity, but most people won't think about that.") Without pausing from his work, he falls easily into conversation, happy for the opportunity to express his many opinions. He is astonished by the current interest rates, reduced to an all-time low. ("We should be borrowing all the money we can.") He is angry about the quagmire that the Iraq War has become. ("Anyone could see what was going to happen; it was like banging on a wasp nest with a stick.") He is disgusted by the unreliable pitching of the baseball team he follows. ("If El Duque had Burnett's arm, he never would have lost a game.") Eventually he inquires after the progress of my carpet mania, and I confess my continued ignorance, saying that even after seven years of obsessive attention, there are many things I still don't know.

"If you want to learn more, why don't you take a class?"

"How would I do that?"

"People are always offering classes in antique furniture; there are lots of them. I've been asked now and then to teach one myself, not that I ever would. But I bet you could find a course on oriental rugs. Give it a try."

It's an immediately attractive notion—why didn't I think of it before?—and I start to search. I've got high standards. It will have to be a serious class and not some continuing-education community-outreach fluff; it will have to be on oriental carpets specifically rather than Asian art in general; and of course it will have to be nearby, because I don't intend to become a commuter. But in fact my standards are irrelevant. There's only one possibility. After a good deal of

asking around, I hear of a professor who teaches a graduate course in oriental carpet studies at a university an hour and a half away. I go to Google and discover that this professor is one of the two or three most distinguished carpet scholars in the world. Learning from him would be ideal, though since I am not about to become a college student again and will never embark on a career in carpet studies, there's no obvious reason why he should want me in his class. The Distinguished Professor has no obligation to me, and I have no connection to him, but as a former copywriter for several New York advertising firms, I muster my skills of persuasion and sit down to compose the most effective plea I can, which I send to his university email address.

> *I have been collecting carpets and carpet literature for six or seven years now, and I would like to learn about the field on a more formal basis. I greatly admire your work as a scholar, and I would be interested in whatever courses you might offer in Oriental Carpet Studies. I doubt I am what your university envisions as a student—I don't have a future on a museum staff, and my responsibilities as a grown-up do not permit full-time matriculation—but if there were room for me in some way, I could be counted on to pay attention.*

I hear back from him almost immediately, and his brief reply is brisk in tone and generous in spirit, both of which qualities I will discover are characteristic.

> *The History of the Oriental Carpet meets at 9:30 AM on Tuesdays and Thursdays. We're just dealing with early Anatolian carpets, having spent the first weeks of the semester discussing carpet technique, carpet social environment, and the prehistory of the carpet. You are welcome to audit the course.*

And so I become a commuter after all, rising early twice a week to drive eighty miles and sit in the back of the Distinguished Professor's college class. All of his enrolled students are young women,

and the only male besides the D.P. and me is a man in his forties who works as an electrician at the university and is auditing the course purely for entertainment. (We inevitably sit next to each other, and I soon learn he knows nothing about carpets. Instead, his interest is Polynesian weapons, and he shows me dozens of photos of antique wooden war clubs and elaborately carved stone knives. I'm reminded of the cookbooks hoarded by Dave Blumenthal's wife. I don't see the attraction, but I recognize the devotion of a fellow carrier of the collecting gene.)

The D.P. is short, with a trim white beard and a paunch. He walks with a limp that grows more pronounced when he tires, and he is instinctively a showman. Not lacking in ego, he is self-assured in manner, and I like him right away. (Ego in a person of ability does not offend me. In fact, I find it is often a positive leading indicator, suggestive of ambition and accomplishment. My brother, who lives on the West Coast and follows a guru, disagrees with me about this. He disapproves of ego as might a Buddhist monk, believing it to be a selfishness one must learn to overcome, but I would argue otherwise. Ego funds a hospital, ego founds a university, ego developed the polio vaccine, ego built Hagia Sophia, ego put the paintings on the Sistine Chapel ceiling. Absence of ego contemplates its navel and accomplishes nothing of use to anyone. Which is truly selfish?)

The course the D.P. teaches covers a lot of ground, and I can sense the students around me struggling to get a handle on the steady flow of information and the many images projected on the screen. It turns out there's a great deal to be learned about the history of carpets, and given only a short semester in which to instruct, the D.P. moves quickly. Since I have missed the first two weeks of the curriculum, in which he outlined the origins of carpet weaving insofar as they are known (I will later be told that fragments and even whole carpets have been found—in Egyptian oases, in Siberian burial mounds, in Central Asian caves—that can be carbon-dated as far back as two or three thousand years), the overview of carpet types that I get begins in the thirteenth century and advances rapidly from there. Seljuk carpets, Damascus carpets, Safavid carpets, Cairene carpets, Ottoman carpets, Mughal carpets, and more. . . .

Regardless of what I missed, the point where I start is not unusual. A lot of the texts that have as yet been written about the history of carpets begin in earnest with the late Middle Ages, because the carpets that have been most widely illustrated and are thus readily available for study are those made in the 1200s and after. Another factor is that, during the late Middle Ages and Renaissance, many carpets were illustrated in the paintings of Timurid miniaturists and European Old Masters, and these paintings constitute a body of evidence. What the evidence shows is that up until the 1400s, carpet iconography was essentially geometric in conception and often angular in its drawing. This sort of carpet predominated until the fifteenth century, when the Persian and Ottoman courts introduced one of the most radical revolutions in fine art that the world has ever known. In the course of a few decades, the angular designs based on geometric grids were replaced by elaborate curvilinear patterns. By the late 1400s the revolution was complete, and the great Timurid and Turkmen carpets in Iran began to be produced, the vividly dyed and lushly floral rugs that originated the type of textile most people think of when they hear the words "oriental carpet." Dozens of them have survived to grace the world's major museums, and they remain among the most beautiful artistic creations in existence.

I take assiduous notes on all this and am happy for the historical overview—it is, after all, what I signed up to learn—but the most enjoyable part of the course occurs when the Distinguished Professor digresses. One morning he digresses to tell the story of the discovery that decided him on his career as a carpet scholar and first brought him to the attention of others: the cache of ancient carpets he helped bring to light in a small town in eastern Turkey. The D.P. was a young man at the time and traveling through Anatolia as the protégé of an older academic who was seeking to photograph the architecture and antiquities extant in long-established mosques. Carpets are often given to Islamic religious institutions as acts of piety, and as they wear out, newer ones may simply be added on top of them. This means that by digging down through the rugs on a mosque floor one goes back in time, and the D.P. and his mentor thought they might happen on a few interesting fragments at the bottom of the pile. What

they found in fact was a great deal more than that. Gathering dust in a back room of an eleventh-century mosque previously known only for its architecture were dozens of rugs that had been replaced by more recent donations. Many of them were almost complete, and many were of great antiquity. There were some that dated back to circa 1400, some that had been seen before only in old paintings. It was a discovery that radically expanded the universe of historically important carpets, and the carpets as a whole obviously constituted a treasure of enormous value. Many people faced with such temptation would have tried to carry the riches off, the way the Great Game explorers carted off the artwork of the Taklamakan, but the D.P. is not that sort of person, and he told the village elders what they had.

"Now, listen," he cautioned them during the inevitable ceremonial meal of roast goat, "what you've got here is a patrimony worth a great deal of money, and you must guard it carefully. These carpets are a blessing from Allah, but they come with responsibility. Unscrupulous men will try to take them from you. They will try to buy them cheaply, they will even try to steal them. You must be vigilant and protect these precious objects as you would your wives and daughters."

It was good advice and an accurate prediction, and it got the D.P. in hot water. Sure enough, when word of the exciting discovery reached the outside world, a government functionary arrived in a large car with orders to commandeer all the rugs and remove them to a so-called safe location. "A man told us about you," said the forewarned elders, mentioning the D.P. by name. "He told us to guard against you." The townspeople threw stones at the official until they drove him off, and for several years thereafter the Turkish bureaucracy considered the Distinguished Professor persona non grata.

In spite of the elders' efforts, however, the great treasure did not remain in the small town, and its inhabitants did not benefit from whatever tourism might have been generated had it stayed. The carpets were collected by the Vakiflar authority, the government institution that manages religious endowments, and taken away to Istanbul. Previously housed in a museum near Topkapi Palace, the Vakiflar collection is in the process of being relocated, and when it reopens it will presumably be convenient to administrators and visitors

alike. There are sensible reasons why the carpets the D.P. discovered were removed from their original location, but their absence remains a calamity for the place that had preserved them for so many hundreds of years.

In the digression of another day, during a class in which he has been discussing the way carpet iconography tends to evolve from the precise and curvilinear drawing developed in palace workshops to the more angular and simplified imitations seen in cottage-craft weaving, the D.P. descends into something like a rant. His voice rises, and his tone becomes exasperated to the point of disgust. For a few minutes, he is on a mission.

"I'm here this morning to drive a stake through the heart of the Great Mother myth. Write this down: the so-called ebelinde design does *not* represent a goddess with her hands on her hips. What it is, is a floral motif taken from Ottoman velvets. It's a stylization of what were originally intended as carnations. The Great Mother ebelinde theory was started by a man named James Mellaart, and it's my belief he made it up. He claimed to have discovered archaic symbols at an archaeological site near Konya called Çatalhöyük, and then he proclaimed that these symbols were connected to Great Mother goddess worship, and that the same symbols can be identified in old Anatolian kilims. Other archaeologists did not arrive at his conclusions, and I doubt if Mellaart's Mother Goddess connection exists anywhere except in his notebooks. I think he invented the whole business, but he got a book published, and the next thing you know, some fanatics in San Francisco latched onto the idea and ran wild. All of a sudden Anatolian kilims are proof of an all-encompassing prehistoric matriarchy, and now carnations are goddesses and you're an awful person if you say anything else. But I think Mellaart made it up!"

Whether the Great Mother cult was all-encompassing in Anatolia in ancient times, I wouldn't know, and the degree to which Konya kilims share design features with Ottoman velvets is an open question, but the D.P. is not alone in his feelings about the ebelinde figure. When I go to read about the subject after class, I find the evidence for the Mother Goddess theory is inconclusive

and that the issue is unsettled. Mellaart's claims have been both firmly endorsed and strongly contested, but even so, the motifs in Konya kilims are often described categorically (in auction catalogs, in academic articles, in the spiels of dealers hoping for a sale) as representing a goddess with arms akimbo and her hands on her hips. What the ebelinde signifies is a matter of speculation, but uncertainty is a hard sell.

Along with the verbal digressions that enliven the D.P.'s lectures, there are what might be called physical digressions. That is, there are field trips. On one, the class travels to a nearby museum where the director is the professor's former student. The museum has an excellent collection of carpets, and a number of them have been taken out of storage and are waiting for us on a large table in the basement. Among the items we are shown is a small Kirman mat, and as the D.P. points out, its colors are remarkably vivid. He explains that the mat must have been set aside the day it was made and hasn't seen the sunlight since. The strong colors are jarring to my eye, accustomed as I am to rugs that have gently faded over many years, and yet the aggressive palette of this little piece shows what tones appealed to the culture in which it was made. The same phenomenon can be seen in other fields of art, in classical sculpture certainly, and in Renaissance painting. The now unadorned surfaces of the Parthenon marbles were once lively with many colors, and there exist folding portable altarpieces by Trecento masters that were kept closed for centuries and have thus retained a pigmentation that is almost Day-Glo bright. What we take for sophisticated restraint in old art may be merely the evidence of decay, and our preference for a harmoniously faded palette in carpets was not often shared by the original weavers. It is possible that the synthetic dyes that became so common during the last hundred and fifty years found favor not just because of convenience and cost, but also because their garish look seemed desirable to people living in a landscape so dry it is often drab. "If you want to improve your carpets, you have to use them," is something you will sometimes hear from dealers, meaning that rugs must seem aged in order to seem attractive. But tastes change, and no criteria

are universal, and the elegantly etiolated appearance that many collectors expect in an antique carpet is an aesthetic of our own invention.

At the end of the semester the class goes on a final outing, this time to an apartment in lower Manhattan that is the home of two well-known collectors. The husband, who has prominent ears and thick glasses, is a reticent man, whereas his diminutive wife is endowed with a self-possession that makes her a large presence nonetheless. Their apartment comprises four light-filled rooms in a modern building that faces the Hudson River. One of the rooms is surprisingly narrow, and it turns out to have been altered to specification. The length of one wall has been built out to create a closet, and the closet has been filled with a matrix of racks on which rolled carpets can be stored. In my home, the carpets that pile up must fit the space they find themselves in, behind a couch or under a bed, but here it's vice versa. The space has been made to fit the collection.

We are asked to remove our shoes upon entering, and for good reason. There are fabulous carpets everywhere, many of them spread on the floor. A first glance shows me a Deccan saph from the seventeenth century (saphs are prayer rugs with multiple arches), a "bird" Ushak from the sixteenth (so called because the blossoms it portrays resemble hovering birds), a Caucasian dragon carpet from the early seventeenth (one of a group of large rugs named for the abstract dragons that can be identified in them). It's plain why the class was brought here. These are the sort of carpets I have seen before only in museums and books, and in fact one or two actually *are* carpets I have seen in text illustrations. The collectors who are our hosts are at the top of the acquisition food chain. Dealers and auction houses in many countries let them know when an exceptional textile turns up, and more than one museum cultivates them assiduously, hoping to receive items in bequest. They are the kind of collectors who circle the globe in their search for new purchases, the kind who accompany their carpets overseas so that they may discuss their restoration in person. They are collectors such as I will never be, and the chance to

see some of their world-class carpets up close is a rare opportunity. It makes my long commutes to attend the D.P.'s lectures worthwhile all by itself.

The hosts welcome us and offer a brief summation of their philosophy in collecting. Superior examples within category are the object; rarity trumps condition; historical importance counts. And if the dyes are old, still they must be beautiful. ("There are three things to look for in a carpet: color, color, and color.") Then they turn the proceedings over to the D.P., who takes us around the apartment rug by rug, pointing out salient features of each. We come to the dragon carpet, hung on a wall and extending five or six feet onto the floor, and he tells us that the fantastic animals in it—not just dragons but also winged ungulates and imaginary birds—derive from Chinese mythology; that the latticework and sunburst medallions we see recall both Turkic and Persian models; and that although such carpets were discovered in the Caucasus, no one is sure for whom they were woven or in just what town they were made. We are about to move on when I speak up.

"Don't dragon carpets have some extra-thick wefts we could see on the back?"

I'm only auditing the course, and leaving the questions to the actual students would be polite, but I used to be that obnoxious kid in fifth grade, the one who kept raising his hand. I can't help myself.

"Yes, they do, George, and I'm glad you asked that question. Here, let me show you."

In a true Caucasian dragon carpet, the wefts are interrupted by heavy chords at irregular intervals, and the resulting ridges can be seen and certainly felt on the back. It's been theorized that the extra wefting marked the amount of work accomplished during sessions of weaving and formed the basis upon which weavers were paid, but in any case scholars now realize that this unusual feature distinguishes the genuine articles from the otherwise convincing imitations that were woven in the early years of the twentieth century. The D.P. turns over a portion of the rug to reveal the unusual wefting, and then we move on to consider other textiles in other rooms. An Uzbek wedding veil. A Yüncü kilim. An Azerbaijan embroidery. All too soon

it's time to leave, and we thank our hosts as we file out of the apartment to find our shoes and line up at the elevator. I express my gratitude to the Distinguished Professor, too, for what has been a very enjoyable excursion, and when I do, I see a flicker of appraisal in his eyes. *This one is truly interested, this one I might run into again.* As it happens, I'll encounter the D.P. on a number of future occasions, due in part to his own engineering.

* * *

The year-end holidays come and go, the daylight lengthens toward spring, and it's late March when Tina Kane calls me again. My unusual Shirvan is ready, its foundation rebuilt, and we need to arrange a meeting so that she may hand me the rug and I may hand her the money. She suggests I join her and Paul in New Haven, where she has an appointment scheduled at one of the city's many museums. The Yale Center for British Art possesses a large oriental that has endured decades of foot traffic by visitors who are not likely to remove their shoes unless the high heels pinch, and it has suffered in consequence. Tina has been asked to assess the damage and offer an estimate for its repair.

It's raining the day I arrive for the rendezvous, and after parking in the nearest lot I can find, I make my way to the museum through the grimy puddles and soggy litter of the dank city streets. Out of the weather, inside Louis Kahn's elegant building of travertine marble and oak, I find Tina and Paul already in conversation with members of the museum staff. Tina makes the introductions, and then Paul and I step away so that there may be no confusion as to who is the expert being consulted. The two of us sit on the back of a Chesterfield sofa and chat quietly while Tina examines the enormous carpet that fills most of the floorspace of an enclosed courtyard. It's of a dimension that auctioneers like to call "palace size," though in this case the money to buy it came from Andrew Mellon rather than a Middle Eastern emir. About twenty by thirty feet, the carpet has a dark-blue ground covered with a lattice pattern in crimson and pale green, and

the dyes tell me it dates to the 1930s. Walking back and forth across it, Tina pauses now and then to indicate problematic areas, and at one point she kneels to make a provisional repair with the tapestry needle and linen thread she carries with her. Paul and I are at the edge of the room, and, glancing down, I find the carpet's border under my feet. The design looks familiar. Palace carpets are not something I trade in or know much about—they're inconveniently large, and I don't have a palace myself—but I recognize what this one is. The large palmettes framed by leafy circles are something I've seen in photographs. I tell Paul what I think, and after a few moments he walks over to Tina and touches her arm. She turns to him, he whispers a few words, and now we all know. It's a Mahal.

The Mellon Mahal will need lots of work, and Tina will need time to draw up a contract, but as the meeting concludes, it's obvious that the museum wants to go forward with the project. The big contract will mean a profitable year for Tina's business and months of employment for her assistants, so she and Paul are elated when the three of us head off to lunch. We decide to celebrate by going to one of the eateries Paul and I frequented in our student years, and for old times' sake we order a pitcher of beer along with slices of pizza and tuna grinders. It's the sort of food we gobbled down on a daily basis as teenagers, and it still tastes pretty good, but what tastes best are the memories. Recollection has its savor, too.

When we've finished and the waitress has cleared, Tina extracts my Shirvan from a tote bag and unfolds it on the table. Her reconstruction has been meticulous. The missing warps and wefts have been rebuilt with wool that simulates the original, and in the process all of the extant knots have been scrupulously preserved. She has created the necessary selvedge for the new areas of foundation without sacrificing any of the old, and she has removed two of the motifs that had been repiled with poor-quality yarn and replaced them with better repiling of her own. It's a superlative job, and yet somehow I'm disappointed. The $1,800 Tina asks for is a friendly price considering the time spent, but I can't help thinking that the money would buy a pretty good rug in pretty good condition from Jim Barnard or Robyn Del Vecchio,

whereas my rebuilt Shirvan still appears worn. That's not Tina's fault, of course. Examining the result of her labors, I realize that I have disappointed myself. After all, it was my choice to ask for neither minimal repair nor complete restoration. Tina has done what I requested and done it well, but I won't choose the Goldilocks option again.

I do my best to conceal my feelings and compliment Tina on her work, and when the check comes, I insist on paying it, even though Paul objects.

"You don't have to do that."

"Hey, you're the ones with the long drive. Put it into the gas tank."

"Don't flatter yourself," he says. "We were coming here anyway. We didn't do it for you."

"So you can pay next time. Let's meet up again."

We all agree on that as we head off into the rain, but we live hours apart, and our lives are full, and next time doesn't happen anytime soon.

Even so, unlike before, we don't fall completely out of touch. Paul and I send each other our publications, and we hear about one another from colleagues in the poetry world. And then one day, after another year has gone by, I get an email from Tina. She wants to know about Indian carpets, and on the basis of my chance observation in New Haven, she thinks I'm the person to ask.

> *When you identified the Mellon rug as Mahal it was useful to me, because I could refer to it that way from then on. Another rug project has come my way, this time in Jaipur, to propose a conservation program for the Imperial Carpet Collection of the royal family. Just in case Indian carpets are another area of your expertise, I'd love to hear whatever you have to say on the subject.*

Tina has overestimated my ability (recognizing a Mahal is no great feat in the world of carpet connoisseurship, and furthermore my doing so was no more than a serendipitous accident), but hers is an interesting request, and I do my best to help her the only way I can, by resorting to books. There are those in the carpet world who prioritize on-site experience and maintain that confining research to a library

results in the perpetuation of conventional wisdom, and they've got a point, even if their argument in favor of "fieldwork" would be more convincing if the people who wove antique rugs hadn't been dead for generations and the craft they excelled at had not been largely abandoned. Visiting the locales where the weaving took place satisfies curiosity, and there are travel agents who cater to carpet enthusiasts by organizing tours to locations in Asia known for their antique textiles, countries such as Turkey, India, China, and, when circumstances permit, Iran. As it happens, I've been to Jaipur myself, thirty years ago, back when I had loads of animal energy and alas no interest whatsoever in carpets. Even if I hadn't been ignorant, though, I probably wouldn't have learned much. What information may survive in the field is surely worth gathering, but as with the study of any historical art, carpet scholarship largely involves categorizing examples according to material and appearance and seeking to identify these categories in archival records and old eyewitness accounts.

Turning to the literature, however, I find that the publications in English that deal with Indian carpets are few, and, reading over such books as exist, that the Jaipur royal carpets have elicited rather more theories than conclusions. So there's not much help to be had, but I send Tina a couple of paragraphs sifting the speculation and synthesizing what information I can discover. I tell her that the provenance of the Jaipur carpets is a matter of debate, but since they are anything but uniform, they appear to have come from quite a few different places.

> *A lot of the royal carpets have been dispersed, but looking at the technical analysis of those still in the collection, one notices that there is a considerable variety of construction. Some of them have two wefts, some three; some have silk foundations, some cotton; some of their wefts are dyed, some not, etc. So a variety of sources—Khorasan, Kirman, Agra, Lahore—seems a reasonable deduction. If you wish to consult a text prior to your departure, there's* Indian Carpets *by Gans-Ruedin. It's not very good, but it does have color illustrations of eleven of the Jaipur palace carpets, and it includes some structural description. Knowing ahead of time what you will*

be dealing with might help you impress the royal curators, though I'm sure they'd be impressed by you anyway. Good luck, and let me know what you find.

Tina goes off to India accompanied by Paul and Nobuko Kajitani, and for quite a while I think little about her. One reason is that I have started to shop elsewhere. As my connections in the rug world grow, my possibilities for rug repair expand. I become friends with a dealer who has excellent contacts in Turkey, and the next time I have a good rug in bad condition I have him send it overseas. It's a Yürük, an Anatolian tribal piece, so sending it to the land where it was made is ideal, and when the rug comes back, the work is so good that when I show it to Robyn Del Vecchio, she's impressed. "This one scares me," she says, meaning that since she can't identify the rewoven areas, she worries that she won't be able to spot interventions in other pieces she handles. She's not alone in her fears. Even the Distinguished Professor shares her anxiety. When he's not teaching school, the D.P. works as a consultant to major museums and well-heeled collectors, and I've heard him lament: "I'm no good to anyone if I can't spot a fake, and it gets harder every day."

Provided with an alternative, I cease to require Tina's professional services, because sending my damaged carpets overseas yields results as good as or better than sending them to Warwick. What's more, it's cheaper, or at least it's cheaper at first. Gradually, however, the cost goes up—evidently the "muscle" involved in the international restoration business wants a bigger piece of the pie—and soon there is the added complication of world politics. In an attempt to discourage Iran's nuclear ambitions, an economic embargo is imposed, and thereafter the importation of Iranian products into the United States is illegal. That means that while those able to afford it can still send a Turkish carpet to and from Izmir, a Persian one can't be repaired in Isfahan, at least not without subterfuge and risk. Because of this, when I buy a torn Qashga'i kilim a few years later and am looking for someone to sew it back together, Tina comes again to mind. She's a flatweave specialist, after all, and basic repairs on a kilim shouldn't cost too much. I give her a call.

It's Paul who answers the phone. We exchange greetings, and I ask for Tina, and he stuns me.

"Tina died, George. I thought you knew."

"What? No, I didn't know. Paul, I'm so sorry."

"She died in Australia this past July. She wanted to go back."

Tina Kane died of ALS—Lou Gehrig's disease—a fatal progressive paralysis that is not how anyone would choose to depart. As she got weaker and the end grew near, Paul took her home to their place in Victoria so she could see the landscape she loved a last time. And then she was gone and he was alone—alone in the hospital room where she died, alone for the long plane ride back to the States, alone in their big house in Warwick, alone through the days and months and years to come. I learn some of the details and register something of his loss when I go to see him at a poetry reading he gives in lower Manhattan. He's written a book-length cycle of poems about Tina, or more precisely a sequence of poems addressed to her. Graceful, questioning, seeking acceptance, they are Paul's attempt to transmute grief into art, but they are grief-soaked all the same.

> *When I find myself sighing, murmuring your name over and over,*
> *it is not you I am thinking of but the ghost who has taken*
> *your place.*

Paul is haunted by Tina's ghostly presence, but for the rest of her friends and colleagues, she has abruptly disappeared. She's vanished as completely as Ben Behzadi did, though unlike Ben she left a good deal behind to remember her by. Among other things, she left a book, *The Troyes Mémoire*, her sensitive and accurate translation of a manuscript that describes the planning and production of a fifteenth-century French tapestry. And of course she left all the carpets she carefully restored.

I have a photograph of Tina, one she sent in an email from Jaipur. In it, she is standing next to a Mughal carpet that is part of a group illustrated in the Gans-Ruedin book (these are unmistakable because they are shaped to fit around a throne or arch, curved on

one side, rectangular on the others). She carries a clipboard, and a man who I presume is a museum curator kneels at her feet to point out a spot in the rug's crimson field. Bending forward and staring intently, Tina seems unaware of the camera and entirely engrossed in her work. It's an emblematic image, a visual record of her collaborative professionalism and her deep devotion to the art of weaving.

The conservation project for the Jaipur royal collection turned out to be both a fascinating and a frustrating experience. As I learn from Paul, the once magnificent carpets that he and Tina and Kajitani were shown were in desperate need of attention. Faded and worn, tattered and torn, they were also incredibly dirty. The thick dust of the Jaipur's desert surroundings had worked its way into the pile, and removing it was a Herculean labor. For starters, there was only one small vacuum in the entire palace, and when they tried to use it, the electricity shorted out. With no better alternative, they were reduced to cleaning the large carpets by hand, but that presented its own problems. Caste prejudice was a major obstacle. Because the cleaning effort involved soil, none of the museum personnel would consent to participate, insisting instead that Dalits—so-called untouchables—be called in to work in total isolation. The Dalits beat and brushed the carpets with whisk brooms fashioned from twigs, and the dust of centuries was swept up as it emerged. This was repeated until no more dust could be extracted, at which point the carpets were wiped down with a damp cloth, and that was the best that could be done. There were other difficulties, too. The heavily damaged carpets required reinforcement, but professional-quality conservation materials were not in the budget. Ever resourceful, Paul went to the local markets and bargained for homespun muslin in whatever sizes he could find. The various pieces were pieced together so that the necessary dimensions could be achieved, and in this way the carpets were provided with an adequate backing. There was no money for insect-proof storage, either, and once again a makeshift solution had to be found. In the absence of the hermetically sealed polyethylene standard in Western muse-

ums, the otherwise unprotected carpets were rolled up with neem leaves. (Neem trees are native to India, and their leaves contain a natural insecticide.) All the work was improvised, and all of it was underfunded, but at least when the little team of conservators left Jaipur, the carpets they had treated were reasonably clean and more or less secure.

They had done what they could with what they had, but clearly more intervention was needed, and they drew up a proposal for a return trip. Alas, due to either a lack of resources or bureaucratic intransigence or simply a loss of interest, their proposal was not accepted. That was discouraging, and all the more so because they knew that there were other carpets in the royal collection that had not been attended to in any fashion. Access to these had been denied, though just why wasn't clear. (Rumor has it the sequestered carpets are involved in an inheritance dispute.) For whatever reason, the team was not invited back, and a carpet collection of major importance has been left to languish in neglect.

Any collector of art, or any thoughtful collector, comes to understand that we are not just gatherers but custodians, too. In acquiring rare and beautiful objects, we acquire also an obligation, for as the D.P. told the village elders, we have a serious responsibility. If we take proper care, the carpets we love may be passed on to others, perhaps to our descendants, the way the Jerusalem consul's Ferahan-Sarouk was passed on to me. Alternatively, someday our carpets may be auctioned off to be appreciated in turn by a new generation of enthusiasts. Or, for those collectors at the top of the food chain, our carpets may be donated to a museum and displayed to the general public. But leaving our antique carpets for the enjoyment of others can happen only if we do our best to conserve them.

Tina Kane, of course, conserved many carpets, and you can see them in many places. You can see the Burgos tapestry in the Cloisters in New York, where it draws thousands of visitors every year. You can see the Mellon Mahal in New Haven. And the old Shirvan she rebuilt for me can be seen hanging on my office wall. Its reconstructed foundation is ready to be repiled, but I don't think I'll have

it done. Maybe the Goldilocks option wasn't such a bad choice, all things considered. In its present condition, the worn and partially repaired rug testifies to both the imagination of the original weaver and the care that was put into preserving that weaver's achievement. In any case, it reminds me of Tina, so I'll leave her handiwork as it is. It's what I asked for, and she did a superlative job.

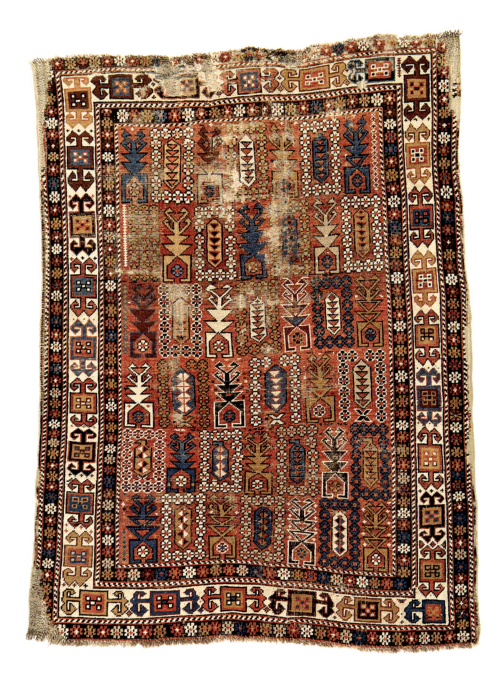

The Rebuilt Shirvan, 3 ft. 10 in. x 5 ft. 4 in.

NINE

The Hajji Babas

The Fragile Tabriz

I have a cracker loaded with cheese dip in my mouth and another in my hand when a large, sleek man in a suit and tie comes out of the neighboring room and tells me: "OK, you're in." I've just been accepted into the Hajji Baba Club, the oldest organization in America devoted to oriental carpets, and at one time quite selective about its membership. Times have changed.

The Club meets once a month in a building a few doors down from the Algonquin Hotel in midtown Manhattan, and the evening's events—usually a lecture and slide presentation followed by a show-and-tell of various textiles and concluding with a sit-down dinner—are preceded by a half hour of mixing and milling over cocktails and hors d'oeuvres. I know what to expect because I was at the meeting the month before, attending as a guest so that my fitness to join could be judged. Evidently I passed inspection, for the Club board has just voted to approve my application.

"Thanghx," I say, swallowing. "I'm really looking forward to being a member."

That I am here to be voted upon is a contrivance of the Distinguished Professor. On the last day of his course on oriental carpet studies, he pulled me aside to ask a question.

"Have you thought about joining the Hajji Baba Club in New York?"

"No," I answered. "I assumed that was only for society people on Park Avenue."

"That's not true. Well, maybe it used to be, but it's not anymore. Would you like to join?"

"I'd love to."

"All right, I'll get you sponsored."

The sponsors the D.P. persuaded to put me up for membership are the same collectors whose apartment I visited with his class. There is a pecking order among the members, with important scholars and prominent collectors high on the list, so the endorsement of people who have a five-hundred-year-old saph hanging on their bedroom wall is a persuasive recommendation. The truth is, though, that the sponsorship requirement is a formality left over from another era, and my acceptance was never really in doubt. The Club needs new blood.

The Hajji Baba Club, or HBC, was founded in 1932 by a group of businessmen who were sufficiently well-off to indulge in an expensive hobby but not so wealthy that they could afford the magnificent Safavid court carpets purchased by the fabulously rich industrialists and entrepreneurs who had assembled collections at the turn of the twentieth century. The Hajji Babas, as they called themselves, or sometimes just the Hajjis, turned their attentions elsewhere: to Anatolian village rugs, the nomadic rugs of Iran, the cottage-craft rugs of the Caucasus, the cargo bags and tent bands and animal trappings of Central Asian Turkmen tribes. Henry Frick or Benjamin Altman would have looked down on such things, but the various weavings collected by the early Hajjis greatly broadened the scope of those carpets thought worthy of scholarship, and their bequests now form an important part of the collections of several major museums. When you go to the Met to see the latest carpet rotation, what you find hanging there may well have once belonged to James Ballard or Russell Pickering or Joseph McMullen, Hajji Babas all.

The original members wanted what they considered the right sort of people. They wanted amateur enthusiasts only—no dealers seeking to profit by Club connections—and they wanted those they found socially acceptable. This left a lot of people out, and the restrictive attitude of some of the old guard led to the founding of another club to accommodate the excluded. The New York Rug Society existed from 1970 to 2000, but as America became less exclusionary, so did the HBC, and eventually the two clubs merged. Today's Hajjis are quite varied in background, and while no business is supposed to be conducted on premises, still the Club now welcomes profession-

als in the carpet trade. The HBC has grown to have an international membership, and it currently comprises collectors, scholars, dealers, consultants, auction specialists, and museum curators from around the world. Some members are all of the above.

It being my first meeting as a bona fide Hajji, I make a point of introducing myself to others. After the evening's lecture (it's about eighteenth-century rugs woven in the Ladik area of western Turkey), I sit down at the long table where dinner is being served and start to make acquaintances. The Club is a tightly knit group of unusual people, many of whom will become my friends, but I know no one at first, and I'm in for a few surprises. Sitting to my right is a young woman clad in a purple caftan and what appears to be a turban crossed with a top hat. When I ask her name, she tells me:

"Osprey."

There's a pause while I try to figure out where the conversation goes next. Judging by her clothes, I imagine the name is that of her spirit animal, though this Osprey doesn't seem like a bird of prey, and parents can make impulsive decisions in nomenclature. But regardless of what's on her birth certificate, looking at her I feel a wave of nostalgia. I used to wear pretty odd clothing myself. Of course that was in 1969, when I was sixteen.

"What do you collect?" I decide to inquire, falling back on what is the standard opening among rug enthusiasts.

"Oh, nothing really. I never bring anything in to show. All I can afford are little mats, and I don't think anyone would be interested."

"So you come here for the food?"

I'm being facetious. The food is typical banquet fare, not awful but nothing to write home about.

"No, I like to see the things other people bring."

"Sounds like a good approach. Sort of like sailing on other people's boats instead of buying a yacht of your own."

"Totally."

"Well, I sympathize, I don't own a lot of yachts, either."

On my left, it's different story. My neighbor on that side is a middle-aged man wearing designer-frame eyeglasses and a monogrammed shirt. Educated, sophisticated, and quick on the uptake, he is also an

amiable dinner companion, and in the course of a wide-ranging conversation it emerges that he was born into an old family in central India. Old Indian families are old indeed ("We're really from northern India; we only moved south seven hundred years ago"), so I surmise blue blood. A mutt like most Americans, I don't speak of my ancestry (English, Irish, Scots, Dutch, and if paleontologists are to be believed, a smidgeon of Neanderthal), and instead I'm about to ask him his profession when he asks me mine first:

"What is it you do?"

"Oh, I used to work in advertising, but that was quite a while ago. Now my wife and I have a little company that imports olive oil. We sell it in a few stores, but it's mostly for friends and family. How about you?"

"I run the second biggest hedge fund in the world."

Pause.

"Really?" I say, resisting the temptation to ask who runs the biggest. "And what do you collect?"

"Anything that catches my eye. I'm not one of those disciplined collectors, mind you, not like some people here. If a carpet is beautiful, I'll buy it, it doesn't have to be a particular type. I just bought a Lotto rug yesterday. I must bring it in."

Lotto rugs, named for the Venetian painter Lorenzo Lotto, who illustrated one in a sixteenth-century altarpiece, were woven in Anatolia anywhere from four to six hundred years ago. This man does not need to sail on other people's boats. He can afford any boat he wants.

The talk among the Hajjis flies up and down the table, as the members concur with one another, correct one another, cajole one another, join one another in laughter. They overhear one another, too, and my self-description has caught the attention of the person sitting across from me, a petite woman wearing a Chanel blouse and a discreet amount of what looks like very good jewelry.

"Did you say you import olive oil?"

"Yes, indeed," I answer, waxing expansive and taking the opportunity to entertain. "I married into it, which is about the only way anyone starts in the business. My wife's parents had olive trees in Italy, and my father-in-law wanted to sell our oil by the bottle here

instead of selling it there in bulk. So I created a little company to do that for him."

"How little?"

"Tiny. That's probably a good thing, though, because it means we're no threat to the big boys. You see, I read in a book that olive oil was a cover business for the Mafia for years. In fact, apparently some companies still have what you might call family connections. Salvatore Calatafimi was a notorious consigliere, and his son Joseph has his olive oil in every supermarket in America. So we're happy not to offer competition."

"Joseph Calatafimi is my uncle."

Pause.

I marshal my thoughts and choose my words.

"Well, ma'am," I offer, "I guess you know all there is to know about olive oil."

The months and meetings go by, and having become a persistent presence myself, I soon recognize the other members who are frequent attendees. It's quite a mix. There's the large man who informed me of my acceptance and who collects Uzbekistan ikats but would rather talk about the ballet. There's a short, round man of Turkish descent who is a bon vivant and likes to talk wine and martinis. There's an imperious woman who collects saddle blankets and has firm opinions about opera. There's a rail-thin man who loves Baluch weaving and whose angular features match the sharp wit of his New England sensibility. There's a fine-boned woman with a serious expression who publishes a textile quarterly. There's a woman who spent time in Iran prior to the revolution of '79 and owns a large collection of south Persian tribal rugs. There's a man who works for the Transit Authority and is interested in bag faces made forty miles southeast of Tehran in the town of Varamin. There's a woman who deals in pre-Columbian clothing from Bolivia and Peru. There's a contrarian dealer in flatweaves who is eager to disagree with anyone about anything. (That includes poetry; I restrain myself when he tells me Wallace Stevens is overrated.) There's an Iranian immigrant with beautiful manners who sells top-quality carpets to the city's carriage trade. There's a former financial analyst who buys new imitations

of old rugs ("They look better and last longer") and advises me to invest all my money in Apple. There's a successful music producer who restricts himself to Turkmen pieces. There is a small man who repairs large carpets after washing them in the bathtub of his tiny apartment. There are several retired diplomats who acquired their interest in exotic textiles while posted to faraway places. There are beginners just learning the basics, and there are scholars who have written authoritative books. It's an assortment of eccentrics with a common obsession, and I feel right at home.

The people are fun, and the food is tolerable, but the best part of being an HBC member is the opportunity to learn from the lectures. Or some of the lectures.

On one occasion, not long after I become a member, I arrive at the Club to find it packed. The hors d'oeuvre table is three deep, and the room where the lecture will take place is already filling up. The speaker who has drawn the crowd is a German dealer who sells nothing but high-end collectible carpets (most rug dealers carry furnishing carpets, too, if only to pay the bills), and who is ready to bid extravagant sums at auction to secure his desired acquisitions. His other expenses are correspondingly high, and his annual catalogs—hardbound, with fine color prints, detailed structural analysis, and extensive commentary—are so sumptuous that they are collectors' items in themselves. The spend-whatever-it-takes attitude has made the man well known in the trade, and the large audience this evening has gathered not because of the announced topic ("Celestial Geometry as a Soul Carrier to the Other World"), but because the amateur Hajjis have heard a lot about him and the professionals hope to do business with him in the future.

The dealer's spendthrift approach has brought him recognition, but it has brought him trials as well. Literally. He has spent so much money in his quest to handle the best rugs on the market that at one point his estranged wife tried to have him committed to an asylum. Fleeing to Switzerland to avoid capture, he took his carpets with him, whereupon a bank back in Germany accused him of absconding with entailed collateral, and he spent a short time in jail. Word got around, and his business collapsed, after which it took him years to

settle his lawsuits and rebuild his reputation. That remains a work in progress, but whatever the state of his mind or the condition of his finances, no one has ever questioned his eye for a fine carpet. He has years of experience and an instinct for quality, and now he has come to the HBC to share his ideas.

They are unusual ideas.

The lecture that ensues is both bizarre and boring. It starts with the premise that the observation of the heavens is the origin of all art, a hypothesis not implausible in itself, but not one admitting of proof. The currently unconfined dealer sets out to prove it nonetheless by means of a "new discipline" he has invented, which he calls "Applied Mathematics in Art History." This consists of measuring the lines and dimensions found in carpet design and comparing them with the angles of inclination found in astronomy. Armed with these angles, he has created charts and diagrams to demonstrate the correspondence he has detected between orbital planes and "a few basic patterns, layouts, and measures used in Oriental carpet and textile art." He shows us image after image of rugs that contain what he asserts are "practical examples" of motifs derived from the trajectories of heavenly spheres. And he is not a man afraid to extrapolate. He reveals that carpet motifs, properly understood, represent portals to a supernatural world. As he explains in detail, they illustrate "transition, infinity, and direction" and are "gateway designs expressive of eschatological geography." Alas, the metaphysical connections plain to him are not obvious to anyone else, and when the lecture finally winds up after two hours (twice the usual time allotted), it receives no more than polite applause, and no one has any questions. The best response to the wild speculation is that of the sharp-witted Baluch specialist, whom I happen to be sitting beside. As the patter of applause dies down, he turns to me and says with a deadpan worthy of Buster Keaton: "Well, I don't think we heard anything new here this evening, did we?"

The Celestial Geometry lecture is an extreme case, but it lies at the end of the crank spectrum, so to speak. Many people with bees in their bonnets are tempted by the exegesis of carpet iconography. The best scholarship is reserved on the subject, but reading less sober authors, one encounters all sorts of pronouncements as to

what the motifs signify. They are fertility symbols, they are tribal insignias, they are religious emblems, they are superstitious ornaments intended to ward off the evil eye. Any and all of this might be true, at least on occasion, but what is also true is that the mechanics of weaving undeniably impact design. Because the warps and wefts of a woven fabric intersect at right angles, certain patterns are easier to produce than others. For example, an eight-pointed star is much less difficult for a weaver to achieve than a five-pointed star, and while octagons are no doubt ancient motifs, the nomad who includes them in a horse blanket in preference to a pentagram may simply be saving herself work. Similarly, the right angles built into carpet structure mean that cross-shaped devices are very common, and yet not all crosses are necessarily freighted with significance. A big book appeared in the 1990s written by an author who claimed that the ubiquitous right-angle configurations found in oriental carpets are proof that they are Christian in origin. (This in an art form most often Islamic!) Few people in the carpet world give that theory much credence, but many will tell you that a cross shape seen in a Caucasian rug indicates the hand of an Armenian—that is, Christian—weaver. To which I say: maybe, and sometimes.

Some lectures given at the Club are less than convincing, but for the most part they are highly interesting, assuming one is interested in rugs to begin with. A particularly good one is given by a dashing and talented Iranian, a successful artist who is also a carpet connoisseur and has written many books about the animal trappings and cargo bags made in various parts of his country. Recognized nationally and even internationally for his sculpture and painting, the man exudes an implicit secularism and obvious modernity that have drawn the disapproval of Iran's theocrats, and he is often harassed and periodically arrested. Recently he was detained at the Tehran airport and refused an exit visa, essentially for the crime of being admired by the world at large, but was released in time to keep his date at the HBC.

The dashing artist is a handsome man, and he is assisted in his presentation by an extraordinarily beautiful young woman. As his lecture progresses—it's about contemporary carpets as fine art, in particular those he has commissioned to be woven from traditional

materials according to his instructions—the short bon vivant, whose name is Joe, whispers to me: "Where did he find that amazing girl?"

"In the cradle," I answer.

"What do you mean?"

"That's his daughter."

"Is that right? I think she's the most gorgeous thing I've ever seen. Don't tell Ivy."

Ivy is Joe's wife, who is quite attractive herself. She has a practice as a psychologist and a calm manner that is no doubt useful professionally, and I suspect it would come as no surprise to her that a beautiful woman can make an impression on a man. Like me, for example. Earlier, over the pre-lecture hors d'oeuvres, many of the Y-chromosome contingent in the Club found an opportunity to speak with the artist's daughter, and I took my turn. In our brief chat, I discovered that, unlike her father, she does not live in Iran. She lives on the West Coast of North America, where she currently works as a "life coach" (a West Coast employment par excellence) but would like to move on to something else.

"What I really want is to make films."

Godspeed. My guess is she has what it takes to open studio doors. If I see her name in film credits someday, I won't be surprised.

After the lecture concludes, the evening's show-and-tell session begins. Various members have brought in a few of their rugs to be passed around and commented upon, and in view of tonight's speaker, most of the items on display are Persian. I've brought a rug I think was made by the Khamseh (though it differs from the flawed Khamseh I got from Ben Behzadi), a confederation of tribes that used to migrate between pastures in the vicinity of Shiraz. The artist and carpet expert not only confirms this, he tells me which of the tribes most likely produced it: the Baharlu, a Turkic group that moved into Iran from an area in Central Asia that once supplied bodyguards to Darius the Great.* Wonderful stuff. Later on, when I leave the HBC

* The history of the Baharlu is by no means certain, however, and both Syria and Anatolia have also been postulated as their place of origin.

to walk to the subway and take the tube to a parking garage and drive two hours through the night to my home in Connecticut, I have plenty of time to think, and as I do I reflect that access to this kind of information is why I make the long trip. There are not many people outside of Fars Province who could tell me about my carpet in such detail and with such authority. It's good to be a Hajji.

Being a Hajji Baba, however, is not free of obligation. Only a few months after I join, I get a phone call from the HBC president, a placid and avuncular man whose even temper helps him interact with the Club's many unusual personalities. We exchange pleasantries for a minute or two, and then I assist him in getting to the point.

"So tell me, do you want time or money?"

"Time, I guess. Would you be willing to serve on the Club board?"

Oof, I'd rather not. I want to spend my time writing. I'm away overseas for much of every year. I'm the sort of person who does better working alone than as a member of a team. I live a long way from New York, where the board meetings are held. There are all sorts of reasons why I'd like to say no. Still, the board needs live bodies, and there are only so many bodies available. The HBC has hundreds of members worldwide, but only twenty or thirty of them are active on a regular basis, and many of these have already given their time in the past. I have to admit that if I'm going to enjoy what the Club offers, I should be willing to help it function. I'd like to say no. I say yes.

I'm in for more than I anticipated. When I join the board, I find I have been dropped in medias res into a struggle between the way things were once conducted at the Club and the way certain members would like to see them conducted going forward. The person at the heart of the push for change—and I will come to agree that change is necessary—is the diminutive yet self-possessed woman who was one of my sponsors. A former Club president herself, it is she who overcame the resistance of the old guard to the merger of the HBC with the New York Rug Society, and she now wishes to ensure that the unified organization she has created is stable enough to endure. Whereas the Club had long operated on the basis of gentleman's agreements and unspoken understanding, she wants to codify her ideas of how it should be run by drawing up a formally binding

set of bylaws. More broadly, she wishes to diminish the influence of anyone she views as a threat to the Club's future and increase that of her chosen successors.

All this means that some people are pushed out of positions of responsibility while others are advanced, and there are hurt feelings and flare-ups of anger in consequence. A simpatico but stubborn man is replaced as Club treasurer by the Calatafimi niece, who has a background in accounting, and he is so resentful that he at first refuses to cooperate in signing over the bank accounts involved. A mercurial woman who had thought herself in line for Club president finds she is maneuvered off the board instead and phones me in high dudgeon to complain about the many Benedict Arnolds who have stabbed her in the back, myself included.

"George, how could you do it? How could you betray me? I thought we were friends! I was going to make you vice president."

Heaven forfend.

"Come on, now, I actually supported you. I think the Club needs all of us, and I want us all to get along."

Which would be nice, but life doesn't work that way. There is no teapot too small for a tempest, and there is no collection of people too tightly knit for a controversy. Just read the Acts of the Apostles. Even a tiny group of committed believers united in their astounding faith and expecting the end of all earthly strife to be announced at any instant can fall into factions and serious disagreement.

Eventually, though, the controversy runs its course. The bylaws are drafted and approved, cooperative board members are found, a different candidate is singled out to succeed as next Club president, and ruffled feathers are smoothed. The tensions subside, and I am able to concentrate again on the most enjoyable aspect of Club membership, which is finding out all I can about carpets. Learning, what an inexhaustible pleasure! There's no end to the mind's hunger to learn, and there's no way to learn everything about anything. But one can try.

Useful instruction and shared information may be had at the monthly meetings, but the HBC offers other attractions, too. As with the D.P.'s college class, there are fields trips. Some Hajji Babas are part-time travel agents and organize tours to look at textiles

and observe artisans in countries around the world. Here at home, the Club makes expeditions once or twice a year to visit major museums and view some of their holdings. Major museums don't have the space to show all of what they own, and typically only a few of their carpets will be on permanent display; but in return for a modest donation, the Hajjis get to see many more, if not always as closely as we could wish. Museumgoers are expected to look, not touch, an understandable rule that is nonetheless frustrating; the way a rug feels is a large part of its appeal, and the way it looks on the reverse often says a lot about it. Fortunately, however, in our private viewings that rule is sometimes suspended. It depends on the staff. Some of the curators we encounter have little interest in us and treat our presence as a chore. Others are happy to have the Hajjis visit—we can tell them things about their carpets that they didn't know—and they let us examine what we are shown to our hearts' content. When that happens, I can find myself fingering carpets that date back many hundreds of years, and I'm reminded of a conversation I had with the D.P. about the textiles to which his status as a recognized expert gains him access.

"So what do you collect?" I asked early on, the standard question.

"Nothing now. I used to have a collection of Turkish kilims, but that went in my divorce. I don't really mind, though. After all, I can go to museums any time I like and handle the best carpets on earth. You might say my collection includes any carpet I want to see, and I don't pay for storage and I don't pay insurance. It's better this way."

Since the HBC is located in New York, the museum we visit most frequently is the Metropolitan, and it is often the D.P. who shepherds us around. Sometimes we go to the Met basement, where Tina Kane used to work and where there is a conservation and study facility that contains thirty-six thousand textiles stored flat in banks of enormous drawers. Other times we tour the carpets currently on view in the museum's public space and listen to what the professor has to say. For example, I learn that Portuguese carpets, so called because of the European sailing ships depicted in them, were made not in a colonial outpost and nowhere near the sea but rather in Khorasan, eight hundred miles inland. I learn that the design of old Persian garden carpets rep-

licates the layout of the walled gardens uncovered in Middle Eastern archaeological digs, good candidates in their turn for the design of the Garden of Eden. And I learn that you won't be thrown out of the Met in the D.P.'s company, at least not for a first offense.

Most of the very old garden carpets that survive were woven in Kurdistan, in northwest Iran, but a few early ones came from Kirman instead. One of these is now housed in Glasgow and has never traveled to the United States before, so when it arrives at the Met on loan, the HBC goes to see it en masse. Our group gathers around the knee-high dais on which the big carpet lies and hears about how it made its way from Iran to Scotland, about the profusion of plants and animals illustrated in it, about relevant descriptive passages in classical Farsi poetry, and as we listen quietly, the polished dealer to the carriage trade whispers in my ear:

"George, let's have a look at the back."

I don't say anything.

"Come on, let's see. Turn it over."

I'm tempted, not only curious but challenged by the boyish dare.

"Come on," he urges again.

What would Tom Sawyer do? I hesitate a while longer and then reach out impulsively to expose some of the carpet's reverse, and the two of us bend forward to peer at the warp and weft.

"Do not touch the carpet," comes the stern reproof of a curator. "It's not allowed. I could ask to have you removed."

"Sorry," I say, laying the carpet flat again. But we've seen what we wanted. The tightly packed weave, so worn that the warps are beginning to emerge on its back, does indeed say Kirman, even though this rug is four hundred years older than the nineteenth-century ones I am familiar with.

Touching a carpet at the Met is forbidden, but that's not the case with the next four-hundred-year-old Kirman I inspect, an auction lot that is soon to cross the block. The elegant and able woman who has agreed to serve as the next Club president is the specialist at Sotheby's, where the Corcoran carpets are to be sold, and she invites the Hajjis to a private preview. The gross mismanagement that has led to the dissolution of the Corcoran Gallery of Art in Washington, DC,

and the deaccession of its carpets is depressing to contemplate, for many beautiful old rugs will be leaving this country to be held permanently in institutions elsewhere, but before that happens the HBC gets to see them up close.

The collection that will be dispersed to settle some of the foundering museum's debt consists of twenty-five Persian carpets woven for the Safavid court during the sixteenth and seventeenth centuries. Safavid carpets are the most prestigious ever made in Iran—they are what scholars writing in the aftermath of World War II used to call "the big guns" of the carpet world—and the ones being offered at auction now include some spectacular examples. Chief among them is the Clark Sickle-Leaf Carpet, named for a Montana copper magnate who bought it in Paris and left it to the Corcoran. About nine feet by six with a bloodred field surrounded by a narrow blue border, the carpet has a design of winding stems bearing Shah Abbas palmettes that are framed by saber-like serrated leaves. Its many colors—when I get close, I count fourteen—are deeply saturated, and the carpet is so magnetic that it pulls me across the room to the exclusion of other lots in the sale. I linger beside it for a long time. Feeling its soft wool and peeking at the back to see its pink and red wefts, I tell myself that I have had my fun in life. I've seen the interior of Hagia Sophia. I've tasted Chateau Mouton '45. I've heard Joan Sutherland sing *Lucia*. And I've touched the most expensive carpet in the world. The catalog estimate for the Clark Sickle-Leaf is around $7 million, and the next Club president says she thinks it might even go for twice that much. In the event, it sells for almost $34 million to the Museum of Islamic Art in Doha. You can see it there whenever you like; all it takes is a plane ticket to Qatar. Touching it, though, is probably not a good idea.

Now that I'm satisfying my carpet mania by attending meetings at the HBC and going on Club excursions, I find that my urge to keep adding to my own collection is not as powerful as it used to be. I still like a rug shop, but I don't have to be in one every day. One reason is that in the course of a decade my initiate ardor has passed. Another is that I already own a lot of rugs. If I'm going to buy anything now, it has got to be something truly outstanding, and the price has got to be right. I'm aware of what dealers pay for their stock, and I know

the prices they charge one another, and I refuse to pay retail. That in itself slows down my rate of acquisition, because if you don't want to pay retail in a carpet transaction, you will have to pay with your time instead. You'll need to demonstrate to dealers that you understand what you are looking at and are in some sense a member of their fraternity, and it doesn't happen overnight. It takes repeat visits and plenty of conversation.

A typical conversation of this sort might combine commiseration with a little forewarning. When I enter a shop for the first time, I'll talk about the good old days in the carpet trade, when famous characters were still alive ("Did you ever meet Makarian? How about Vojtech Blau?") and the market was robust. Then I'll lament that the business isn't what it used to be and that you can't get the prices now that used to be standard. While I'm at it, I'll look through the stock and pause to discuss the subtleties of any carpet that appears unusual. The idea is to offer sympathy for the shop owner's difficulties, show some sophistication about the carpets on offer, and at the same time serve notice that I don't intend to overpay. It also helps if one can establish a personal relationship, and one of the best ways to do so is to converse about family. I might speak of my daughter Beatrice, an attractive woman who has become an English literature professor. (She can look like a fashion model and can sound like Erich Auerbach, a combination that has confused the boys ever since she was a teenager.) And I'll express interest in the dealer's loved ones in turn. (I aim to learn "all of their children and all of their names," as the old song says.)

One of the people I cultivate in this way is Rich Hegazy, the owner of a shop in northwest Connecticut, an hour's drive from me. A round-shouldered man with a combative sense of humor, Rich derives a lot of his income from real estate, and he sells carpets mostly because it's the family business and something he's always done. His Lebanese grandparents arrived at Ellis Island bringing little besides their offspring, and Rich tells me his family started dealing in carpets out of sheer necessity.

"My grandfather opened a corner grocery in Waterbury, but it didn't earn enough to support a family of six, so my *jida*, my grandma, needed to make money, too. She didn't speak much English, and she

didn't have a lot of education, but she had to find some way to help. Carpets were something she knew about from the old country, and she put that knowledge to use by asking people if she could wash their rugs. Actually, she had her children ask, because kids are hard to turn down. She would send my father out to knock on doors and tell him: 'Don't come home unless you bring back some money.' Knocking on doors is a good way to learn. It's a cure for shyness, and it teaches you how to deal with different sorts of people, people you'd never meet otherwise. Like for instance, back in the 1920s, when my father was ten years old, he tried a big, fancy house in the center of Litchfield. It's the expensive houses that have the expensive carpets, so he figured it was a good prospect. He knocked and knocked on the front door, but nobody answered, and he was about to go away when he heard laughter. The sound was coming from behind the house, and he walked around to the back yard to see. What he found was a party in progress. That was the Great Gatsby era, when the movie business was still based in New York, and in summer the film stars used to retreat to the Connecticut hills to get out of the heat. Sitting around a swimming pool and drinking prohibition martinis at eleven o'clock in the morning were Douglas Fairbanks and Mary Pickford with a bunch of their friends. 'Sure, kid,' said Fairbanks, flashing his cinematic smile, 'wash the rugs. Here's ten bucks.' That was real money in those days and it made a real impression. My father used to tell that story all the time."

As someone who grew up in the trade, Rich has an almost instinctive understanding of carpets—he's a person who actually *has* touched a hundred thousand of them—and he likes to tease me about my own depth of knowledge.

"Uh-oh," he says when I walk in his shop, "here comes Mr. Hajji Baba, the rug expert. I'm going to get porked today, aren't I?"

Porked is Rich's favorite vulgarity, possibly an inheritance from his Arabic-speaking forebears.

"Are you kidding?" I answer right back. "I don't ever see you that I don't pay too much. You've got the highest prices around. I can't figure out how you stay in business."

"High prices! I'm almost afraid to ask a fair price from you. I end up giving my rugs away."

"Then how come I never leave your shop without instant buyer's remorse? You should sell your rugs with complimentary tranquilizers."

And so on, back and forth. In fact, Rich's asking prices are a bit high, but he's usually willing to come down far enough to make a deal. Unlike with Robyn Del Vecchio, however, bargaining with Rich is a drawn-out affair. Robyn and I can arrive at an agreement in a matter of minutes. With Rich, it takes hours, even days. Sometimes he'll try to bait and switch: "Well, if that's all you want to spend, I could sell you this rug instead." Sometimes he'll counter my protested sticker shock by needling me about my politics: "A guy who's OK paying Obama's ridiculous taxes should be OK paying me." Sometimes he'll ask for sympathy: "George, help me out; I can't let it go for that little, it cost me more than that to buy it." Which is almost certainly not the case, because Rich is notorious for his parsimony. There's a saying in the carpet business that you make your money not when a rug is sold but when it's bought, and that's definitely what Rich believes. I've never managed to sell him any of my offerings, though on occasion Robyn will buy a piece from me only a few days after he has refused it at the same price. "You can't do business with him," I hear from other dealers more than once, "he's too damn cheap."

I spend many hours with Rich and join in his raillery because some of what he has on hand is well worth buying. An eleven-foot Yomut "main carpet" with outstanding color; a fragment of a very old Konya kilim; a Shirvan prayer rug of the type that might or might not be called a Marasali. Attracted by such material, I return to his shop regularly, and we gradually move beyond the dealer-client relationship to develop a real concern for each other. I find that underneath the badinage, Rich conceals a pessimistic outlook and a sense of foreboding. One day he interrupts a bargaining session to say:

"OK, it's about the rugs, but we're friends here, right?"

"Yes, we are," I answer truthfully.

He goes on to tell me that his elderly mother is in and out of the hospital, and that he is burdened with her care even as he is saddened by her decline. His own health is precarious, too, for he has coronary trouble and knows that few of the men in his family have lived into old

age. Among his biggest worries is the prospect that he might die before his mother and not be there to help her in her final days. You can laugh to keep from crying in this world, and so it is with Rich, who is quick with a joke but is at heart an apprehensive and anxious man.

As is typical of oriental rug dealers, many of the antique carpets Rich has in stock are Caucasians, perfectly good but rarely good enough to excite me. He also has a pile of miscellaneous bag faces I dig through whenever I stop in, and he has several room-size Ferahans and Serapis, which are quite attractive and quite expensive and too big to be conveniently collected. He has an assortment of Kurdish village rugs and runners and a fair quantity of Persian tribal pieces, Afshars and Qashga'is, but he rarely has much that is Turkish or Turkmen or Chinese. I get to know his taste and what I am likely to find in the way of new arrivals, but every now and then there are surprises. The biggest surprise of all is a five-by-eight-foot rug that appears to have come from a city workshop somewhere in Iran and looks to be quite old.

It resembles the Kirman carpets made for the Safavid court. Like the Clark Sickle-Leaf, it has a lattice of stems that hold Shah Abbas palmettes, and it has serrated leaves as well, though in this case there are only two. It features a prominent flower vase and a scattering of small blossoms, and the floral design lies on an ivory field. The many petals show a good deal of pink and pale blue, and the field is framed by a madder-red border carrying reciprocal strapwork meanders in indigo and white. The complex interplay of elements is perfectly balanced, and the borders articulate precisely at the corners. It's sophisticated in conception, harmonious in palette, and meticulously woven, a consummate example of the kind of artifice that is cool and cerebral. Looking at it on the floor of Rich's shop, I'm put in mind of Frost's description of his poetry as "a momentary stay against confusion." Wherever this rug is laid, it will be an oasis of serenity and order. It's cool, calm, and highly collectible.

Since the design says Kirman, I assume at first that Kirman is where the rug is from, though it's hard to be sure. Rich isn't certain, and identification is hindered by the fact that it is so fragile it's been given a backing, a fine mesh that covers the knotting on the reverse and obscures the structure. Whatever it is, I want it, and so another session

of drawn-out bargaining ensues. Rich would like cash, of course, and I only have so much with me, and I want to include a trade in the deal, which he would rather not accept. We spend the better part of an afternoon rejecting one another's proposals, until finally I reach my limit. I'm willing to part with $2,000 in cash and check, plus a small Kuba I bought for $800 and no longer like as much as I did.

"Rich," I tell him, "that's the best I can do. Why don't you just take whatever money came in the door today and go on to the next deal? You don't have to make a killing every time."

He thinks for a moment, shrugs his thick shoulders, and nods, and I roll up the rug and get ready to leave.

"You look happy," says Rich as I'm on my way out. "I must have been porked."

Which is what he says anytime I leave his shop with a purchase. It's essentially his way of saying goodbye.

The fragile old rug is a fine thing, but it isn't the thing I thought. I had wondered if it might not be a late exponent of the Safavid design tradition in Kirman, but it turns out to be something else entirely, and it's my fellow Hajjis who enlighten me when I bring it a few months later to the HBC annual picnic.

Once each July, the Hajji Babas gather outside of Manhattan for a catered buffet and an extensive session of show-and-tell. It's a chance to escape the city in summer, and because many members arrive by car, it's an opportunity to appreciate larger pieces than can be easily transported to the monthly meetings. The picnics are hosted by any one of several Hajjis who own suitable homes in the suburbs and are gracious enough to take on the trouble and expense (in theory their costs are reimbursed, but they rarely accept payment). The host on this occasion is the blue-blooded hedge fund manager from central India, and when the date on the calendar arrives, Spencer and I load some carpets into our station wagon and drive to his large house in Greenwich.

It's a humid day and very hot, and the Hajjis have dressed accordingly. The people I usually see wearing business attire or evening clothes are draped in baggy shorts and loose T-shirts, and they have broken into small groups to huddle under patio umbrellas and the

property's specimen trees. Even in the shade, I am soon sweating profusely. Seeking relief, I step inside and wander through the house from room to room. I'm drawn on by the rugs. As our host told me over my first dinner as a Hajji, there's no rhyme or reason to his collection, but the miscellany is impressive. Much of what I see—on the beds, on the floor, on the furniture, on the walls—would tempt any enthusiast. In the terminology of carpet appraisal, there's a scale of quality that runs from poor to good to very good to superior. A rug of superior quality is so fine that it instantly stands out in its category and makes others of its type seem mediocre by comparison. To my eye, the most superior of the many superior rugs in this home hangs in the stairwell that rises from the entrance hall, and it is thus visible from both the first and second floors, enjoying pride of place. A Central Asian Suzani, it was possibly a dowry piece and is made of brilliantly dyed silk embroidered on sections of cotton. The design consists of green vines and large swirling rondels in bright red (blossoms? fertility symbols? both? . . . who knows, ask the carpet cranks), and the overall effect is of great power and great beauty. Suzanis are popular with collectors just now, and the painstaking technique required to make them is not so painstaking as to prevent new manufacture. There are faux antiques on the market, but this is not one of them, and I realize once again that our host does not need to sail on anyone else's boats. He can own whatever vessel appeals to him, and what appeals is the best. If this Suzani were a yacht, it would be the prettiest one in the harbor.

After everyone has eaten and chatted a bit, we all move to a section of lawn where several rows of collapsible chairs have been set up in a semicircle, and the show-and-tell begins. The sun is no longer directly overhead, and there is a little more shade, but the day is still hot. It would be easy to be distracted if the items on view weren't so compelling. We are shown some Kashmir shawls that date to the early seventeen hundreds. We see some Shahsavan animal covers, flatweaves whose patterns are composed of horizontal bands in many colors, and analogous Anatolian pieces that have weft-wrap designs. One dealer, a woman of Middle Eastern origin, displays a pictorial rug that is undeniably one of a kind. It's a portrait of herself seen against the background of a carpet shop, and she tells us that the image constituted a

deliberate act of rebellion, a celebration of her defiant independence. She explains that she was heavily discouraged from entering the carpet trade by the male professionals who controlled her culture's business world. Commissioning the woven likeness of an unveiled and self-confident woman was her way of rejecting the repression and chauvinism she had successfully risen above.

Eventually my turn comes. I show a Demerçi prayer rug, a small Tekke carpet, and an Ersari animal trapping, and they receive respectful if unexcited appreciation. When I spread the fragile Persian on the ground, though, the group perks up, and some people clap.

"Look at that!" exclaims our host, coming over to get a better view. "What do you think it is?"

"I'm thinking maybe Kirman."

But other Hajjis think otherwise.

"The colors aren't right for a Kirman," says one.

"It's an odd size for south Persia," says another.

"What it is," says an elderly scholar, leaning forward in his seat and resting both hands on his cane, "is a mid-nineteenth-century Tabriz. I recognize the border pattern. It was probably soaked in a wood-ash solution to tone down the colors, which is something they did there before they had chemical bleaches. That's why it has the soft palette."

"Why do you think it needed the backing?" I ask.

"Tabriz carpets are thin to begin with, and the wood ash stressed the wool, so it's not surprising it started to fall apart. And it's old: 1860, 1870, something like that. Tabriz was the first place that began weaving rugs for export when the Iranian carpet business revived. Elsewhere, a rug like this wouldn't have been made until the 1890s, but in Tabriz it happened earlier. You don't see them much anymore. This one's nice."*

They're nice words to hear. I feel like a proud parent, and it occurs to me that I've come a long way in my mania. A find like this one, the

* A carpet of this type—a copy of the old Kirman vase carpet design—was exhibited in the Vienna World's Fair of 1873, and perhaps my rug was woven in response to the enthusiasm generated by that exhibition; but the rug seen in the fair was of course woven earlier, as may also have been the case with mine.

sort of beautiful rarity that collectors seek and specialists admire, is something I couldn't have imagined owning—something I didn't even know existed—back when I was looking through the carpets in Jim Barnard's storage shed and beginning to fall in love. Since then, the process of refining my taste and deepening my understanding has added immeasurably to my interior life and has widened my perspective on the world. Carpet collecting has introduced me to people and places I would never have encountered otherwise, and while there have been ups and downs, I'm happy with where I've arrived. Day by day for over fifteen years, the fascination that comes with the collecting gene has helped put the savor in life. The ambition I started with—to "learn all about carpets"—was laughable, but that doesn't mean the effort was wasted. Beautiful carpets reward the touch and entrance the eye, but assembling my collection has been satisfying intellectually as well. Most people buy carpets to furnish their home. I've bought them to furnish my mind.

When Spencer and I thank our host and make our goodbyes and get in our car to drive home through the weekend traffic on I-95, I'm glowing. Glowing is not something I do a lot of, and Spencer notices.

"It's been a good day, hasn't it?"

"It's been great. What shall we do with the carpet?"

A question not easily answered. The old Tabriz is too delicate to walk on, even in bare feet in a bedroom, and it can't be hung on a wall. The ceilings in our house are too low to accommodate it, and in any case its own weight might tear it apart. I could sell it, of course. When I show it to Robyn, she's eager to buy it—and if her interest is obvious, that means it's a very good rug—but selling it would only result in its being destroyed on somebody else's floor. And so, since I can't display it and don't feel right about selling it, it will have to become another pet, like the Khamseh I bought from Ben. I'll store it carefully and pull it out now and then to look at it, and every once in a while I'll take it someplace to show to someone who shares my obsession. There aren't many people who think that a passion for carpets is one of the best reasons to get up in the morning, but by now I've met a few. And I'm about to meet another, a Hajji Baba who will prove to be even more rug-crazy than I am.

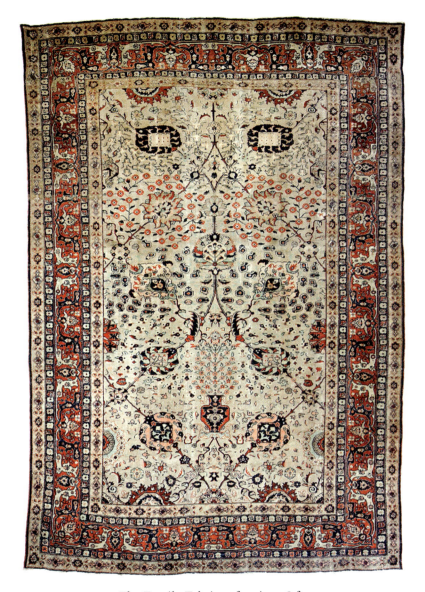

The Fragile Tabriz, 5 ft. 5 in. x 8 ft.

TEN

Wrong about Everything

The Reduced Kazak

"I'm telling you, George, there's no such thing as Ferahan-Sarouks."

"What are you talking about? Everyone knows what they are."

"It's a misnomer. There's no legitimate difference between them and a Ferahan. They were all made in the same area by the same people, and then somebody, probably some auction house, decided to call them separate names. They're just plain Ferahans, that's all."

I'm standing at the HBC hors d'oeuvres table talking to a new member, a balding man wearing wire-rim glasses who is perhaps a few years older than I and is certainly in better condition. He's lean and energetic and cheerfully sure of himself, and he has recently retired after serving as a New York State judge for thirty years. John Bean, known to rug dealers near and far as Judge Jack, or simply as the Judge.

"Nobody's saying they don't come from the same place, Jack. But the weaves are different. The names are just a way of distinguishing structure, that's all. Look, a lot of carpet terminology is arbitrary, right? As long as everyone knows what you're talking about, that's what matters."

"What matters is getting it right. Names get invented, and when they do, they get in the way. Use different names, and people think there's a difference when there isn't."

"But the weaves are different, so there is a difference."

"Not really."

"What are you, living in an alternate unreality?"

We're both smiling and both enjoying ourselves, but we're a bit like two dogs standing stiff-legged at their potentially confrontational first encounter. We both think we know more than the other, and we are both competitive people. As we reiterate our positions, I'm reminded of an acquaintance I made in a hotel lobby in Istanbul at the

age of twenty-five. I fell into conversation with a young couple from Holland, and soon the man and I were in lofty argument, correcting one another's opinions about marble revetments and floor mosaics and decorative brickwork, each demonstrating his unrivaled appreciation of Byzantine art and superior grasp of medieval chronology. We continued in this insufferable behavior for some time (longer in fact than made sense . . . ten minutes? fifteen?), and then we paused to consider and looked again at each other and recognized ourselves as kindred spirits. We've been friends ever since. Something of the same is happening now between me and Judge Jack.

"George, lots of carpet names mean more than one thing."

"Well, I suppose enforcing confusion won't get you committed," I allow peaceably, "though maybe it should. Anyway, tell me, what do you collect?"

Which is to say, let's agree to disagree. That's often where our conversations about rugs wind up, because connoisseurs will quibble, and because conclusive proof where oriental carpets are concerned is rarely available. But in spite of what becomes our habitual sparring, Jack and I gravitate to one another, and before long we are buying each other drinks prior to the HBC lectures and sitting side by side at the dinners that follow.

Jack is an enthusiastic and gregarious man, and I soon learn a good deal about him: that the original name of his French-Canadian ancestors was Haricot and became Bean only when anglicized; that he still lives in the town in Orange County where he was born; that he went to a local college, where he played basketball, but went all the way to Oklahoma to attend law school. Many lawyers wind up working in the place where they got their degree, but Jack came back home to practice law and there gained the confidence of the politicians who would appoint him a judge at an early age. They were conservative politicians, and I discover that Jack's political opinions are considerably to the right of mine. It's the summer of 2016, the final months of the tumultuous presidential race between Clinton and Trump, and it seems no one can avoid the subject.

"I wouldn't vote for Hillary if you put a gun to my head," says Jack. "She's a crook."

"*She*'s a crook? Compared to Trump? Anyway, what's she ever done that anybody ever proved? Ken Starr tried to find stuff on her for years, and he came up with nothing."

"George, I'm telling you, nobody trusts Hillary. Come upstate and look around, you won't see a single sign for her. I bet you Trump's going to win."

Political differences are notorious for driving people apart—no one changes their mind when confronted with opposing views, they just grow exasperated—but Jack and I don't let that occur. We're careful of one another's feelings and tread lightly through the emotional minefield the election season has laid down, and in any case we are too busy agreeing to disagree about carpets to have much time for other disputes.

There's no shortage of items for discussion. I own many rugs, but Jack owns hundreds more, and he buys them at a breakneck pace. Three at a time, five at a time, almost every week and certainly every month. He acquires them in every possible venue, in small shops and at sprawling antique fairs, in warehouses and out of private homes, from other collectors and from dealers high and low. He takes frequent trips to play golf or tennis or to fish for salmon or trout, and his recreational travels give him a wide range in which to hunt. As a result, he is known to merchants in many places. From Yarmouth, Maine, to Palm Beach, Florida, from Pacific Palisades to Washington, DC, in San Francisco, in Denver, in Philadelphia, and of course in New York, dealers all over will set aside collectible items for him, confident that if a piece is good and the price is reasonable, the Judge will buy it whenever he next comes their way. With no family to support, he has money to spend, and he has the collecting gene in spades. He always has a new rug to show me, and I don't even try to keep up.

I do, however, offer my opinion. Jack regularly emails me photos of rugs he has bought or is thinking about buying, and the two of us will analyze and argue. For instance, a picture comes

in on my cell phone of a small rug he calls a Chondzoresk, and I respond:

Dear Jack,
Your possible purchase is attractive, but the drawing is very regular, the colors don't seem right for the Caucasus, the borders don't seem very Caucasian either, and the warps look to be cotton rather than wool, at least in the photo. Maybe it's somebody's idea of a Chondzoresk, it's got those thick cloud bands, but whatever it is, I don't think it's nineteenth century. It's nice, but is it collectible? Of course, I could be wrong about everything. Who knows? The rug can't talk.

—GB

His answer comes right back:

Hi George,
I think you're wrong about everything!! I'm not sure about the foundation of this rug, but I'll check. It does have a very fine weave, so the wefts may be cotton. By the way, Chondzoresks are not Caucasians. They're from Karabagh, and the red is the proper hue for Karabagh. As to its age, you may be right. The rug may only be 112 to 117 years old. I don't know if it's a collectible rug. I haven't examined it that closely.

—JACK

Additional information that only sets off further bickering:

Jack, look at a map. Karabagh is part of the Caucasus. You'll notice Armenia and Azerbaijan are fighting over it right now.

Geography, however, gets me nowhere:

When it comes to carpets, George, Karabagh isn't the same thing at all.

I try resorting to outside authority:

Aren't Kazaks Caucasian? Then how come the rug books call Chondzoresks "Cloud Band Kazaks"?

Which elicits an answer I hear from him often:

Because the books are full of wrong information, I keep telling you that. Talk to you soon. Say hello to Spencer.

Neither of us ever wins. Our unresolved conversations are as inconclusive as art. As with a poem in the making, you're never satisfied, you just give up. (Or at least I do. Yeats said that a poem comes right with a click like a closing box, but such finality in composition has rarely been my experience. I'm always tempted by further revision. The poem as imagined and the poem as I leave it on the page resemble one another more closely now than they did when I was younger, but they're never identical. After a while, though, revision yields diminishing results. You've done what you can, and it's time to move on.)

Since his thirst to acquire is never quenched, the Judge has lots of things to bring to the HBC monthly meetings, and between the two of us we are in danger of overwhelming the show-and-tell. I try to encourage wider participation, telling other Hajjis that the more they bring in the better and telling Jack that he and I should go easy so as to avoid dominating the proceedings. Jack, though, has limited patience for such delicacy.

"George, we're not stopping anybody else, we're the only ones who care. If they loved rugs the way we do, they'd all have stuff to show."

"I worry we might be intimidating people."

"Nah, they're just lazy. If we didn't bring stuff, nobody would. It's no fun when there's nothing to see, so we're doing everybody a favor."

He's got a point. It's axiomatic that when carpets are involved, there will be a lot of lifting, and not enough Hajjis go to the effort of packing up their rugs and carrying them to the Club. In the absence

of other material, the profusion of bag faces and rugs Judge Jack can be counted on to bring is much of what makes the meetings such a pleasure. If he's attending, there's certain to be something lovely to look at, something to understand better by holding it in your hands, and there's no predicting what.

Jack's appetite for oriental rugs is cormorant. He collects everything: Kurdish bag faces, Baluchi bag faces, Anatolian yastiks, Ottoman velvets, Shirvan kilims, Bijar kilims, Bijar rugs, Bijar carpets (he likes Bijars), Kirman mats, silk Kashans, Qashga'i shoulder bags, Azeri embroideries, Shahsavan jajims, Turkmen camel trappings, Chinese saddle covers, Afshar rugs, and also Bakhtiaris, Ferahans, Isfahans, Varamins, Kazaks (Chondzoresks included . . . he bought it, of course), Khamsehs and Kubas and more, even low-prestige rugs like Hamadans, even Hamadans of relatively recent vintage . . . on and on, et cetera, et cetera, et cetera. He is so avid a collector and has such wide-ranging tastes that dealers are constantly trying to get in touch with him, hoping to tempt him with a photo. When it gets around that he and I are in frequent contact, I start to get emails and text messages asking about him. "Do you have a current phone number for the Judge?" "Could you pass on these pictures?" "I've got a really nice Yürük, would you ask Judge Jack if he's interested?" And it's not just dealers trying to sell, it's dealers looking to buy.

All dedicated collectors of oriental carpets will sooner or later have ones they would like to get rid of, meaning that everyone you meet in the field is looking to sell something. A collector is an amateur dealer almost by definition, and the rule holds true for Jack. Unlike most of us, however, he owns so many carpets and so many of them are of such good quality that rather than going to any trouble to deaccession those he no longer wants, he can simply wait for buyers to come to him. Professionals who need to replenish their stock will stop by his home and leave with five or ten or fifteen carpets, purchased in cash of course, cash that the Judge will quickly use for yet more acquisitions.

A mania for acquisition can easily end in chaos, but in spite of the great quantity of textiles he has accumulated, the house Jack lives in

is surprisingly clean, and orderly in its way. That's not to say, however, that it has much room for anything except his collection. His home has rugs in all the usual places—on the floors and walls, over armchairs and beds, behind the appliances and under the furniture—but it doesn't stop there. His dining room table is entirely occupied by a pyramid of rolled room-size carpets; his mudroom contains a stack of rubber tubs that hold fifteen or twenty bag faces apiece; and when I first come to visit, I open what I take for a coat closet and count twelve more carpets standing on end.

"Oh, those are some of my Bijars," says Jack.

He likes Bijars.

The house the Judge lives in has space for hundreds of rugs, but one glance will tell you it doesn't have space for a woman. Nothing about it speaks of a woman's touch, and anyway, where could you squeeze one in? Even if you could, it wouldn't go well. Jack is a healthy animal, but he is a lifelong bachelor and hence undomesticated. Active, well-to-do, and socially respectable, he is attractive to the opposite sex, but he belongs to that category of men who find women a necessary annoyance. Drawn to them, he is not patient with them, and he is forever complaining about his current partner. At the moment it's a lawyer named Julie, who is easily ten years younger than he and is both pretty and in pretty good shape. Physically, they seem a good match, but there's little meeting of minds.

"George, she wants us to move to San Diego! Who in hell wants to live there? Get rid of everything here and buy some zillion-dollar cubbyhole two feet from Mexico? Give me a break!"

There's so little understanding between them that Julie has made an obvious unforced error.

"She wants me to get rid of the rugs! She keeps telling me it's stupid to buy more at my age, she says it's a waste of money. I should quit being interested in things just because I'm not a kid? That's nuts. And, besides, it's my money!"

A showdown about carpet acquisition would clearly be ill-advised. If something has to go, it won't be the rugs. Nothing in Jack's home betrays a woman's touch, but there is a lady of the house: a

brown-and-white short-haired pointer bitch named Isabelle. People love their pets, and Isabelle is the creature in this world that Jack cares about most deeply. As old in canine years (she's ten) as he is in human, she has begun to have ailments, and no nurse has ever had a better bedside manner than the Judge has with his dog. She suffers from an immune disorder that causes swelling in one of her legs, and Jack has her on a special diet as a result. He buys Isabelle "medically formulated" food off the internet and mixes it with tidbits he cooks himself, and he feeds her by hand, sitting beside her on the kitchen floor. The elaborate attention might seem excessive, but Isabelle certainly seems happy. Whether it's the diet or the affection, the treatment seems to work.

Jack takes his dog everywhere, and he's rarely without her.

Because she's too large to be allowed in the cabin of a plane, he travels on his various trips by automobile. Many of the trips are spontaneous, and many are long distance. It's not unusual for him to wake up one morning and grab a few trout rods and drive off with Isabelle to fish in Montana. I've reached an age when three or four hours spent in a car will make my body complain, but the Judge has no hesitation about driving across the country. He'll spend days on the road, and the long hours behind the wheel give him plenty of time to fill. The phone will ring, and I'll hear his buoyant voice echoing through the communication system of his BMW:

"Hi, George. Me and Izzie are headed down to Florida to play a little tennis and hit the Miami Beach antique show. Sometimes you can find really good stuff there. People go south for the sunshine, and then they kick the bucket and whatever they brought with them gets sold off cheap. That's why, if you know what you're doing, the dealers down there will give you a bargain, they can afford to. I bought a nice little Kirman in Miami last year, I mean it's really nice. It has a very fluid version of the millefleur design, probably the best I've ever seen, in a small piece anyway, and it's got a really tight weave, over four hundred knots to the square inch. It's got great color, too, fourteen different dyes, that's top-quality Kirman. Kalabian tried to buy it from me, he offered a lot of money for it when I showed it to him

in New York. Of course, you know why he wants it, he wants to sell it in Europe, that's where the high prices are now, but I'm holding on to it, I don't care how much he offers...."

Jack's rug-buying forays are the stuff of envy, or at least of serious admiration, and when he suggests one day that we do a little shopping in tandem, I'm quick to say yes. Each year there's a textile trade show held at the Javits Center in New York, and this year it will be accompanied by an oriental carpet fair featuring multiple dealers who have rented space in an old factory building a few blocks down Eleventh Avenue from the convention site. The Judge and I decide to go, and we rendezvous ahead of time to have lunch together nearby. That is, we meet at a food cart on a street corner outside the entrance, where we eat souvlaki while standing on the sidewalk.

When we've swallowed the last of our lamb and wiped the yogurt off our fingers, we pass under the twenty-foot arch that frames the doors of the factory's brick facade, and once inside we are instantly in carpet heaven. There are five or six rooms holding five or six dealers apiece, dealers from around the country and around the world. The smell of high-lanolin wool is everywhere, and there are so many excellent carpets on display that it's hard for my distracted eyes to focus on any of them. I know some of the dealers already, and Jack introduces me to several more, so we chat with various people for a while before getting down to business. Then we go through everything on offer, room by room and just about rug by rug.

We find much worth bargaining for, and some of our bargaining meets with success. I've been looking to acquire a Senneh mat of the sort that were made a century ago to a very high standard and purely for display. They were created to be collectible, which they are, but they're getting hard to find, and now here one is, a lovely piece I manage to buy after a little haggling. (It has some moth damage, not so much as to be disfiguring but still deserving of a discount.) Jack buys a south Persian *chanteh*, an exquisite little bag intended to hold a woman's personal items, her combs and kohl. Then I buy a nineteenth-century cottage-craft rug that the seller, a Turkish national named

Mehmet Özdemir, tells me was woven in Taskale, a village close to Karaman, where he was born. Then Jack buys a pictorial Qashga'i that shows King Darius stabbing a lion, an image copied from the monuments of Persepolis. As the two of us move from room to room, we keep up a running commentary on what we see (Do you think that Kazak might be Armenian? . . . Can you believe that bleached Qasvin they're trying to sell as an Ushak?), and then we come to a stop, brought up short by what looks like a seventeenth-century Anatolian prayer rug but is a bit stiff in its drawing and a little off in its palette.

"What do you suppose it is, Jack?"

"I don't think it's the real thing. It's a pretty good copy, but I'm not sure it's even from Turkey."

"The colors are strange," I say. "How about Indian? It's on cotton, and those palmettes in the border could be lotus blossoms."

"Hmm. How about Tabriz? They imitate everything there, you know that. Especially Turkish designs."

"Yeah, but most of those are silk. And they're smaller."

"Check the ply of the warps," says a voice behind us. "If they're four ply or less, it's not Indian."

I turn to see who's talking, and I stare. The man is nearly as tall as I and wears what's left of his radically receding blond hair pulled tight in a long ponytail. He's dressed in pale-green tights and a blue gingham dress that is hemmed mid-thigh and cinched with a leather belt. Oversize plastic costume jewelry adorns his wrists and fingers, and the circular frames of his orange eyeglasses are plastic, too. He's tall enough that I look down to see if he's standing in heels. He's not. He has on basketball sneakers, bright red with green laces.

"I'm pretty sure it's Persian," he says. "Tabriz is a good bet."

The apparition speaks with a New York accent, and his words are a little slurred. I notice he's missing teeth.

"Thanks, Andrew," says Jack after we do what the man recommends and check the warps. "Only four strands, we'll call it a Tabriz."

"Who in the world was that?" I ask the Judge as we walk away.

"Oh, that's just Andrew."

"Who's he?"

"Andrew Sawyer, carpet dealer to the stars. He's got a bunch of celebrities for clients, movie actors and rock musicians. Andrew sort of speaks their language, if you see what I mean, so they feel comfortable with him. Other dealers only wish they had his customers."

"He looks like he comes from Mars."

"Oh no, George. Andrew comes from much farther away than that."

"Does he always dress that way?"

"Not at all. Usually he wears better shoes."

Hunting for rugs with Judge Jack is exhilarating, and when the day comes to an end, I'm eager to do it again. The textile show at the convention center happens but once a year, though, and there's no telling when another carpet fair might come to town, so for our next foray we decide on an expedition to visit several dealers who have set up shop in Queens.

People with rugs for sale are like jewelers; they tend to band together. Just as New York has its diamond district, it also has areas where its carpet dealers congregate. When I first moved to the city, I lived in Hell's Kitchen across Eleventh Avenue from a building on Fifty-Fourth Street that contained seven or eight rug shops distributed over several floors. Following the completion of Lincoln Center, however, the West Side became an increasingly desirable neighborhood, and when Times Square was renovated, the nearby blocks of blighted tenements ceased to be the hottest part of hell. Rents rose, and when they did, the carpet dealers left. Many of them moved to the market that already existed in the lower thirties off Park Avenue, and some of them are still there, but as Manhattan grows ever more expensive, and as the oriental carpet business in general has suffered a decline, dealers who lack a kid-glove clientele have once again begun to look for cheaper alternatives. Some have moved to the postindustrial swamplands of New Jersey. Others have moved to New York's outer boroughs, and that's where the Judge and I go to find them.

We meet after rush hour under the zodiac ceiling in Grand Central Station, where we're joined by another Hajji, the bon vivant Joe. "Top of the morning to you, gents," he says when he sees us. Joe used to work handling legal affairs for a brokerage firm, and perhaps as a

result, his manner oscillates between ceremonious and blunt. "Jesus, the subway, what a pigsty. I should have worn hazmat." As it is, he has on a sports jacket and wool slacks for a rug crawl in Queens, whereas Jack is wearing khakis and I'm in chinos. The three of us exchange greetings and decide we've all had enough coffee and don't need to stop in the station for more. Then we descend two levels and take the 7 train under the East River to Long Island City.

One of the reasons the Judge remains in top physical condition is that he treats any activity as an athletic event, and when we emerge from underground, he sets out walking at a rapid clip. *Rapidissimo.* I run for exercise and do my best to stay fit, but I'm having trouble keeping up; and Joe, who has short legs and drinks martinis for exercise, is soon breathing hard. After a few blocks of trotting at Jack's heels, I'm about to tell him to slow down, much as I'm loath to. It's embarrassing to ask for an easier pace, but Joe has stents in his arteries, and we wouldn't want him to have a heart attack. Hell, I don't want me to have one. Just when I'm about to call for a halt, though, we arrive.

The riverfront in Long Island City has seen a construction boom in recent years, both commercial and residential, but just a few blocks away from the burgeoning glass towers gentrification is still in the offing, and the area remains unimproved. As close as it is to Manhattan, someday soon this will be a fashionable place to live, but today we've been walking past empty lots and abandoned warehouses and plenty of razor wire. The building we come to looks empty as well, but the Judge makes a phone call, and somebody buzzes us in. We climb three flights of stairs without seeing a soul and reach an unlit hallway that has peeling paint on its walls and worn linoleum underfoot. Most of the doorways along the hall stand open, and in one of them a man is waiting for us. Wearing brown pants and a baggy sweater, he looks dignified, serious, and reserved. Under the sweater, he's thick around the waist, and his ruff of remaining hair is gray. He isn't old quite yet, but he's a long way from young.

"Samir!" calls out Jack as we're still walking toward him. "I've brought some people to see you. And I've got a yastik with a selvedge

the girls can sew up for me. It needs an end worked on, too, but no big deal. So how have you been, how's your family?"

The introductions are made (rather than shaking hands, Samir places his hand on his heart and bows slightly), and then we enter the most crammed and cluttered rug shop of all the cluttered rug shops I've been in. So much of the floor space is filled with carpets that the effect verges on claustrophobic. There are rugs piled up to the ceiling on large shelves made of angle iron, and there are rugs stored on end as well, so many of the latter that fully half the available area is occupied by a palisade of rolled carpets that support countless others heaped on top of them. A row of grimy windows, partially blocked by the mountain of rugs, lets in some natural light, but the small wooden table that is Samir's desk stands in shadow and is lit only by a computer screen and a gooseneck lamp. The packed room would seem to have no room for anything else, but I hear voices coming from somewhere, and I discover that one of the walls in the shop is actually a partition. Behind it, two women sit with carpets spread before them and needles in hand. Jack greets them by name ("Leila!" "Yasemin!") and they smile to see him, though their fingers never stop moving.

In spite of Jack's assurance that sewing up his yastik will be simple, his instructions for repair are quite detailed. It's an east Anatolian piece, by the look of it—probably Kurdish, given its palette and place of origin—and in order for the ends to match, Jack wants a line of embroidery added to arrest its unraveling instead of a simple overcast. He addresses his instructions to Samir, even though the women who will do the work can hear every word, and there's nothing said about cost. I learn later that due to his constant collecting, the Judge has so many rugs in need of attention that he has Samir on retainer. Periodically, he writes a check for $1,000, and Samir tells him when the money left on account has been used up and he needs to write another.

With the repair work decided upon, we ask to see what Samir might have to show us. On Jack's advice, he crawls up on top of the carpet mountain and digs until he finds a Ferahan-Sarouk of the sort

I often like. It's about four feet by seven, with a serrated central medallion and an ivory field filled with branches and blossoms. "Right in George's wheelhouse," exclaims Joe, who knows my tastes, too. And he's not wrong. Ferahan-Sarouks ("They're just Ferahans," says the Judge yet again) have appealed to me ever since the Jerusalem consul's souvenir first launched me on my carpet adventures. The best of them combine the refinement of Persian workshop weaving with the individual hand of cottage-craft work, and in my opinion they have many of the virtues of a Kashan for considerably less cash. But this rug is not among the best. It's not in great shape, and there's nothing out of the ordinary about its design, and in any case Samir's price is too high for a carpet that is only OK. I pass.

Joe passes on what he is shown, too, but that isn't surprising, because he never buys anything unless the price is rock bottom. It's not a matter of what he can afford. He and Ivy own an apartment on Central Park West plus a home upstate on several acres of land, and furthermore some of the textiles he has collected are top notch. (A terrific Shekarlu, which is the Qashga'i group whose work is the most tribal in appearance. A Luri bedding bag in its original condition, complete with leather straps and handles. A Turkmen camel trapping made for a wedding procession.) The bulk of what he owns is not top notch, however, because Joe loves to shop in flea markets. A minimal expense is part of his pleasure, and the cheap rugs he buys usually have some suspect dyes or areas of damage. It must be said, though, that his finds are often attractive in their compromised way. He's a bottom feeder, but one with an excellent eye.

After Joe and I have demurred, Samir turns to Jack and unrolls an item he has been saving for him. It's a small rug whose central medallion has large appendages that resemble anchor flukes, and its vivid dyes, predominantly light blue and bright pink, look very good. It has a classic Bijar design and the typical Bijar palette, and it ought to be right in the Judge's wheelhouse, as Joe would say, but he just groans.

"Oh, gosh, another one. I need another Bijar like I need a hole in my head. Well, all right, what would it cost?"

Samir answers softly, and I don't catch it.

"But it's only a *zaronim*," protests Jack. "It shouldn't be that much."

The Judge often uses the Farsi words for textile dimensions: *pushti* for a small mat, *zaronim* for a little throw rug, *dozar* for a bigger one, *ghali* for something room size. He got his start in carpets attending upstate auctions as a picker for dealers in the city, and perhaps what seems like an affectation is just the vocabulary he learned from the people who taught him the business. Or maybe it's more calculated, a way of establishing rapport in hopes of getting a better price. If so, the technique doesn't work this time. There's some further dickering, but no sale.

"Let me think about it," says Jack at last, like someone turning down a proposal of marriage.

I'm surprised by his restraint, and after we've said our polite goodbyes to Samir and his assistants and gone on our way, I want to know the reason.

"It seems like your kind of thing. Why'd you turn it down?"

"It's the principle, George. It's important to show these guys that you've got your limits. Besides, I'll be back soon, and I bet I'll get a better price."

Joe, Jack, and I proceed along the dim hallway to investigate the other open doors in the building, and at each one we're greeted effusively.

"They seem quite happy to see you," I whisper to Jack as he makes another introduction.

"You bet they're happy," he says out loud. "The market's gone to hell, and they're sucking wind."

The three of us are in high spirits, and we reinforce one another's enthusiasm. ("We're the Three Musketeers," says Joe, who enjoys the camaraderie as much as he likes the hunt; and while we're in no danger of being run through with a rapier, he's right that a sense of sharing a boyish adventure is no small part of our fun.) We spend most of the afternoon rummaging for rugs, gossiping and joking with the shop owners even as we dig through the piles, and by the time we're done, each of us has found a prize. Jack has purchased

his Bijar for the day, a mat about two feet square that has pink and red roses—the *gul farang*—on a ground of sparkling midnight blue. Joe has managed to acquire a nice little Sarouk for very little money, a bargain made possible by the fact that it has been stripped twice: once in the 1930s when it was bleached and overdyed with an eye-dropper, and once in the 1990s when the overdye was removed to leave a pale orange pile of the type inventive dealers used to call "golden." (These were popular for a few years with the German market, but the Germans don't want stripped carpets anymore. What they want now is perfection, so much so that a textile showing no damage whatsoever is said to be in "German condition.") And I've bought a Sarouk myself, a remarkable discovery that is five feet long and stapled to a wall.

Who staples a rug? Actually, quite a few people. Ben Behzadi's grandfather, for example, who according to Ben used to hang rugs this way in the family's Tehran home.

"I saw him do it once, George, and I was horrified, but he got angry when I objected. He turned and pointed at me and said: 'Not another word. It's my carpet, I do what I want. When it's yours, then you decide.' It was a beautiful thing, or at least that's how I remember it, but it wasn't ever mine. It got left behind in Iran."

Dealers, too, used to put staples in their carpets. Today, a label is generally attached using aluminum wire and a vinyl tag, but a hundred years ago it was common practice to secure a cloth label to the back of a rug using steel staples. If the rug was well enough made and had a thick pile, little damage was done, and even if a staple is still in place now, it may be so deeply embedded it's invisible. But steel rusts, and rust stains, and it's not unusual to find small brown marks near the corner of an antique carpet that show where the corroded metal was removed.

The stapled Sarouk I've found today has never been bleached—not all of them were—and although it was probably woven sometime in the 1920s and includes some chrome dyes, the colors gleam, the wool quality is good, and the design is most unusual. It consists of two ogive frames, one containing realistically drawn goats browsing on trees and shrubs, the other showing waterfowl nestled in a reed-

bed under oasis palms. The weave is tight, and all the drawing is extremely detailed. A rug this fine must have been made in a workshop and is therefore unlikely to be one of a kind. But if it isn't unique, it's certainly rare. It's one of the very few pictorial Sarouks I've seen.

I point to the rug and inquire. I'm told twelve hundred—already less than I'd pay if I had to—and counter with eight. We settle on nine, and it doesn't take long to do so. The Judge is right: the market's gone to hell, and the dealers are "sucking wind."

Once my trophy is pried off the wall, our rug crawl is finished, and soon Jack is striding off to the subway with Joe and me trailing behind him. When we get back to Manhattan, we decide to have an early dinner before we head home. There's nothing to gain in leaving the city at this hour: my drive to Connecticut would be a four-hour death march through stop-and-go traffic, and the commuter train Jack takes to Orange County would be so crowded he might have to stand. In keeping with the occasion, we choose a Persian restaurant on Thirty-Fourth Street.

"*Tadiq*, we must have *tadiq*. Do you have *tadiq* today?" asks the Judge as we're seated, and the amused waiter nods. *Tadiq* is the layer of rice left sticking to the bottom of a pan when a pilaf is cooked, and a taste for the crispy treat is something else Jack picked up from the carpet dealers who taught him. Partially burnt rice is produced in any kitchen that cooks Middle Eastern cuisine, but it's rarely seen on a menu. You have to ask for it, as Jack knows, and he knows, too, to ask for beef stew to ladle over it as a way of softening the brittle grains.

When the *tadiq* and the stew and the skewered kababs we've ordered come to the table, we dig in with gusto. The Judge and I wash our food down with beer, but Joe drinks a dry martini, straight up with a twist.

"Gentlemen," says Joe, lifting an empty glass, "what a triumph! Let's raise a toast to our success. I believe that means I'll need a refill. Don't tell Ivy."

"Now that was what you call a carpet raid," I say, when the second cocktail arrives and we clink glasses. "That was one for the books."

"I love that Sarouk you found, George. Good goats."

"Yours is a good find, too, Joe, but you better wash it twice. All those rugs heaped up like that, they've just got to have moths in them. The way some dealers keep their shops is beyond belief. They're risking their own inventory."

"That's why they use bug bombs," says Jack. "They mist their shops every couple of months, and they spray their rugs with Hitman."

"What's Hitman?"

"Deltamethrin."

"Isn't that used to fight malaria?"

"Beats me, but it kills insects. They all use it."

"Well, then, we better wash the rugs just to get rid of it. I don't want that stuff around me, and it can't be good for the carpets, either."

Which is what the experts think, too. I brought up the subject of moth prevention once with a Berlin-based curator—an archetypical Teutonic blonde speaking typically excellent English—and she explained that her museum prefers not to treat its textiles with insecticides, because even if the chemicals cause no immediate damage, there's no telling what degradation or discoloration they might produce in the long run. Better to avoid them altogether.

But if one doesn't wish to use chemicals and doesn't have access to a museum conservation facility, and if one doesn't live in a part of the world where natural insecticides grow on trees, how can a collector fend off the moths and beetles that are a continual threat to fine carpets? Moths seem to lurk everywhere, and that's particularly true if one lives in the sort of home that Spencer and I inhabit. Our timber frame house was built around 1800, and its insect population has long since become a permanent part of its wooden pegs and hand-hewn beams and twenty-inch chestnut boards. The infestations of centuries have hidden in its crevices, the moth eggs it contains could never be eliminated, and any rug left unguarded on its premises is begging to be consumed. What to do?

It's a battle, and it's never over. Joe's approach is to have all his rugs on display, since a carpet lying out in the open is rarely attacked. Moths thrive in seclusion, and a rug on a floor or a table or hanging

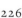

on a wall is usually safe. It's the rug rolled up and squirreled away that's in danger. Moths operate in the dark, and they don't like to be disturbed, which is why Judge Jack carries some of his carpets outside whenever the weather's good and exposes them to sunlight. He also vacuums his carpets regularly, front and back, and he rotates the ones in storage. It's a lot of work, and it can't be ignored. Carpet moths are connoisseurs, and the luscious wool of an antique oriental attracts them as much as a cashmere sweater.

There are other tactics that are effective, too. It helps to keep your carpets clean, and I add a little white vinegar when I wash a rug, because moths can't survive in an acid environment. Moths don't like newsprint, either, so I include a layer of yesterday's *New York Times* when I roll up a carpet. Rather than paying for conservation-quality polyethylene, I encase my rugs in Tyvek—what construction workers call house-wrap, a product available in any hardware store—and I seal them shut with packing tape.

"What about mothballs?" people often ask. Mothballs don't work, or at least not unless you use so many that the smell is overwhelming, and furthermore the naphthalene that is their toxic ingredient is toxic to humans, too. What does work is a frigid climate. Moths can't live where the winters are harsh, but Connecticut is not Minnesota, and winters here aren't up to the job. It requires a temperature of no higher than eighteen degrees Fahrenheit for several days running to kill off the adult insects, and the eggs and even the larvae can survive in conditions much colder than that. The bleak midwinter in Chester isn't bleak enough, so instead of leaving my rugs outside, I put them in our freezer. The bags of peas and lima beans will then have competition, and I'll hear from Spencer when she wants ice for her bourbon and has to root through the kilims and yastiks.

Household freezers are not very large, and even a small rug doesn't leave room for much else, and so although I still avail myself of our kitchen appliance and Spencer still needs to dig around for the ice, several years ago I bought something bigger. We now have a six-foot chest freezer standing next to a heavy-duty outlet in our garage, and with the food racks removed, the interior accommodates over twenty

rolled carpets. Every few months, I'll plug the freezer in and let it run for a week. That suppresses the wildlife, and there is the added benefit that the chest locks, so it is effectively a rug safe. It may not be as sophisticated as the conservation lab in the Metropolitan, but as a homeowner's humble substitute, a six-foot chest freezer's not bad. The only problem is, I could use two or three more.

Once dinner is over, Jack, Joe, and I go our separate ways, but before we do, we make plans for a next outing. Brimfield's autumn session is coming up at the end of the month, so we set our sights on that. It's an obvious choice, because looking for rugs at Brimfield is like going on safari in the Serengeti: it's a vast terrain on which to hunt, and you can count on finding something that was worth the expedition.

Many of the small towns in rural New England have fallen on hard times, but Brimfield, Massachusetts, has survived and even flourished by turning itself into an antiquarian mecca. Three times a year, spring, summer, and fall, it hosts one of the country's largest antique fairs. Some of its stores are permanent, but the fair consists mostly of visiting dealers who either rent space under tents or pay for locations on the acreage of several big meadows. The fair runs for a week, and while the shops and tents are accessible throughout, the meadows are enclosed in chain-link fence and charge admission. So as not to compete with one another, the fenced-in areas open their gates on different days and at different times, and it wants an experienced fairgoer to know which sites the rug dealers favor and what days are therefore the best for a visit. Judge Jack is experienced.

The day the Judge says is the best one turns out to be a date on which Joe has a conflict, so there are only two musketeers on this occasion. Jack and I meet east of Hartford in a parking lot near the UConn football stadium (a gigantic structure set down in an empty surround like the mother ship in a sci-fi film), where we leave one of our cars and drive the rest of the way together.

"Where's Isabelle?" I ask.

"I left her home. It was either that or leave her in the car all day. Some of the fields, they don't allow dogs."

It's not yet nine a.m. when we arrive, but Brimfield is already overflowing with people. Traffic moves slowly, and we decide to park outside of town and walk in. More like jogging in, of course, since I'm following Jack. Once we reach the fair, we wander through various tents and pause at a few shops where the Judge knows the owners, but we don't buy anything. The day is still young, and he recommends that we "save our powder." There are two of the fenced-in areas he wants to explore, one of which opens at ten and the other at two, and that's where we can expect to find the best material.

After buying our tickets for the morning meadow, we line up with the growing crowd. At ten o'clock sharp the gate swings open, and people pour in like it's the Oklahoma Land Rush. Jack and I move slowly until the big field has absorbed the invasion, and when the crush eases, we search out the dealers we're looking for. There are four of them, and as we did in Long Island City, we gossip and josh as we go through their inventory and now and then ask about cost. It's not until we come to the last, however, that Jack actually barters in earnest.

The fourth dealer is a man named Murad whom Jack has met previously at the annual antique fair in Saratoga Springs. Next to his much-used van (the rug dealer's standard equipment), there's some vintage furniture of no great value, and turned upside down and fitted over a table is a bedding bag, one of the box-shaped flat-woven textiles that Iranian nomads used as their suitcases. Usually attributed to the Shahsavan, these have primitive-looking designs on their side panels, and they are often cut apart so that each panel can be sold as its own piece. This one is complete, however. The tribal motifs are crisply executed, the colors are saturated, the condition is everywhere excellent. It's fine work, and clearly the woman who made it was exceptionally skilled.

The purchase takes time. Jack knows what the price parameters are at auction, but a dealer's price will be higher than the auction one, and Murad is stubborn. He bargains with a stony face and only grudgingly agrees to accept $1,600. That's expensive, at least by the standards of collectors used to receiving a discount. ("George, you

and I are spoiled. Most people pay a lot more.") Still, I understand what the Judge is thinking. An exceptional piece is just that, an exception, and if it's good enough, you go ahead and buy it. You'll kick yourself if you don't. Jack picks up his bedding bag, and we're ready to go to lunch, but before we leave he asks about a Caucasian rug lying open on the ground.

"Murad, do you still want two thousand for that beat-up Kazak?"

"More than that, Judge, more than that. People keep thinking they can steal it from me, but I won't sell it cheap. I can wait."

"Well, don't wait for me. That's too much. Come on, George, let's get a hot dog."

"Are you serious? Jesus, I should have brought a sandwich."

Which might have been a good idea, because a fairground is not a place for fine dining. The food tent pitched in the meadow has a limited menu, and when our order comes, it's delivered on paper plates and wrapped in aluminum foil. The Judge and I squeeze ketchup and mustard out of the packets provided and carry our trays to a table in the shade to eat our franks and fries.

"You've seen that Kazak before?" I ask.

"Yep."

"It's interesting. How long has he had it?"

"He's been pretending to sell that rug for months, and he could if he really wanted to, because it's old. But Murad's got a rock for a head. He won't come down."

"Oh well, so what. There's always another rug waiting to be bought. Where do we go next?"

"Let's go see Nurse Kay."

Kay Oliver is a dealer Jack has known for a long time, one who puts rugs aside to save for him, and we find her in the two o'clock field sitting under an awning she has erected next to her own aged van. Dark-haired and thin, she is a registered nurse and also a social worker, but she somehow makes time to deal in carpets, too. How, I can't imagine. I was employed in a hospital half a century ago, when I was in graduate school, and even then it was obvious that nursing was an overworked and underappreciated profession. It's perhaps

due to weariness, then, that her manner is, if not quite gloomy, certainly subdued, and rather than trying to sell the Judge on the rugs she shows him, she simply places them on the ground and lets him do the talking. Which he does, volubly and at length, before eventually selecting a Varamin bag face, a Shirvan runner, and a pretty Hamadan he decides to call a Tafrish. The transaction appears to be a balancing of accounts, because Kay is one of the dealers who now and then buy carpets from Jack, and while the details are being worked out and the largely one-sided conversation continues, I make up my mind.

"I'm going to look around for a bit, guys. I'll meet you back here in half an hour."

Where I'm going to look is where we've already been. I cross the road and return to the ten o'clock field, hurrying to find Murad before he leaves town. I get to him just in time. He is loading up his unsold items and is about ready to drive away when I ask him to pull the Kazak I saw earlier out of his van so I can look at it again.

The rug is five and a half feet long—a bit small by Kazak standards—and shows two large blue stars on a white field filled with variously colored diamonds. Its primary border is white as well, and on it are a series of latch-hook medallions in green or blue or red, each of them carrying a star or a rhombus or a cross in its center. The drawing is in some places extremely precise, in others so casual it is almost childlike, and the irregular effect is increased because the rug is damaged and seems to have been pieced back together.

"It's mostly all there," says Murad, but I'm not so sure. It has several holes and there are gouges in its border, and moreover a typical Kazak would have three stars, not two. I suspect it's been reduced, but even if it has, it still has immense impact. The colors—teal green, cherry red, midnight blue—are just right for an old Kazak, and the wool pile is remarkable. It's bulky and thick, and it's unusually deep. The carpet books (though not the best of them) often state as a blanket rule that Kazaks have a heavy pile, but in fact many of them don't. Many of them are no more substantial than a south Persian tribal rug, a Qashga'i or a Khamseh. It's improbable that so many of

the extant Kazaks should be evenly worn down from a shaggy past to their present pile of average depth, and it seems more likely that their structure changed over time. Once they were thick rugs made to keep villagers warm in the high Caucasus. Later, when they became exclusively items for trade, the quantity of wool in them was reduced, and their drawing was regularized. That's my theory, anyway, and if it's historically accurate, the rug in front of me now was woven before such changes occurred. It's the heaviest rug inch for inch I've ever seen. Caucasian carpets don't often attract me, but this one is irresistible.

I've witnessed the way Murad bargains, so I know what I'm in for. One thing in my favor, though, is that having met him in Jack's company, the bargaining won't open at the stranger's price. I've already heard a figure mentioned—two thousand—and it forms a frame of reference: in theory it's not enough for Murad, and plainly it was too much for the Judge.

Murad starts at twenty-two hundred. I kneel down on the rug and say nothing for a while. Eventually I offer fourteen, to which Murad responds by shaking his head back and forth like a horse avoiding the bridle. He tells me two thousand, and I say fifteen. Without even responding, he goes back to loading his van. The afternoon sun of September is beginning its slow descent, and shadows are marching in from the edge of the half-empty field. The dealers are clearing out, and clearly Murad would like to do the same, but I don't stand up from the rug. I stay where I am, and Murad will have to agree to a deal or physically remove me.

The deal, when it comes, is for $1,800, which is more than I had hoped to spend on a damaged Caucasian. But if a rug is so good it screams "You're an idiot if you don't buy me," you don't pass it up. That's what I tell myself walking back across the street to where the Judge is still talking to Nurse Kay. And it turns out they agree.

"That's a good carpet," says Kay immediately when I spread the Kazak on the grass next to her chair.

"George, you did it!" says Jack. "Lots of people have tried to buy that rug, and you had the guts to go get it. I didn't think Murad would come down."

"Well, he didn't come down all that much."

"It's the principle of the thing. He came down. You did it!"

"It wasn't cheap."

"Hey, sometimes to get something great, you have to pay."

Kay nods matter-of-factly.

"That's a good one," she says again. "That's a good carpet."

I'll hear the same from other dealers as well. Robyn Del Vecchio tells me how much she likes it when I take it to her to be washed and have a linen backing added. And when I bring it one evening to show my fellow Hajjis at the Club, the gracious dealer to the carriage trade asks me what I paid. I tell him, and he smiles, saying: "I would have wanted six thousand." Flattery perhaps, but still a testament to the rug's quality. The little Kazak is not, shall we say, in German condition—close inspection will show that its irretrievably damaged center was removed at some point and its less damaged sections cunningly fitted together, and what is now its highly irregular lower border was no doubt assembled from parts salvaged in the process—but even reduced to its present state, what remains is splendid.

Evening is coming on when the Judge and I set out for home, and as the cocktail hour approaches, we stop at a roadside market. Sitting in the parking lot to each drink a bottle of beer, we replay the events of the day, and it doesn't take long for us to fall into our habitual good-natured argument. The teasing one-upmanship and jocular contradiction that so often characterizes masculine conversation comes naturally in such circumstances, and in a sense our back-and-forth is a way of celebrating the end of a successful hunt. We might be companions circled around a campfire, ribbing one another as we cook the day's catch.

"So what makes you think your Hamadan is necessarily from Tafrish? It doesn't look like it."

"It doesn't have to. It's the weave that counts, George, you know that."

"You're telling me you can distinguish a Tafrish weave from the carpets made nearby? What, were you born there?"

"I wasn't born in Bijar, either, but I know one when I see it."

"Bijar's easy."

"So's Tafrish."

"If you say so, but the ones I've seen are different. Yours doesn't have rows of birds or a clockface medallion, and those are the Tafrish designs. Correct me if I'm wrong."

"I think you're wrong about everything, I keep telling you that. You want to do Brimfield again next May?"

"Sure, as long you're going."

"I'm definitely going, and let's bring Joe. It'll be fun."

"It'll be fabulous. I can't wait for spring. And I think you're wrong, too."

The Reduced Kazak, 3 ft. 10 in. x 5 ft. 6 in.

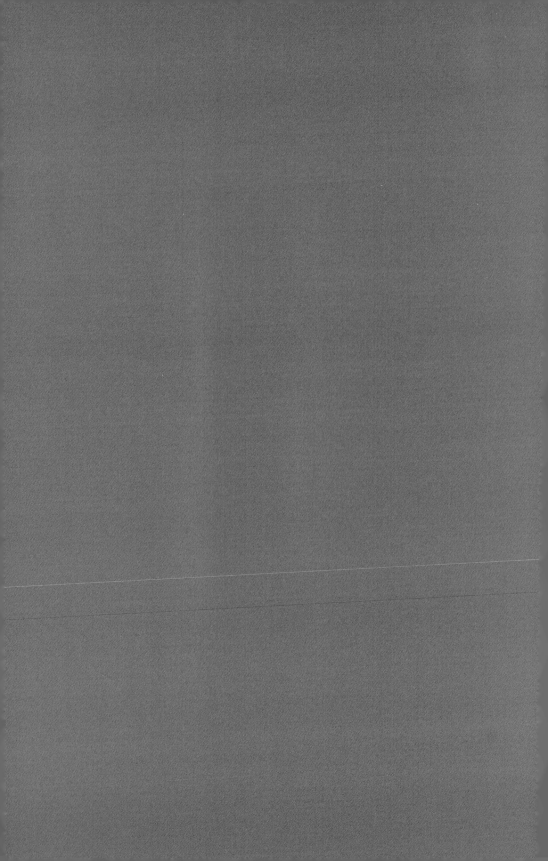

ELEVEN

But If They Could

The Sufi Kirman

Then COVID hit, and everything changed.

The spring of 2020 was a watershed moment, not so cataclysmic as the advent of the Black Plague or the French Revolution or World War I, but still a date that would thenceforth divide the lives of those who lived through it into a Before and After. It was astonishing to discover how closely the course of this epidemic paralleled that of others in the past, to be newly impressed by how unaltered human nature has remained over the course of centuries. The rumors, the fear, the irrational behavior, the urge to assign blame, the attempted flights to safety, the mountebank cures, the ethnic scapegoating . . . all of it mirrored behavior seen in London in 1665, in Siena in 1348, in Constantinople in 541. But there was a difference, too. In distinction from all the previous mass infections that have beset our species since time out of mind, a genuine remedy for this one was developed within a year—a set of highly effective vaccines—and yet so many people either refused the injections or had no access to them that the contagion could not be controlled and returned in wave after wave of new variants. Clever enough to invent a medical miracle, foolish enough to reject it: what a piece of work is Man.

The COVID-19 virus altered most aspects of life, and it had a major impact on the carpet world. Among other things, the spring session in Brimfield was canceled (it would have been a superspreader event of giant proportions), and the Hajji Babas ceased to meet in person. When travel restrictions were instituted and all interaction became remote, the presentations at the Club were replaced by online lectures, a shift that had many drawbacks and some advantages. On the plus side, the fact that speakers were no longer required—or indeed allowed—to be physically present in Manhattan opened up possibilities.

"Webinars" given on Zoom could originate in distant locations like Italy, Lebanon, or Istanbul, and the audience, too, could attend from afar. Presentations that might once have been made to a gathering of twenty or thirty people could now draw an audience in the hundreds, and because geography did not restrict the potential attendance, a single lecture could be hosted simultaneously by organizations based in more than one place. This meant that speakers could be sponsored jointly, and the HBC could split expenses with the Textile Museum in Washington, DC, the New England Rug Society in Boston, or the Textile Museum Associates of Southern California.

On the downside, the personal contact that had been such a large part of the monthly meetings vanished entirely. The small talk, the shared meals, the conviviality—the clubbiness of the Club—were replaced by an assembly of isolations. The lecture audience now consisted of muted individuals sitting in front of their computers, and any comments or questions they might have were expressed via the keyboard. Worst of all, such textiles as were displayed could be seen only as digital images, and there was no pile to touch, no lanolin to smell. Whatever a picture might be worth in words, it's no substitute for an oriental rug lying in your lap.

The carpet trade had already been affected by the new technology, much the way Becky Cohen's book business had been, but COVID accelerated the process. During the epidemic, the marketplace for rugs became exclusively electronic and was thus impersonal, international, and fragmented. Websites (rugrabbit, Etsy, 1stDibs) allowed prospective buyers to scroll through thousands of offerings, and any serious dealer now needed an online presence in order to generate sales. The business model for auction houses changed as well, and whereas computer bidding had formerly been just one component of an auction, it now became the primary and often the sole means of participating. That made it much harder for buyers to collaborate during and after the sale, and therefore auction rings and knockout rounds were no longer ubiquitous. The pace of auctions slackened because the auctioneer's urgent voice went mostly unheard, and the incremental raises of competitive bidding were numbers appearing on a screen rather than price levels called out loud. The previews took

place remotely, too, with the result that buyers had to depend exclusively on the accuracy (or lack thereof) of photographs to judge a rug's value. As was the case with items shown in a Zoom lecture, the quality of the wool in an auction lot could not be assessed, the structure could not be examined, the dyes could not been seen in natural light, the degree of wear could not be easily determined. The tactile element that is such a large part of oriental carpet appreciation was virtually eliminated.

The shift to an online marketplace would prove to be irreversible in the long run, and COVID had a short-term impact as well. A great many businesses of all types failed during the epidemic, and a lot of dealers closed up shop. As it happened, many of those I had come to know were close to retirement anyway, but their exit was hastened by the economic downturn created by the virus. Gary Clifton auctioned off the last of his improved furniture and left the nation's attic, moving to Florida to sit in the sun and complain about his ball club from there. ("Could somebody please tell the owners where their team is playing? Nobody wins in that stadium without left-handed pitching and left-handed power.") Rich Hegazy decided to concentrate on his real estate interests and cease simultaneously dealing in carpets. He staged a going-out-of-business sale (N95 masks required), the only legitimate GOB involving carpets that I had ever seen. And Robyn Del Vecchio left the business, too, though in her case the pandemic wasn't the only reason why.

Shortly before the "boomer-remover" pathogen began killing off its older victims, Robyn's husband Roger died of cancer. It was sudden, or at least it seemed so if you weren't a family member sitting beside him and watching his decline. I attended the memorial service a bare two months after I heard he was seriously ill. The first speaker was the son she had conceived with Ron Somerset, and as he began to talk about the friendly and generous man who had been his stepfather, there was a loud and inarticulate outcry in the audience. It was Robyn's second son, the one she'd had with Roger, who was confined to a wheelchair by cerebral palsy and would not be quieted until he was brought to the front of the room to be included in the proceedings. Seeing him there, bent by sorrow and by disease, I thought of

the day eighteen years earlier when I first met Robyn and waited for her to finish a phone call about a motorized chair for a disabled child.

Roger Del Vecchio was dead, and Ron Somerset had died already, which meant that, although she had divorced one of them long ago, Robyn was the survivor of two husbands. For most of human history it was men who married multiple times, since their wives so often died in childbirth, but birth control and improved maternity care have changed the actuarial tables. These days it is the males who are most likely to succumb early, whereas a healthy and active woman like Robyn stands a chance of moving on to a third marriage. Quite a good chance, as I discover when I go to see her a few days before she shuts her doors permanently.

She looks different. She's grown her hair out to shoulder length and is holding it in place with a hairband, and she's lost weight. The heavy hips have disappeared, and her trim figure looks almost athletic. Instead of wearing a cardigan sweater and sensible shoes, she's dressed in jeans and sandals, and between the altered physique and the casual clothing, at a distance you might mistake her for a woman fifteen years younger. It's a transformation, and the makeover is not accidental. Still grieving, she has fallen again in love.

"It's the strangest thing, being in love with two men at once. I miss Roger every day. I think of things I meant to tell him, things we meant to do, things I know he would find funny, or that only he would understand. But I love this man too, I love being with him. We knew each other in high school, and we reconnected online, and now we're moving in together. It's new, it's wonderful, I'm incredibly happy. I'm happy and sad at the same time. It's strange."

Robyn has a new love interest, but she no longer has Roger's help with the business. He minded the shop or the fair booth in her absence, he did much of the lifting and carrying and washing, and he eventually gained enough experience to be a sounding board, another set of eyes. Her partner now has no knowledge of rugs, and there aren't decades left in which to learn. She doesn't wish to carry on alone, so she has decided to liquidate her stock, selling off what she can to others in the trade and putting whatever is left up for auction. I got a phone call from her explaining what she had planned, which is why I've come by for a look.

"I'm surprised, Robyn. I figured you for a lifer."

"So did I once, but not anymore. It's not just COVID, it's everything. Back when I started, prices were always going up, and you couldn't lose. Now nothing's worth anything except at the high end, and you can't make a living unless you're dealing with the Aga Khan."

"There must be other customers."

"I guess so, but I get sick of them. The homeowners are ignorant and have unrealistic expectations; the decorators are dishonest and pressure you to do unethical things; and the dealers are always trying to beat you down another ten percent."

"What about collectors?"

"The collectors never want to spend any money, they only want to argue about where the rugs are from."

"Pretty much. So do you have anything collectible left that might be in my price range?"

It doesn't appear that she does. The shop isn't empty yet, but most of what remains are room-size carpets, rolled and bound and ready for shipment. There are still a couple of piles of smaller pieces, but I've been through them before, and I know there's nothing in them I have to have. I take a last glance around and shrug and begin my goodbyes.

"Wait a minute," says Robyn, pulling a rug out from behind her desk, "I've got something here. It was ours, it was in our house, but I'm moving and I can't keep everything. I'd like to see it go to someone who knows what it is."

What it is is a Kirman prayer rug from the late 1800s. Like many Persian prayer rugs, it is a miniature vision of paradise, an ideal garden blessed with water and flowers and peaceable animals. It shows a small pool of the sort that might be seen in a mosque courtyard, and in it is a large vase that has sprouted a blossoming tree. There are four pairs of birds in the branches, and there are ducks and fish in the pool. The idyllic scene is framed by the broad niche characteristic of Kirman, and in a whimsical touch, the weaver has included the faces of two sheep in the spandrels of the arch. But the most prominent feature is a pair of dervishes, Sufi holy men who kneel beside the little pond and eye one another while smoking realistically drawn water pipes. Sufis—the mystics of Islam—are depicted often in Iranian art.

Wandering mendicants, they are typically shown carrying bowls for begging and axes for self-defense, but those identifying objects are missing from this scene, and the hookahs that have replaced them are unusual. Presumably whatever the dervishes are smoking is intended to assist their mystic contemplations.

The rug has lots of charm, and part of its appeal is its somewhat homemade quality. Its borders do not articulate, which says it is a cottage-craft weaving rather than the output of a workshop, and there has been a design mishap at the apex of its arch, where the reciprocal halved cartouches that form its major border have run out of room and come together awkwardly. Considerable precision is required in making a formal prayer rug, and to avoid unintended asymmetry, particularly in the arch, most of them are woven upside down. That is, the top of the rug visually is the bottom of the rug as woven, so that getting the arch right can be achieved early on. That's important, because a small error at the beginning of a carpet may lead to larger ones later. This rug, though, was not woven arch end first, and it shows.

Unlike most other artforms—painting, say, or poetry or musical composition—weaving is a medium in which one cannot revise. You can touch up a canvas or rewrite a stanza, but you can't rethink your intentions or erase your mistakes while making a carpet without tearing it apart and starting over. Because the knots tied in previous rows are there for good, missteps can't be eliminated, they can only be accommodated, and the skill with which potential problems have been resolved is one thing that distinguishes the work of a truly accomplished artisan. Sometimes the adjustment involved is obvious. In Caucasian rugs, for example, one often sees disjunctions in design where the weaver has expanded the field or altered a border and has not been concerned to disguise it. With Persian weavers, however, even nomadic ones, such redirection is less common.* When it hap-

* An exception are the Luri of the Zagros Mountains, whose piled work often delights in eccentric variation. I have a Luri salt bag in which the border design changes three times in the course of fourteen inches.

pens, it's usually because materials have run out and the rug cannot be finished as planned. (Some dealers will tell you that tribal weavers on occasion include deliberate "mistakes" in their designs as a way of expressing religious humility, since "only God is perfect." Maybe.)

"I'll let you have it for what I paid for it," says Robyn, "but I got it a long time ago, so that's three thousand."

A Persian carpet with a formal design is generally more expensive than a tribal one, all things being equal: whatever an old Qashga'i or Khamseh costs, an old Kashan or Kirman will cost more. The current market is weak, though, and even a good rug isn't worth what it was. I think about haggling.

"You wouldn't pay that much for it now."

"No. I've had it for twenty years, at least."

She's parting with something from her own collection.

"Where'd you get it?"

"From Donnie."

"Donnie Zahabian?"

"Yes, back before I stopped dealing with him."

The name evokes unpleasant memories and is a reminder that Robyn has always treated me well.

"I'm amazed you got something that nice out of him. All right, I'll buy it. You think it might be an Afshar?"

If so, I've come full circle. The first rug I ever bought from Robyn was an Afshar, though I traded it back to her soon after.

"Afshar? Anything's possible, but it doesn't look tribal. And the colors aren't right."

"Not the dyes, the shape."

An interesting feature of this Kirman is the ratio of its dimensions. Only a foot longer than it is wide, it is almost a square. A squarish shape is something you see in Afshar weaving, and the Kirman area is home to many members of that tribe. Little else about this prayer rug speaks of that ethnicity, but its dimensions suggest that the woman who made it, if not Afshari herself, might have been influenced by the tribespeople around her.

"Thanks, Robyn," I say after I've loaded my purchase into my car and the two of us are standing outside her shop. "Thanks for the rug,

thanks for everything. You taught me a lot. I'd say my carpet insanity is basically your fault."

"I'd say you were rug-crazy before I ever met you. But you're welcome, and it goes both ways. I learned from you, too."

"What are you going to do now? You're not the kind of person who's happy doing nothing."

"I'm managing three different antiques shows, or I will be whenever they start up again. They take loads of work. Don't worry, I'll keep busy."

"Sounds like it. Well, then, so long. I'm going to miss you."

"Come on."

"No, I'm serious. I'm running out of rug shops around here."

Which is merely the truth. Now that so many local dealers are in the process of closing, the only stores left in my area selling oriental carpets are ones that advertise their wares on highway billboards ("Broadloom! Wall-to-wall! Custom cuts!") and carry an inventory of brand-new furnishing "products." Such old rugs as they have are trade-ins, which are rarely old enough and never reasonably priced. For a real rug shop and something truly antique, I'll need to travel in the future to New York City, but that densely populated metropolis has been in lockdown for months and continues to carry the threat of infection. I stay away.

COVID keeps happening, and time inches by, and each day seems the same as the last. Summer stretches into fall, and there's still no way to satisfy my interest in carpets except to watch Zoom lectures, follow the auctions online, and talk on the phone with Joe or Judge Jack. Jack has not stayed out of the city and has caught the virus twice already, but it hasn't dampened his spirits. Cheerful as usual, he has an idea.

"Listen, Joe and I were thinking, let's all get together at his and Ivy's country place. They're there full-time, they moved there to be safe. It's about an hour up the Taconic from where I am, so that's, what, three hours for you? You and Spencer drive on up, and we can sit outside and have our own private show-and-tell."

"When would we do it? It's starting to get chilly, maybe we should wait till spring."

"Nah, we'll dress warm. It's a really nice place, me and Isabelle went there three weeks ago. I'll tell Joe to give you a call. Let's see some rugs!"

It is indeed a nice place, as Spencer and I discover when we respond to Joe's invite and arrive on what is indeed a chilly day in November. The house sits on several acres, and although it's close to the road, the road is not heavily traveled and the house is protected by plantings. Joe and Ivy have remodeled their home with a light touch—most of the improvements consisted of modernizing the kitchen—but they have made major changes to the property around it. They have dug out a swampy area to form a small pond, and they have periodically added outbuildings to contain Joe's various collections. The rugs, of course, are everywhere, in every room of the house and in every building, but his vintage BMWs are kept in a couple of sheds and his books are shelved in a two-story barn. Joe is a reader, and he owns thousands of books, though the books he collects are not the ones he reads. They're the ones he can't resist buying, 1950s pulp paperbacks with gruesome titles and lurid cover art. The titles often include the words *killer*, *blood*, or *murder*; the covers typically show a terrified young woman in revealing clothing. They're ideal fodder for the collecting gene, and Joe enjoys showing them off.

"Here, look at this one: *Girl on a Slay Ride*. Don't you love it? They don't make trashy novels like this anymore, and you can still get them for nothing."

After we've seen the property, the three couples—Joe and Ivy, Jack and Isabelle, Spencer and myself—sit down around a fire pit where a couple of logs are burning steadily on a bed of coals, and lunch is served. Pizza and Sazerac cocktails, a combination of the thrifty and the sybaritic that sums up Joe's character in a nutshell. Well away from the fire, so as to avoid infusing them with smoke, we've laid out an assortment of rugs on a tarp, and periodically one of us will walk over to examine a piece and offer any thoughts. The thoughts range from naked admiration to teasing deprecation, with now and then some impromptu theorizing.

"Wow. Do you think this pile might be pashmina? It's amazingly soft."

Or alternatively:

"Good God. Did you pay money for that, or did they throw it in with the shoeshine?"

Or speculatively:

"I'm guessing this one was soaked in black tea to tone down the colors. I've washed it three times, and the whites won't freshen up."

Eventually our little group is reduced by two: Ivy goes into the house for a patient's Zoom appointment (COVID has upset the equilibrium of millions, and psychologists have more work now than ever), and Isabelle trots off to investigate the fascinating odors she finds under the new-fallen leaves. The four of us remaining settle back into our garden chairs, and the conversation ranges.

"I've got a question for you gents," says Joe. "Seeing as neither one of you had a Turkish grandfather, how'd you catch the carpet bug? Just bad luck?"

The Judge answers first.

"I bought a house with a leaky roof."

"And?"

"There was a carpet in a bedroom that the water ruined, and I went out and replaced it with a machine-made one from a department store. It wasn't a week before I realized the thing was so ugly I couldn't live with it, and when a neighbor told me the previous owners covered their floors with orientals, I decided to do the same. I got some carpet books and started to educate myself, and then I was off to the races. The first decent rug I bought was a blue-field Manchester Kashan. I still have it. What about you, George?"

"Some achieve addiction, some have addiction thrust upon them."

"What do you mean?"

"There were oriental rugs in my family, a whole lot of them, and one came down to me. I was curious to find out about it, and that's all it took. It's like the fatal glass of beer."

"Well," says Joe, "I guess it could be worse. As addictions go, carpet mania is pretty low-impact."

"True. Nobody ever lost their job or wrecked their car or beat their kids because they bought another Kirman."

"I'm happy I got hooked," says Jack. "I think collecting carpets has been the most interesting thing in my life. I never get tired of it. The rugs are so beautiful."

"I agree," says Joe. "The rugs are beautiful, that's the bottom line."

"They're beautiful," I say, "and there's always something more to learn about them. I mean, not if you talk to Jack, but from other people."

"Not if you talk to me? Who else are you talking to? The dealers? They just make it up. And the people who write the books, none of them really know anything. I keep telling you that."

"Didn't you just tell me that books are how you got started?"

"That's how everybody starts, but eventually you realize that you know as much as what's in the books."

"Not all of them, that's not fair. Some are written by real scholars. They do carbon dating and dye analysis and archival research, and you're not doing any of that. Give them a little respect."

"My problem," says Joe, "is that a lot of what they say amounts to guesswork, but they make their pronouncements like they're Moses coming down from the mountain."

"They're smart people, and smart people tend to be confident in their opinions."

"So are idiots," says Jack. "Thirty years on the bench, I've seen a lot of morons who were totally sure they were right. Anyway, most people buy rug books just to look at the pictures."

"Could be, but I notice you buy lots of them yourself."

"Of course. So do you."

"I think George buys them to add to our collection," says Spencer. "We must have hundreds."

As with Dick Sise and his wife Peg, you can't say she doesn't know me.

"That's probably true," I admit. "Including the catalogs, that's definitely true."

"And the histories," adds Joe. "And the travel literature."

"There's no end of stuff to read," I say, "and aren't we glad there is? Learning by doing is great, but how much doing can you do in one lifetime? That's where the books come in."

"I read books to catch up with the past," says Joe. "They're how you find out what other people found out already. No books, and everyone starts from square one."

"That's exactly right. Books are where the past goes to wait for us."

"What about carpets?" says the Judge. "It's in the carpets, too."

The afternoon sun of November is too weak to take the chill off the air, but it adds a glow to everything it touches: the pond, the bare trees, the many textiles scattered on the tarp. A photographer once told me that the colors in an oriental rug are best seen in natural light under a cloudy sky at noon, and in terms of photons and retinas and accuracy of reproduction, that may be the case. For all other purposes, though, it is bright sunlight that makes a carpet sing. It was sunlight that persuaded me to buy my first rug, the little Baluch I purchased from Jim Barnard almost two decades ago. And it's the sunlight now that reveals the beauty of the carpets we've assembled for our show-and-tell today. Gazing at them fills up the soul, and as I look, I let my imagination roam. There's a flatwoven Tekke bag face decorated with thin bands of pile; the woman who wove it may have lived in a yurt and watched with alarm as Russian soldiers arrived on the newly built Trans-Caspian Railway. There's an Indian carpet with a design copied from a Persian Quran cover; it could have been produced in a Bombay prison by a man who resisted colonial rule. There's a thick-piled sleeping rug from eastern Turkey; it might have been the one possession carried by a refugee fleeing into Armenia in 1915. There's a Bijar kilim, a Konya runner, a horse blanket made near Baku, a door surround made near what was once the Aral Sea . . . Testaments to human ingenuity, exquisite artifacts produced in the service of physical necessity and commercial expedience, the beguiling, reticent objects that make up a carpet collection are the echoes of vanished lives. The rugs can't talk, or not that anyone can hear, but if they could, they'd each have a tale to tell.

We sit quietly for a moment, and then Jack has a question.

"You're the writer," he says. "Have you thought about writing a carpet book yourself?"

"I've thought about it. Joe, would you have a cup of coffee before we hit the road? We've enjoyed ourselves, but sooner or later it's time to call it a day."

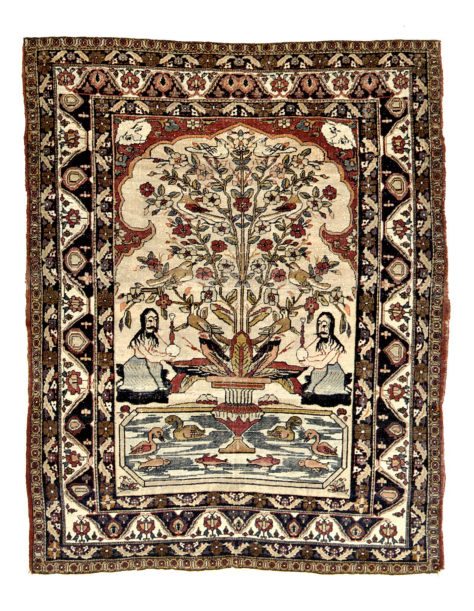

The Sufi Kirman, 4 ft. 5 in. x 5 ft. 5 in.

APPENDIX

Palette

The first thing to do to gain an appreciation for oriental rugs is to develop an eye for their dyes: which are natural, which synthetic, where and when they were likely made. The appearance of an antique carpet depends in large measure on its palette, and this varies from place to place in accordance with tradition and the dyestuffs locally available. (One of the most obvious distinctions is between tones of red. Some reds are made from madder root and tend toward warm earth tones; others—cochineal, lac, kermes—are derived from insects, and these have a cool, dark, bluish cast to them.) Because of such variations, the palette of a rug can offer an immediate indication of its place of origin. Below is a list, by no means complete, of some of the colors that predominate in certain types of carpet or are particularly associated with them. Most rugs, of course, will have more colors than are indicated here, but if one were to enumerate them all, the descriptions would be useless. The point is that certain tones stand out. Not every specimen will have the palette indicated, but many of them will.

AFSHAR: Denim blue, ivory, copper red

BALUCH: Dark brown, light brown, dark blue, electric blue, fire red

FERAHAN: Pale green, tomato red, lavender

INDIAN (AGRA, AMRITSAR, and so on): Pea green, pale blue, cochineal, pink on red

KASHAN: Dark cochineal red, dark blue

KAZAK: Bottle green, teal green, cherry red, ivory

KHAMSEH: Chestnut brown, baby blue

KIRMAN: Bright white, purple (cochineal)

KONYA: Golden yellow, brick red, brown

KUBA: Burgundy red, eggplant purple

NAIN: Gray, white, light blue, navy blue

NINGXIA: Brownish yellow, dark brown, dark blue

QUCHAN KURD: Mustard yellow, scarlet

PEKING: Wedgwood blue, white, peach

SEICHOUR: Cobalt blue, white, salmon pink

USHAK (nineteenth/twentieth centuries): Oatmeal brown, apricot, shell pink

YOMUT TURKMEN: Maroon

Glossary

The words glossed below occur in the chapters of this book and are intended as an aide to readers rather than as a compendium of carpet terminology. For the latter, see the *Oriental Rug Lexicon* by Peter F. Stone, listed in the bibliography.

ABRASH, OR ABRAGE. A variation of tone within a single color field due to differences in dye absorption or to separate dye lots.

AFSHAR. An Iranian tribal group now living mostly in the Kirman area, although found also in the northwest and northeast of the country. Afshars of one sort or another have produced bags and small rugs in enormous variety, and a monograph illustrating all the weavings that go by this name would be lengthy indeed.

AGRA. The best nineteenth-century Indian carpets are often assigned to Agra, though there is no guarantee that they were actually made there. Lahore and Amritsar were also major centers of rug production, and reliable diagnostic information that might firmly connect a given carpet to one of these cities in particular is difficult to come by.

ART DECO CARPETS. During the first half of the twentieth century, rugs inspired by Art Deco design were produced in Tianjin, China, for the European and American markets. These rugs have uncluttered (in fact, often entirely open) fields, and they typically show floral motifs in their borders that may extend into the rug's center. Made with mostly synthetic dyes, they are not much admired by collectors, but their soft colors and flowery designs have gained them popularity with homeowners.

ARTICULATED BORDERS. If a carpet is carefully planned and executed, its border motifs will continue around its corners without interruption,

in which case they are said to articulate. Whether or not they do so is a diagnostic tool.

BAG FACE. The front side of a bedding or saddle bag from which the back has been removed to leave what looks like a miniature rug.

BAKHTIARI. A once powerful tribal people of Iran's Zagros Mountains that produced flatwoven bags and animal trappings, as well as some piled rugs. The name is more commonly applied to the many piled rugs and carpets made in villages west of Isfahan that are ethnically diverse but were once under Bakhtiari control.

BALUCH, OR BALOUCH, BALOCH. A nomadic people of eastern Iran and western Pakistan whose name is used for the often dark-toned bag faces and small rugs made by a variety of ethnic groups in eastern Iran and northwestern Afghanistan.

BAYBURT. A town in northeast Turkey that is, with its surrounding province, a source of particularly good kilims.

BIJAR, OR BIDJAR. A town in northwest Iran famous for its densely packed, hard-wearing, brilliantly dyed carpets. Top-quality ones are sometimes called Garrus Bijars, particularly those with an arabesque design. Bijar is ethnically Kurdish, and the less densely woven rugs made in the vicinity are known in the trade as Bijar-Kurds.

BOTEH. The "pine cone" or "paisley" motif that appears to have entered carpet iconography in the nineteenth century via Kashmir shawls, and which continues to be common in rugs woven throughout India, Iran, and the Caucasus.

CAIRENE CARPETS. Made from the fifteenth to the seventeenth centuries, these carpets were first produced in Cairo under the Mamluks and continued to be made after the Ottoman conquest. They feature glistening wool, a restricted palette, and designs that combine large octagons and eight-pointed stars with Egyptian motifs such as papy-

rus fronds. Cairenes are made of yarn plied counterclockwise, unlike the clockwise spin given to the ply of virtually all other carpets.

CARBON DATING. Plants and animals absorb carbon during their lives, including the naturally radioactive carbon-14, and the age of their remains (such as wool, cotton, or silk) may be measured by the degree to which the carbon-14 they contain has decayed. Carbon dating is far from exact, but it can provide a rough estimate of a carpet's age.

CHANTEH. A small bag intended to hold a nomadic woman's personal items: combs, needles, makeup, etc.

CHONDZORESK. The name used for certain rugs made in the Karabagh region of the southern Caucasus. They feature lobed medallions containing central squares, wavy swastikas, and what might be interpreted as thick cloud bands. Sometimes called "Cloud Band Kazaks," they typically have red grounds and white borders. See also CLOUD BANDS.

CLOUD BANDS. These are ribbonlike motifs seen frequently in Indian and Persian workshop carpets. Originating in China, where they represented clouds, they are purely decorative in the Middle East.

DAMASCUS CARPETS. This is a term used as early as the Italian Renaissance for carpets produced in Syria. They resemble Cairene carpets in palette, though not in wool quality or structure, and they often feature a repeat pattern of octagons, each surrounded by a radius of small lozenges.

DECCAN. The south-central Indian Deccan Plateau is a region that was already manufacturing carpets prior to the sixteenth century Mughal invasion. Deccan production seems to have been exported not only westward to Iran but also to countries farther east, such as Japan.

DEMERÇI. A village in western Turkey known for its rugs, a group of which are prayer rugs with an unusual tree of life design that is believed to date to the eighteenth century. See also TREE OF LIFE.

DERBENT. A port on the Caspian Sea that made rugs that tend to be large by Caucasian standards, often have synthetic dyes in them, and, unlike other Caucasians, are sometimes single-wefted.

DOUBLE-WEFTED. Piled carpets in which at least two wefts are passed through the warps between every row of knots—a structural feature found in the majority of oriental carpets—are described as double-wefted. Weft description (number, thickness, type of fiber, color if any) is a useful diagnostic tool. See also SINGLE-WEFTED.

EBELINDE MOTIF. A figure frequently seen in Anatolian kilims, especially those from the Konya area. Some say it represents a woman with her hands on her hips, while others believe that it derives from carnations as drawn in Ottoman velvets.

ERSARI. A Turkmen tribe of Central Asia that produced a wide variety of weavings, particularly bag faces and full-size carpets. The Ersari were located farther from Iran than other Turkmen groups, yet paradoxically some of their bag faces are the Turkmen textiles most clearly influenced by Persian design. See also TURKMEN.

ERZURUM. A town in eastern Turkey that is a major source of prayer kilims.

FERAHAN, OR FEREGHAN, OR FARAHAN. A plain in the Arak area of central Iran where many of the first carpets exported to Europe in the second half of the nineteenth century were made. These were not originally woven for export, and hence their oblong dimensions were designed to suit Iranian rather than European rooms. Though usually double-wefted, they can be single-wefted, and they often feature a corrosive pale-green dye, the presence of which is dispositive as to provenance.

FERAHAN-SAROUK. A rug from the Arak area that is more densely woven than those called simply Ferahans. Many of these are fairly small, and the prayer rug format is common among them, but from about 1885 to World War I, elegant double-wefted carpets sized to fit West-

ern rooms were also produced in the region, and the name Ferahan-Sarouk is sometimes used for these as well. Ferahan-Sarouks rarely if ever show the corrosive green dye typical of Ferahans.

GENDJE. A name used with no great precision for rugs that perhaps come from the area of Ganja, a town in Azerbaijan. They are often about eight feet long, and frequently show a field design of diagonal stripes.

GOB. Going-Out-of-Business. A standard ploy among rug merchants is to announce extraordinary discounts resulting from supposed necessity, though usually this is no more than a ruse.

GOL FARANG. This is Farsi for "European flower" and means a blossom drawn in the Western manner, most often a rose. In the late nineteenth century, the *gol farang* began to be seen often in Persian carpets, particularly in Afshars and Bijars.

GÜL. The Turkish word for "rose," this is the term used for the various geometric motifs basic to Turkmen carpet design. These motifs, which do not resemble roses and may or may not have anything to do with flowers, are said to identify the tribal affiliation of the weaver, though in fact there seems to have been considerable sharing of designs between the Turkmen groups.

HAMADAN. A city in western Iran (classical Ecbatana) as well as the name of the extensive plain around it on which hundreds of villages have produced hundreds of thousands of single-wefted cottage-craft throw rugs, with production greatly increasing in the 1940s. These multitudinous little rugs are often looked down upon by collectors, and those that are of higher quality are therefore usually attributed to individual towns—Malayer, Tafrish, Ingeles, and so forth. Hamadan itself has produced large workshop carpets, which are double-wefted.

HANDLE. The way a rug feels in your hands. Terms used to describe the handle include: firm, flexible, floppy, meaty, chunky, leathery, stiff as a board, soft as a handkerchief. Handle is a diagnostic tool.

HARSHANG MOTIF. A design element seen most often in the rugs of northwestern Iran, particularly those of the Bijar area. It is sometimes called the "crab" motif, because it resembles a crab shell.

HERATI. The term used for two very common motifs in carpet design. The Herati field motif is a repeat pattern of blossoms embedded in a matrix of stems and each surrounded by four leaves. The Herati border motif (sometimes called the "samovar" or "turtle" pattern) consists of a reciprocal series of palmettes that are floral in origin, though often schematically drawn and roughly triangular, and have leafy extensions. Presumably these motifs originated in the city of Herat, which became a cultural center after Tamerlane's son Shah Rukh made it his capital in AD 1409.

HERIZ. The town in northwest Iran that is the source of the currently fashionable carpets that for the most part feature medallion designs drawn in an angular style. Rugs from this area get called by several other names, too, depending on their quality and appearance: Gorevan for crudely made ones, Mehriban for better ones, Serapi for those that are very fine and have an individual design, Bakshaish for ones with a tribal look. In addition, the nearby town of Karadja produces similar carpets, though unlike a Heriz, they are single-wefted. There are also small silk rugs that go by the name Heriz, though most experts now think they were actually woven in Tabriz.

IKAT. A fabric, most often silk, made by dying the warps in various colors along their length and then aligning them so as to create a design. Spectacularly colorful, ikats were originally produced in Central Asia, where they were used for clothing and to provide a backing for other textiles.

INDO-TABRIZ. Many of the carpets made over the last couple of centuries on the Indian subcontinent (in India itself, but also in Pakistan) have copied well-known Persian types. One that is genuinely antique will usually be called by the name of the city where it might

have been woven, such as Amritsar or Agra. The terms used for newer ones, however, reference the type imitated: Indo-Tabriz, Indo-Heriz, Indo-Kirman, and so forth. Similarly, contemporary Chinese rugs that copy Persian designs may be called Sino-Tabriz or Sino-Heriz, etc.

ISFAHAN. A city in central Iran that is believed to have produced many of the classical Persian carpets woven in the Safavid era and that since the early twentieth century has produced formal, curvilinear carpets often inscribed with the name of an individual workshop.

JAJIM. The Farsi term (in Turkish it's *cicim*) for a flatwoven woolen fabric, sometimes embellished with embroidery, that is used as a spread to cover pack loads, beds, tent floors, etc.

KARABAGH. A rug-producing region of the south Caucasus, long contested between Armenia and Azerbaijan.

KASHAN. A town south of Tehran in which medium-size carpets were made in the Safavid era and where carpets both large and small have been made in the nineteenth and twentieth centuries. Densely woven and curvilinear, these latter-day Kashans often feature a dark red and blue palette, and their borders almost always articulate. Genuine Mohtashem Kashans, of which there are few, were woven in the eponymous nineteenth-century workshop, though the name is often applied to any Kashan of high quality. Manchester Kashans are room-size carpets made with a glossy wool imported from England. Dabir Kashans are twentieth-century workshop carpets that have chrome dyes (a kind of synthetic) but are sumptuous and brightly attractive nonetheless.

KAZAK. The name used for the boldly geometric and, in early examples, heavily piled rugs made in the southwest Caucasus. A town called Qazax (or Gazakh) in what is currently Azerbaijan may be the source of this name, though it seems not to have been used for rugs until well into the twentieth century.

KELLEH. A fairly long oblong carpet (five feet by twelve would be typical, though the term is inexact, and many are longer) of the sort that formed part of the layout of carpets in a traditional Iranian home. The arrangement consisted of a large central carpet (the *mian farsh*) flanked on either side by a runner (a *kennereh*) and held together visually by a crosspiece known as the *kelleh* (pronounced "kelly," like the green).

KHAMSEH. A political coalition of five nomadic tribes in southern Iran that existed from 1861 into the 1930s. Like the nearby Qashga'i, the Khamseh produced high-quality weaving. (Khamseh is also the name of an unrelated village on the Hamadan plain, farther north.)

KILIM. A flatwoven textile with no pile or added embroidery. The pattern of a kilim is created by the colors of the wefts alone. Many of the kilims now most appreciated by rug collectors were woven in Anatolia, but the basic technique is used worldwide, and prestigious types have come also from Iran and the Caucasus.

KIRMAN, OR KERMAN. A city in southern Iran where carpets were woven in Safavid times and that is known now for its elaborately formal workshop carpets. The best Kirmans feature complex and precisely drawn designs that exhibit a wide variety of vivid natural dyes. Their luminous colors are attributed by some authorities to the unusual whiteness of the local wool. A top-quality Kirman will often be called a Lavar (sometimes Ravar), a name taken from a nearby town that had a reputation for exceptionally fine weaving. Kirman is also the marketplace for the rugs and bag faces of the area's Afshar tribe.

KNOT COUNT. A carpet's density is usually measured in the United States by the number of knots per square inch, abbreviated as kpsi. (In Europe and elsewhere, density is often measured by the square decimeter.) Knot count varies enormously according to type, from as little as 40 kpsi in a rough nomadic rug to several hundred in a city workshop carpet to perhaps 600 or more in a fine silk piece.

Knot count is a diagnostic tool, as is also the horizontal to vertical knot ratio.

KNOT STRUCTURE. The pile of an oriental carpet is formed by myriad strands of wool or silk (or sometimes other fibers), each wound around a pair of warps. If both ends of the strand emerge from between the two warps, the resulting knot is termed "symmetrical." If one end of the strand emerges to the left or right of the pair of warps, the knot is "asymmetrical." Occasionally one encounters knots tied around four warps rather than two (the "jufti" knot sometimes seen in northeast Iran), and in the case of antique Spanish carpets, even around just one. Knot structure is a diagnostic tool.

KOCHAK. The so-called ram's horn motif, resembling a pair of diverging hooks, found in many Anatolian kilims and some Turkmen rugs.

KONYA. A city in south-central Turkey (the classical Iconium) where some of the most sought-after Anatolian carpets and kilims were made.

KUBA. A town in the eastern Caucasus and the name given to the usually small rugs woven in and around it, many of which show significant alternate-warp depression.

KUFIC BORDER. A design consisting of a decorative and angular Arabic script running around the edge of a rug. Kufic borders were originally legible, but the loops and spikes and sharp serifs of their orthography became stylized over time, and in later examples they are often entirely abstract.

LATCH HOOK. A very common design element of nomadic and cottage-craft weaving is a diamond medallion edged with rows of angular extensions that resemble hooks. Some scholars believe that these motifs were originally zoomorphic, and represent animal heads.

LOTTO CARPETS. A type of rug woven in western Anatolia during the 1500s and 1600s that features golden arabesques on a red ground. It

is named for Lorenzo Lotto, a Venetian painter who included a rug of this design in one of his altarpieces. Other artists whose names are used for types of carpets that were illustrated in their work include Carlo Crivelli, Gentile Bellini, Domenico Ghirlandaio, Hans Holbein, Hans Memling, and Tintoretto.

LURI. An ancient population in Iran, the Luri are a tribal people living in the Zagros Mountains as well as around Shiraz. They are responsible for both flatweaves and piled work, and their bags and carpets are known for their idiosyncrasy and flair.

MAHAL. The name given to room-size carpets from the Arak area that do not qualify as Ferahans or Sarouks. Mahals are thought of in the trade as respectable but not overly prestigious, and those of better quality are sometimes called Sultanabads. Ziegler Mahals, named for an Anglo-Swiss firm that operated in Arak, are characterized by enlarged and simplified versions of Iranian designs and were intended to appeal to European tastes.

MAIN CARPET. Many of the Turkmen tribes produced weavings that are considerably larger than the bags and animal trappings frequently seen in Central Asian work. Often measuring ten or eleven feet long, these larger Turkmen pieces are known as "main carpets."

MALAYER. A town on the Hamadan plain known for its exceptionally good rugs. These are thus a type of Hamadan, but always go by Malayer.

MARASALI. A village in the eastern Caucasus and the name of a prestigious type of prayer rug. Marasalis feature an allover boteh design, and the best of them have many bright, fiery colors. Just where the line lies between a true Marasali and just a Shirvan with a lot of botehs is, however, a matter of opinion.

MASHAD, OR MASHHAD. A city in northeastern Iran where large, formal carpets are made, many of which resemble Kashans in having a

dark-red and blue palette, a high knot count, and a medallion-and-pendant design. Unusually for workshop carpets, Mashads can be woven either symmetrically or asymmetrically. Like Isfahans, they often carry signature inscriptions.

MEDACHYL. A design motif of reciprocating keyhole shapes used for the border stripes of many rugs, particularly those made in northwest Iran and the southern Caucasus.

MERCERIZED COTTON. In 1889, an industrial process invented by John Mercer was adapted to give cotton thread a glossy appearance, and by the early twentieth century mercerized cotton was being used to make imitation silk rugs, particularly in Anatolia.

MINA KHANI. A design seen most often in room-size carpets from Varamin but also in smaller Caucasian and Baluch pieces. It consists of an allover pattern of alternately colored blossoms connected by a curvilinear lattice of stems.

MUGHAL CARPETS. The Mughals who invaded from Herat to conquer much of India in the sixteenth century brought with them their own tradition of carpet weaving. Carpets made during the three hundred years of their rule are usually much longer than they are wide and show freestanding motifs, such as individual flowers. Often they are made with pashmina and have a bright red ground. See also PASHMINA.

NAIN. A city in central Iran where workshop carpets have been woven since the 1930s. Nains are formal in design and have a restrained palette, an extremely high knot count, and great precision in execution. Neither old enough nor spontaneous enough to appeal to most collectors, they are prized as furnishing carpets, particularly in the Middle East, and as new rugs go, they are expensive.

NINGXIA. A town in northeast China and the name often used for the best Chinese carpets. Some Ningxia carpets appear to be quite old

and were woven well before the twentieth-century expansion of the export trade, although even by the uncertain standards of oriental rug chronology, Chinese carpets are very hard to date.

OTTOMAN CARPETS. Woven for the Turkish court, these were made in western Anatolia during the heyday of the Ottoman Empire, from the fifteenth to the eighteenth century. Many feature large star-shaped medallions on a red ground; others show large circular medallions surrounded by leafy foliage.

PALAMPORES. Antique silk-on-cotton embroideries made in India for export to Europe, where they were often used as bedcovers.

PASHMINA. Though used popularly as the name for any plush shawl, true pashmina is the hair of the changthangi goat or chiru antelope, both of them native to Kashmir and Tibet. Remarkably soft, light in weight, and excellent in its absorption of dyes, pashmina is responsible for the great beauty of many Mughal carpets.

PEKING. The name used for the Chinese rugs produced in and around that city during the first several decades of the twentieth century for export to the European market. Pekings feature traditional Chinese decorative motifs and often have an ivory and blue palette.

PERPEDIL. A village in the Caucasus close to Kuba. Perpedil rugs are identified by their distinctive design—blossom medallions and/or octagons aligned vertically, amid what look like horizontal phallic symbols—rather than their exact provenance.

PRAYER RUG. A small rug with a unidirectional design that could be oriented toward Mecca if a Muslim celebrant were to kneel upon it to pray. Piled prayer rugs have a niche—that is, an arch of some sort—drawn at one end. (Anatolian flatwoven prayer rugs, of which there are many, are also unidirectional, but their niches are sometimes too abstract to be easily read as such.) The design has proved popular

with non-Islamic customers, and most prayer rugs have long been made for the export trade rather than for actual worship.

QASHGA'I. A centuries-old confederation of five tribes in southern Iran occupying territory near Shiraz, all of which are known for the high quality of their weaving.

QASVIN. A city west of Tehran where certain scholars believe a number of very high-quality Safavid carpets were woven. The name is also used in the United States for the room-size double-wefted carpets produced in the city of Hamadan, which in Europe are called Alvands.

QUM, OR GHOM. A city in central Iran that since the 1930s has become a major center of carpet manufacture. Qum produces small and medium-size rugs, many of them silk or with silk highlights, that tend to have fussy designs and a garish palette.

RUNNER. A long narrow rug (often about three feet by ten, and sometimes much longer) frequently used in Western homes for a hallway or stairwell but in Iran placed along the wall of a reception room to provide floor seating with back support. In Farsi, it is called a *kennereh*.

SAFAVID CARPETS. Produced for the Persian court during the Safavid dynasty (1501–1736), these elegant large carpets formed the heart of major collections at the turn of the twentieth century and now bring very high prices. Precisely where they were made has been a point of scholarly disagreement, but the town of Qasvin, west of Tehran, has been proposed for some of them. The usual attribution for the others is Isfahan for those bearing the Herati motif and Kirman for those showing vases, large flowers, and a latticework of stems.

SAPH. A carpet with a design consisting of multiple adjacent niches. Saphs were originally created for mosques, where they marked individual places for prayer, to be used in congregational service.

SAROUK, OR SARUQ. A town near Arak in central Iran, and the name used for formal carpets with floral spray designs that were made there in the 1920s and '30s for export, often to the United States. In response to the American market's preference at the time, these carpets were frequently bleached and then overdyed with deep purple by means of an eyedropper. The resulting "American Sarouks" are ignored if not actively disliked by most carpet scholars, but their sturdy construction has allowed them to endure, and many may still be found in dealer stock or at auction. Rugs with traditional dyes and designs were produced in Sarouk prior to the 1920s, but the production was relatively small and they are seen much less often.

SELJUK CARPETS. Seljuk Turks dominated central Anatolia for most of the twelfth century, and their carpets, presumably derived from steppe nomad prototypes, typically show a repeat pattern of medallions reminiscent of Turkmen motifs, often within a Kufic border. See also KUFIC BORDER.

SELVEDGE. The reinforcement woven into the lateral edges of a carpet. The selvedge is usually made by wrapping the outermost warp or warps with additional wool, cotton, goat hair, or occasionally silk. Selvedges come in many kinds, and their type is a diagnostic tool.

SENNEH. A town in northern Iran (modern Sanadaj) producing rugs that are single-wefted and have a high knot count. The term *Senneh* is sometimes used to refer to the asymmetrical knot, though this is a misnomer, since the knots tied in Senneh itself are almost always symmetrical. Senneh also produces distinctive kilims notable for their curvilinear designs.

SERAPI. The name used for the best carpets made in or near Heriz. See also HERIZ.

SHAH ABBAS THE GREAT. The Persian ruler whose reign (1588–1629) marked the zenith of the Safavid dynasty and whose name designates various designs that originated in his court workshops, partic-

ularly the large floral palmettes seen often in carpets of the period and imitated since.

SHAHSAVAN. The name given to a loose confederation of ethnically Turkic tribes found in the extreme northwest of Iran in the area around Mount Savalan. They are known for their flatwoven bags, most of which were made using soumak technique. Shahsavan has become an increasingly popular designation for the region's rugs as well, though the extent to which these originally nomadic weavers produced piled carpets remains a contested issue. See also SOUMAK.

SHIRVAN. Designating neither a tribe nor a town (the word derives from the name of an old Persian khanate), this term is used for the flat-backed rugs, most often of small to intermediate size, made in the southeast Caucasus. The term also applies to the area's kilims.

SINGLE-WEFTED. A structural feature of piled carpets in which only one weft is passed through the warps after every row of knots. Most single-wefted rugs are Iranian, among them those made in the Hamadan region, those from Senneh, and the so-called Bakhtiari rugs made near Isfahan. See also DOUBLE-WEFTED.

SOUMAK. A technique of embroidery in which extra wefts are wrapped around the warps of a flatweave to produce a design. This technique is easily recognized, because it results in a fabric that is finished on one side but unfinished on the reverse. Shahsavan bags are woven in this way, as are the larger carpets that go by the name soumak and come from the southern Caucasus.

SPANDREL. The corners in the main field of an oriental carpet are often marked off to form their own spaces, known as the spandrels. Spandrels quite often replicate a section of a carpet's central medallion, but the peculiar features of some may suggest provenance. For example, Ferahan spandrels are typically delineated by a stepped or serrated stripe, whereas those of Kashan may have a wavy, ribbon-like edge.

SUZANI. A type of Central Asian flatwoven textile most often consisting of several lengths of undyed cotton cloth, sewn together to create a white field measuring about four by seven feet, which is then colorfully embroidered with silk. There are also Suzanis embroidered on silk grounds, either red or blue, and occasionally on linen.

TABRIZ. A city in the extreme northwest of Iran that has long been a prominent market for carpets and whose merchants are said to have stimulated the great increase in Iranian carpet production that began in the second half of the nineteenth century. Tabriz workshops have produced formal room-size carpets in practically every design imaginable, as well as prayer rugs that imitate those of Anatolia.

TAFRISH. A village on Iran's Hamadan plain whose rugs are better thought of than most of the area's production and so sometimes go by their own name.

TALISH. A town and region west of Baku that produced carpets that are typically long and narrow, and often have an empty field.

THANGKA. A Tibetan Buddhist religious image painted on cotton or silk, using pigments mixed with glue.

TIMURI. A tribal people found in northwestern Afghanistan and northeastern Iran who are said to be descended from Tamerlane's soldiers. Their dark yet glossy carpets and bag faces, which come under the umbrella term Baluch, are sought after.

TRANSYLVANIAN CARPETS. Small rugs, many in prayer-rug design, that were made in western Anatolia and donated to Christian churches in what is now Romania during the Ottoman era.

TREE OF LIFE. A name used not only for what are clearly trees but also for virtually any branched element of carpet design that is arranged on a vertical axis and might conceivably be understood as represent-

ing a tree. Precisely what the significance of such trees might be is not certain, though a tree of immortality does appear in the Quran. Dealers assure their customers that the motif is of great import and antiquity, however—and who could prove otherwise?

TURKMEN, OR TURCOMAN. A name given to the many tribes of Turkic ethnicity located in Central Asia and to the wide range of weavings made by them. Turkmen rugs and bags almost always feature a red or maroon ground and typically show a repeat pattern of geometric shapes known as *güls* that are said to identify the tribe that wove them. These tribes include the Tekke, Yomut, Ersari, Chodor, Salor, Arabatchi, Saryk, and several others. Some of the rugs and larger trappings that Turkmen weavers produced were formerly sold in the West under the name of Bokhara, that being the city in Uzbekistan where many of them initially went to market.

USHAK. A town in western Turkey where large carpets of excellent quality were woven for the Ottoman court in the sixteenth and seventeenth centuries, and where room-size carpets of less careful manufacture were produced for the Western market in the nineteenth and twentieth centuries. Villages in the Ushak area are also where the so-called Transylvanian carpets are thought to have been made. See also TRANSYLVANIAN CARPETS.

UZBEK. Though not usually classed as Turkmens, the Uzbek are ethnically Turkic. They are found in Central Asia, largely in what is now Uzbekistan, and are responsible for a variety of textiles including ikats, carpets, and felts.

VARAMIN. A town southeast of Tehran known for room-size carpets that feature the mina khani design as well as for bag faces that combine Persian and Turkmen motifs. See also MINA KHANI.

WARP DEPRESSION. A structural feature in which the wefts of a carpet are pulled so tightly that the constricted warps alternate in depth and lie on two different levels. If the tension is great enough that

the warps lie directly on top of one another, the carpet may be called double-warped. Degree of warp depression is a diagnostic tool.

YASTIK. Turkish for "pillow"; designates a small piled rug used in Turkey as a cushion cover.

YÜNCÜ. A tribal group in western Turkey that produced distinctive rugs and kilims characterized by primitive-looking branchlike designs and a restricted palette of dark blue or green against purple or magenta.

YÜRÜK. The name given in general to the nomadic tribes of Anatolia, and to the rustic and vigorous rugs and bags they wove.

Bibliography

The literature regarding oriental rugs alone, not to mention other textiles, is extensive. Many of the texts were costly to produce, and many are now relatively rare. As a result, books in this field can be quite expensive, and yet the reliability of the information they offer varies widely. As an aid to navigating the sea of publications, I recommend the titles listed below. I note only those books that were written in English or exist in English translation. Those coming to the carpet literature for the first time might start with the first title on this list and proceed from there as interest suggests and the bank account allows.

Oriental Carpets (General Introduction/Overview)

Oriental Carpets: A Complete Guide (4th edition)
Murray L. Eiland and Murray Eiland III
Bulfinch, 1998
ISBN: 0821225480; ISBN13: 9780821225486

This is the best overall survey of oriental carpets and is the first book to read on the subject. The photos in the 4th edition are of much better quality than those in previous ones.

Oriental Carpets: From the Tents, Cottages, and Workshops of Asia
Jon Thompson
Dutton, 1988
ISBN: 0525484264; ISBN13: 9780525484264

Another good introduction to the field, available in a conveniently priced paperback edition.

Oriental Rug Lexicon
Peter F. Stone
University of Washington Press, 1997
ISBN: 0295975741; ISBN13: 978-0295975740

Of the several encyclopedias of carpet terms available, this is the most reliable.

Oriental Carpet Design: A Guide to Traditional Motifs, Patterns and Symbols
P. R. J. Ford
Thames & Hudson, 2008
ISBN: 0500276641; ISBN13: 9780500276648

This book is organized according to design type, not geographical provenance, and many of its entries are for mid- to late twentieth-century carpets rather than antique ones. The sheer quantity of rugs illustrated, however, together with the author's comprehensive approach, means that useful information about most sorts of oriental carpet can be found here.

Tribal Rugs: A Complete Guide to Nomadic and Village Carpets
James Opie
Bulfinch, 1998
ISBN: 0821225472; ISBN13: 978-0821225479

Opie looks at the tribal weavings of many different regions, providing an overview of carpets produced outside of urban workshops.

The Markarian Album: The Richard R. Markarian Collection of Oriental Rugs
Walter B. Denny and Daniel Walker
Markarian Foundation, 1989
ISBN: 0962111503; ISBN13: 978-0962111501

This book records the private collection of a longtime carpet dealer. It contains photographs of a broad range of high-quality carpets along with structural analysis and a brief commentary.

From Timbuktu to Tibet
Jon Thompson with Thomas J. Farnham
Hajji Baba Club, 2008
ISBN13: 978-1-898113-66-9

This book, which was published in conjunction with the Hajji Baba Club on the occasion of its seventy-fifth anniversary, provides an overview of the textiles and cultures of the major areas of carpet production in Anatolia, the Caucasus, Iran, and Central Asia. (It does not get as far as India or China.) Most of the many rugs illustrated were drawn from the collections of members of the Club.

Persian Carpets (General)

The Persian Carpet
A. C. Edwards
G. Duckworth, 2017
ISBN: 0715650726
ISBN13: 9780715650721

This is a fundamental text and remains a foundational work, but readers should be aware that the structural information it offers regarding tribal rugs is often inaccurate. Originally published in 1953, it now exists in a reasonably priced reprint.

The Splendor of Persian Carpets
Erwin Gans-Ruedin
Rizzoli, 1984
ISBN: 0847801799; ISBN-13: 978-0847801794

Good photos and accurate descriptions of representative carpets from all the major weaving centers of Iran. Better on urban weaving than on tribal production.

Visions of Nature: The Antique Weavings of Persia
James D. Burns
Umbrage Editions, 2011
ISBN: 1884167233; ISBN13: 9781884167232

Beautiful color plates accompanied by the colorful opinions of a prominent collector.

Tribal Rugs
Jenny Housego
Van Nostrand Reinhold, 1978
ISBN: 0442235518

In spite of its all-inclusive title, this book confines itself to the tribal weavings of Iran. Many of its illustrations are in black and white, but its attention to a category of rugs largely ignored by earlier authors was groundbreaking, and it remains a useful volume.

Persian Carpets (Individual Categories)
Kurdish

The Antique Rugs of Kurdistan
James D. Burns
Privately printed, Seattle, 2002
ISBN: 1898406405; ISBN13: 9781898406402

Beautiful illustrations of very beautiful rugs.

An Introduction to Kurdish Rugs and Other Weavings
William Eagleton
Interlink, 1988
ISBN: 0940793172; ISBN13: 978-0940793170

This treats mostly of rugs produced in tribal settings rather than those made by ethnic Kurds in urban environments. The book is interesting, but the rugs shown are of uneven quality.

Discoveries from Kurdish Looms
Edited by Robert D. Biggs; contributions by John R. Perry, Murray L. Eiland, Amadeo de Franchis, John T. Wertime, William Eagleton, and Ralph S. Yohe
Mary and Leigh Block Gallery, Northwestern University, Evanston, IL, 1983
ISBN: 0941680029; ISBN13: 978-0941680028

This is an exhibition catalog with contributions by an impressive lineup of scholars.

Kordi: Lives, Rugs, Flatweaves of the Kurds of Khorasan
Wilfred Stanzer
Adil Besim, 1988
ISBN: 3900921008; ISBN13: 978-3900921002

This book is devoted to the weavings of those ethnic Kurds living in the Khorasan Province of northeast Iran, a group often referred to as Quchan Kurds.

Bakhtiari

Chahar Mahal va Bakhtiari: Village, Workshop and Nomadic Rugs of Western Persia
Peter Willborg
Privately printed, Stockholm, 2002

ISBN: 9187992108
ISBN13: 9789187992100

A thorough examination of the cottage-craft rugs made in each of the many villages lying on the Chahar Mahal plain of western Iran.

Varamin

Rustic and Tribal Weaves from Varamin
Parviz Tanavoli
Yassavoli, 2001
ISBN: 964-306-211-2

Varamin, in north-central Iran, is best known for its production of room-size carpets, typically showing the mina khani design; but Tanavoli concentrates instead on the smaller textiles of the many tribal groups found in this ethnically complex area.

South Persian (Qashga'i, Khamseh, Luri, Afshar, Kirman)

Masterpieces of Fars Rugs
Cyrus Parham
Soroush Press, Tehran, 1996
No ISBN

Parham attempts to identify the provenance of southwest Persian carpets according not only to tribal confederation but also to the subtribes within these groups.

Woven Gardens: Nomad and Village Rugs of the Fars Province of Southern Persia
David Black and Clive Loveless
Privately printed, London, 1979
ISBN: 0950501832; ISBN13: 978-0950501833

Tribal Rugs of South Persia
James Opie
Privately printed, Portland, OR, 1981
ISBN: 0961114401; ISBN13: 978-0961114404

Gabbeh: Art Underfoot
Parviz Tanavoli
Yassavoli, 2004
ISBN: 964306297X; ISBN13: 978-9643062972

Gabbehs are loosely knotted, vividly dyed, and boldly geometric rugs woven by tribespeople of south Persia, often for their own use. Prior to this book they had received little attention.

Afshar: Tribal Weavings from South East Iran
Parviz Tanavoli
Iranian Academy of Arts, 2010
ISBN10: 9642320568; ISBN13: 978-9642320561

The Afshars are a tribal group whose name has been applied to a wide range of south Persian weavings. Tanavoli confines himself to textiles he believes belong to the core group.

Five Centuries of Weaving in Kerman
Taher Sabahi
Textile Museum Associates of Southern California, 2012
No ISBN

This book treats of the urban carpets woven in Kirman rather than the textiles produced by the tribespeople around that city.

Hamadan

One Woman, One Weft: Rugs from the Villages of Hamadân
Tad Runge
Privately printed, Yarmouth, ME, 2002
ISBN: 0615120385; ISBN13: 978-0615120386

Most of the illustrations are of rugs woven in the 1940s. The author argues that rugs made in the villages of the Hamadan plain, though of small prestige, are deserving of more attention.

Hamadan
J. P. Willborg
Privately printed, Stockholm, 1993
ISBN: 91-87992-X

This is an exhibition catalog.

Shahsavan

Shahsavan: Iranian Rugs and Textiles
Parviz Tanavoli
Rizzoli, 1985
ISBN: 2719102334; ISBN13: 978-2719102336

The Shahsavan are a tribal group inhabiting the Mount Savalan area of northwest Iran. The structural information provided in this book is so accurate that it is said to have been used as an instruction manual for creating forgeries of the sought-after soumak bag faces woven by this tribe.

Qarajeh to Quba: Rugs and Flatweaves from East Azerbaijan and the TransCaucasus
Raoul Tschebull
Hali, 2019
ISBN: 1898113610; ISBN13: 978-1898113614

As the title states, this book examines both piled rugs and flatweaves produced in the border region of northwest Iran and the southern Caucasus. These textiles are often called Shahsavan, but Tschebull prefers not to use that name.

Baluch

Rugs of the Wandering Baluchi
David Black
Privately printed, London, 1976
ISBN: 0950501808; ISBN13: 978-095050180

Baluchi Woven Treasures
Jeff W. Boucher
Laurence King, 1990
ISBN: 1856690792; ISBN13: 978-1856690799

Carpets in the Baluch Tradition
Siawosch Azadi
Klinkhardt & Biermann, 1986
ISBN: 3-7814-0262-2

Belouch Prayer Rugs
Michael Craycraft
Adraskand Gallery, Point Reyes Station, CA, 1982
No ISBN

This is an exhibition catalog.

From the Land of the Sun
Thomas Cole
Privately printed, San Rafael, CA, 2022
ISBN13: 978-1-64370098-4

A record of the Richard Stuart collection of Baluch rugs, this volume is valuable for the high quality of its color prints. The book also contains atmospheric black-and-white photos taken in Afghanistan by Josephine Powell during the 1960s.

Anatolian Carpets

Turkish (Antique Collectors' Club Oriental Carpets series, volume 4)
Z. Kipper and C. Fritzsche
Antique Collectors' Club, 1995
ISBN: 1851490914; ISBN13: 978-1851490912

A comprehensive overview of rugs woven throughout Anatolia; some flatweaves are included.

Turkish Carpets
J. Iten-Maritz
Kodansha International, 1977
ISBN: 0870112813
ISBN13: 978-0870112812

This book, too, includes some flatweaves along with many illustrations of piled carpets.

Yastiks: Cushion Covers and Storage Bags of Anatolia
Brian Morehouse
Philadelphia 8th ICOC, 1996
ISBN: 1889666017; ISBN13: 978-1889666013

Antique Ottoman Rugs in Transylvania
Edited by Stefano Ionescu
Privately printed, Rome, 2007
ISBN: 887620752X; ISBN13: 9788876207525

This book examines the so-called Transylvanian carpets that were woven in western Anatolia and donated to churches in Romania, where many of them can still be seen today.

Rugs of the Peasants and Nomads of Anatolia
W. Brüggemann and H. Böhmer
Kunst & Antiquitaten, 1983

ISBN: 3921811236; ISBN13: 9783921811238

This book is of special interest because of its in-depth examination of the chemistry of vegetal dyes.

Carpets of the Vakiflar Museum
Belkis Balpinar and Udo Hirsch
U. Hülsey, Wesel, Germany, 1988
ISBN: 3-923185-04-9

An item-by-item examination of the very old Anatolian carpets, many of them discovered in mosques, that are included in the Vakiflar Museum collection.

Caucasian Carpets

Caucasian (Antique Collectors' Club Oriental Carpets series, volume 1)
Ian Bennett
Antique Collectors' Club, 1981
ISBN: 0902028588; ISBN13: 978-0902028586

Caucasian rugs are still typically classified according to pattern rather than structure, and this volume makes no attempt to defend its attributions other than by appearance and hunch. It nonetheless offers a great many photographs of a great many types of Caucasian rug, and it remains widely consulted by those interested in weavings from this area.

Caucasian Rugs
Ulrich Schürmann
Washington International Associates, 1974
ISBN: 0903580152
ISBN13: 978-0903580151

The color reproduction in this classic book is a bit brassy, but Schürmann's nomenclature and categories became standard.

Caucasian Prayer Rugs
Ralph Kaffel
Laurence King, 1998
ISBN: 1856691179
ISBN13: 978-1856691178

Caucasian Carpets and Covers: The Weaving Culture
Richard E. Wright and John T. Wertime
Laurence King, 1995
ISBN: 1856690776; ISBN13: 978-1856690775

Kazak
Raoul Tschebull
Near Eastern Art Research Center, 1971
ISBN: 091241801X; ISBN13: 978-0912418018

This is a pioneering monograph devoted to carpets woven in the southwest Caucasus, mostly in what is now Armenia, in the late nineteenth century.

Early Caucasian Rugs
Charles Grant Ellis
Textile Museum, Washington, DC, 1975
Library of Congress Catalog Number: 75-27048

An exhibition catalog. Still useful, though many of the illustrations are in black and white.

Turkmen Carpets

Turkoman (Antique Collectors' Club Oriental Carpets series, volume 5)
Uwe Jourdan
Antique Collectors' Club, 1995
ISBN: 1851491368; ISBN13: 978-1851491360

Turkmen: Tribal Carpets and Traditions
Edited by Jon Thompson and Louise Mackie
Textile Museum, Washington, DC, 1980
ISBN: 0874050146; ISBN13: 978-0295965956

Turkmen Carpets: Masterpieces of Steppe Art, from the 16th to the 19th Centuries
Elena Tsareva
Arnoldsche Verlagsanhalt, 2011

This book catalogs 168 items in the Hoffmeister collection of Turkmen weavings. It includes much commentary and analysis and thus provides a wide overview of a complex field.

Turkmen Carpets (The Neville Kingston Collection)
Elena Tsareva
Arnoldsche Verlagsanhalt, 2016
ISBN: 978-3-89790-445-3

Similar to the book above, but a different collection.

Between the Black Desert and the Red
Robert Pinner and Murray Eiland Jr.
Fine Arts Museum, San Francisco, 2006
ISBN: 0-88401-099-6

This is an exhibition catalog.

Turkmen Carpets: A New Perspective (two volumes)
Jürg Rageth; English edition translated by DeWitt Mallory
Privately printed, Basel, 2016
No ISBN

This monumental work examines Turkmen weaving on the basis of recent improvements in the accuracy of carbon dating and dye analysis.

Qaraqalpaqs of the Aral Delta
David and Sue Richardson
Prestel, 2012
ISBN: 978-3-7913-4738-7

A volume examining all aspects of Qaraqalpaq culture, including clothing, embroideries, and carpets.

Tibetan Carpets

The Discovery of Tibetan Rugs: The Claudio Mariani Collection
Claudio Mariani and Diane K. Myers
Family Art Foundation of Victor and Michelle Sassoon, Hong Kong, 2017
ISBN: 9888272143
ISBN13: 9789888272143

Many of the colorful and curvilinear rugs in this collection show the impact that Chinese textile design had on Tibetan weaving starting in the early twentieth century.

From the Land of the Snow Lion
Michael Buddeberg and Bruno J. Richtfeld
Hirmer, 2017
ISBN13: 978-3-7774-2626-6

This large catalog accompanied an exhibition of the Buddeberg collection of Tibetan artifacts, and it contains illustrations of jewelry and furniture as well as of textiles, but much of the book is concerned with Tibetan rugs.

The Tiger Rugs of Tibet
Mimi Lipton
Thames & Hudson, 1989
ISBN: 0500973695; ISBN13: 978-0500973691

Tibetan Rugs: the Molacek Collection
Rudi Molacek, Thomas Cole, Felix Elwert, Ben Evans, *et alia*
Edited by Daniel Shaffer
Hali Publications, London, 2023
ISBN13: 978-1-89811-371-3

A two-volume record of a collection of rugs that mostly predate the twentieth century, this includes commentary and interviews with specialists in the field. As the Rageth publication does with Turkmen carpets, these volumes use carbon dating to establish that some Tibetan textiles are much older than had been previously thought.

Sacred & Secular: The Piccus Collection of Tibetan Rugs
Robert P. Piccus
Serindia Publications, Chicago, 2011
ISBN 13: 978-1-9324-7655-2

This book testifies in part to the change in Tibetan weaving that took place at the turn of the twentieth century, when what had been an austere, geometric style with a fairly restricted palette became accompanied or replaced by colorful figurative weaving heavily influenced by Chinese aesthetics.

East Turkestan Carpets

Carpets from Eastern Turkestan, Known as Khotan, Samarkand & Kansu Carpets

Hans Bidder
Washington International Associates, 1979; original edition 1964
No ISBN

Indian Carpets

There exists no good overview of nineteenth- and early twentieth-century carpet manufacture in India, and no information is generally available concerning such structural detail as might differentiate carpets made in that period in Lahore, Amritsar, Agra, or possibly elsewhere.

Indian Carpets
Erwin Gans-Ruedin
Rizzoli, 1984
ISBN: 0847805514; ISBN13: 9780847805518

This book is mentioned in the absence of others. It treats of carpets either several hundred years old or made after about 1970.

Flowers Underfoot: Indian Carpets of the Mughal Era
Daniel Walker
Metropolitan Museum of Art / Harry N. Abrams, 1997
ISBN: 0-87099-787-4, 0-8109-6510-0

This book was published in conjunction with a museum exhibition, and as the title indicates, it examines carpets from the sixteenth through the eighteenth centuries.

Jail Birds
Ian Bennett
Kennedy Carpets, London, 1987
No ISBN

This is the catalog of an exhibition of nineteenth-century carpets believed to have been woven in Indian prisons.

Chinese Carpets

There are few good books in English treating of nineteenth- and early twentieth-century Chinese carpets, and none that are truly thorough. This absence is surprising, given that China has an ancient tradition of

craftsmanship and design and is believed by many scholars to be the place of origin for many of the motifs found in the carpets of other regions.

Chinese Carpets
Erwin Gans-Ruedin
Kodansha International, 1981
ISBN13: 978-0870114854

As with his book on Indian carpets, Gans-Ruedin's book on Chinese carpets is mentioned in lieu of something better.

Carpets from China, Xinjiang, and Tibet
Lennart Larsson Jr.
Bamboo, London, 1988; reprint, Shambhala, Boston, 1989
ISBN: 187007601X; ISBN13: 978-1870076012

Chinese Carpets
Charles I. Rostov & Jia Guanyan
Harry N. Abrams, 1983
ISBN: 0810907852; ISBN13: 978-0810907850

Moroccan Carpets

From the Far West: Carpets and Textiles of Morocco
Edited by Patricia L. Fiske, W. Russell Pickering, and Ralph S. Yohe
Textile Museum, Washington, DC, 1980
ISBN: 0295965940

Moroccan Carpets
Brooke Pickering, W. Russell Pickering, and Ralph S. Yohe
Laurence King, 1998
ISBN: 1-85669-146-2

Marokko Morocco Mon Amour
Kurt Rainer
Culture and More, 2005
ISBN: 3-200-00209-3

Non-Oriental Carpets

Carpets and Rugs of Europe and America

Sarah B. Sherrill
Abbeville Press, 1996
ISBN: 1-55859-383-7

Flatweaves and Related Textiles
Kilims
Kilims: The Art of Tapestry Weaving in Anatolia, the Caucasus and Persia
Yanni Petsopoulos
Thames & Hudson, 1979
ISBN: 0500233055; ISBN13: 978-0500233054

This volume offers a vast overview, but less than a quarter of its 494 illustrations are in color.

Kilim: A Complete Guide
Alastair Hull and José Luczyc-Wyhowska
Chronicle Books, 2000
ISBN: 0-8118-0359-7

This volume offers many plates in good color, but they are not enumerated and thus sometimes difficult to coordinate with the text.

Kilims: Masterpieces from Turkey
Yanni Petsopoulos; commentary by Belkis Balpinar
Rizzoli, 1991
ISBN: 0-8478-1417-3

Anatolian Kilims: The Caroline and H. McCoy Jones Collection
Cathryn M. Cootner, with contributions by Garry Muse
Fine Arts Museums of San Francisco / Hali, 1990
ISBN: 0-88401-068-6

An exhibition catalog.

A Nomad's Art: Kilims of Anatolia
Sumru Belger Krody, with Serife Atlihan, Walter B. Denny, and Kimberly Hart
Textile Museum, Washington, DC, 2018
ISBN13: 978-0-87405-039-4

This book was published in conjunction with the exhibition of the Samy Megalli collection.

Flatweaves of the Vakiflar Museum
Belkis Balpinar and Udo Hirsch
Wesel, 1982
ISBN: 3-923185-02-2

An item-by-item examination of the very old kilims now in the Vakiflar collection.

Persian Flatweaves
Parviz Tanavoli
ACC, 2002
ISBN: 9781851493357; ISBN13: 978-1851493357

Embroideries, Suzanis, and Soumaks

The Kashmir Shawl and Its Indo-French Influence
Frank Ames
Antique Collectors' Club, 1986
ISBN: 0907462626; ISBN13: 978-0907462620

The Embroidery of the Greek Islands
Roderick Taylor
Interlink Books, 1998
ISBN: 1-899296-05-0

Ottoman Embroidery
Marianne Ellis and Jennifer Wearden
Victoria & Albert, 2001
ISBN: 0-8109-6585-2

Stars of the Caucasus
Michael Franses
Hali, 2018
ISBN13: 9781898113591

Examines Caucasian silk embroideries, many of them made in what is now Azerbaijan.

Suzani: Central Asian Embroideries
Yigal Yanai

Haaretz Museum, Tel Aviv, 1986
No ISBN

An exhibition catalog.

Sumak Bags of Northwest Persia and Transcaucasia
John T. Wertime
Laurence King, 1998
ISBN: 1856691071

Sumakh: Flat-Woven Carpets of the Caucasus
Alberto Boralevi
Karta Sas, Florence, 1986
No ISBN

Felts

Nomadic Felts
Stephanie Bunn
British Museum Press, 2010
ISBN-10: 0714125571
ISBN-13: 978-0714125572

Ikats

Central Asian Ikats
Ruby Clark
Victoria and Albert Museum, 2007
ISBN: 1851775250
ISBN13: 978-1851775255

Ikat: Silks of Central Asia
Kate Fitz Gibbon and Andrew Hale
Laurence King, 1997
ISBN: 1856691012; ISBN13: 978-1856691017

This is a gorgeously illustrated volume devoted to the Guido Goldman collection of these spectacularly colorful textiles.

Carpet History

Carpets and Textiles in the Iranian World, 1400–1700
Edited by Jon Thompson, Daniel Shaffer, and Pirjetta Mildh; contributions by Julia Bailey, Walter Denny, and others

Ashmolean Museum / Bruschettini Foundation, 2003
ISBN13: 978-1-898113-69-0

Carpets and Their Datings in Netherlandish Paintings, 1540–1700
Onno Ydema
Antique Collectors' Club, 1991
ISBN: 1851491511

Oriental Rugs in Renaissance Florence
Marco Spallanzani
Bruschettini Foundation, Florence, 2007
ISBN: 887242314; ISBN13: 978-88-7242-3141

Examines the importation and sale of oriental rugs in fifteenth- and sixteenth-century Florence using archival documents, the evidence of paintings, and the surviving carpets themselves.

The Orient Stars Collection: Anatolian Tribal Rugs, 1050–1750
Michael Franses with Anna Beselin, Walter P. Denny, Eberhart Herrmann, Klaus Kirchheim, Jürg Rageth, and Cosima Stewart
Hali, 2021
ISBN13: 978-18-9811-3959

A large and glossy tome that documents a major collection of very old carpets that are of extraordinarily high quality. It replaces an earlier volume, *Orient Stars*, published in 1998, and contains illustrations of thirty-three additional rugs plus further commentary.

The Persian Carpet Tradition: Six Centuries of Design Evolution
P. R. J. Ford
Hali, 2019
ISBN: 1898113629; ISBN13: 978-1898113621

A scholarly, not to say dense, text that is up-to-date and comprehensive.

The Persian Carpet: The Forgotten Years, 1722–1872
Hadi Maktabi
Hali, 2019
ISBN: 1898113866; ISBN13: 978-1898113867

Maktabi maintains that the period from the fall of Persia's Safavid dynasty to the so-called carpet revival of the late nineteenth century did

not in fact see a total collapse of Iran's carpet industry but instead was a time of continued production and design evolution.

Milestones in the History of Carpets
Jon Thompson
Moshe Tabibnia, Milan, 2006
ISBN 13: 978-8890271014

This sumptuously printed volume examines the Tabibnia collection of fifteenth- to seventeenth-century carpets, arguing in part for the important role of Damascus in production and design.

Classical Chinese Carpets I: Lions Dogs, Hundred Antiques
Michael Franses, Hwee Lie Thè, and Gary Dickinson, with Hans König
Textile & Art, 2000
ISBN: 1898406308

This was published as the first of what was intended to be a series, though other titles have yet to appear.

Seven Hundred Years of Oriental Carpets
Kurt Erdmann
University of California Press, 1970
ISBN: 0520018168; ISBN13: 978-0520018167

A classic in the field, though now somewhat dated.

Museum Collections

The Carpet and the Connoisseur
Walter B. Denny with Thomas J. Farnham
Saint Louis Art Museum, 2016
ISBN13: 978-0891780724

Published in conjunction with an exhibition of carpets once owned by James F. Ballard, whose collection provided a large portion of the carpets now in the Saint Louis Art Museum.

Oriental Rugs in the Metropolitan Museum of Art
M. S. Dimand and Jean Mailey
Metropolitan Museum of Art, 1996 (reprinted 2012)
ISBN: 0300192959; ISBN13: 978-0300192957

Oriental Carpets in the Philadelphia Museum of Art
Charles Grant Ellis
Philadelphia Museum of Art / University of Pennsylvania Press, 1988
ISBN: 081227959-x; ISBN: 0-87633-070-7 (paperback)

Knots: Art and History, The Berlin Carpet Collection
Anna Beselin
Skira, 2018
ISBN: 8857239128; ISBN13: 978-8857239125

Auction Catalogs

Some auctions have offered carpets of such interest that their catalogs are of scholarly value. A few such are noted here.

Turkmen and Antique Carpets from the Collection of Dr. and Mrs. Jon Thompson
Sotheby's, catalog 6518
December 16, 1993, New York

The Bernheimer Family Collection of Carpets
Christie's, catalog 5547
February 14, 1996, London

Carpets from the Estate of Vojtech Blau
Sotheby's, catalog 8291
December 14, 2006, New York

Sammlung Kossow: Teppiche und Flachgewebe der Nomadenstämme in Fars (The Kossow Collection: Carpets and Flatweaves of the Nomad Tribes of Fars)
Rippon Boswell & Co., catalog 77
March 26, 2011, Wiesbaden

Important Carpets from the William A. Clark Collection, Corcoran Gallery of Art
Sotheby's, catalog 9012
June 5, 2013, New York

The Kurt Munkacsi and Nancy Jeffries Collection
Austria Auction Company, no catalog number
May 9, 2015, Vienna

Periodicals

Hali, the International Journal of Oriental Carpets
www.hali.com
info@hali.com
7 Ability Plaza, Arbutus Street
London E84DT UK
ISSN: 0142-0798

A quarterly printing scholarly articles, exhibition reviews, auctions news, etc., this is the bible of the carpet world. Back issues, of which there are now over 220, can be accessed online for free by subscribers.

Textiles Asia
www.textilesasia.com
bonniemcorwin@gmail.com
PO Box 20158, Columbus Circle Station
New York, NY 10023
ISSN: 2225-0190

Jozan Magazine (digital only)
www.jozan.net
ivan@jozan.d

About the Author

GEORGE BRADLEY is a poet, fiction writer, and translator who has published with Yale University Press, Knopf, the Waywiser Press (UK), and Louisiana State University Press. His work has appeared in many periodicals, including the *New Yorker*, the *Paris Review*, and the *New Republic*, and he has received numerous awards, including the Yale Younger Poets Prize and a grant from the National Endowment for the Humanities. He has worked variously in construction, as a sommelier, as a copywriter, and as a literary editor. At present he imports and distributes an Italian olive oil produced on a farm near Florence. George Bradley is a longtime collector of oriental carpets and a member of the Hajji Baba Club in New York City. He can often be found in Chester, Connecticut.